IMAGES
of America

THE BRYN ATHYN
HISTORIC DISTRICT

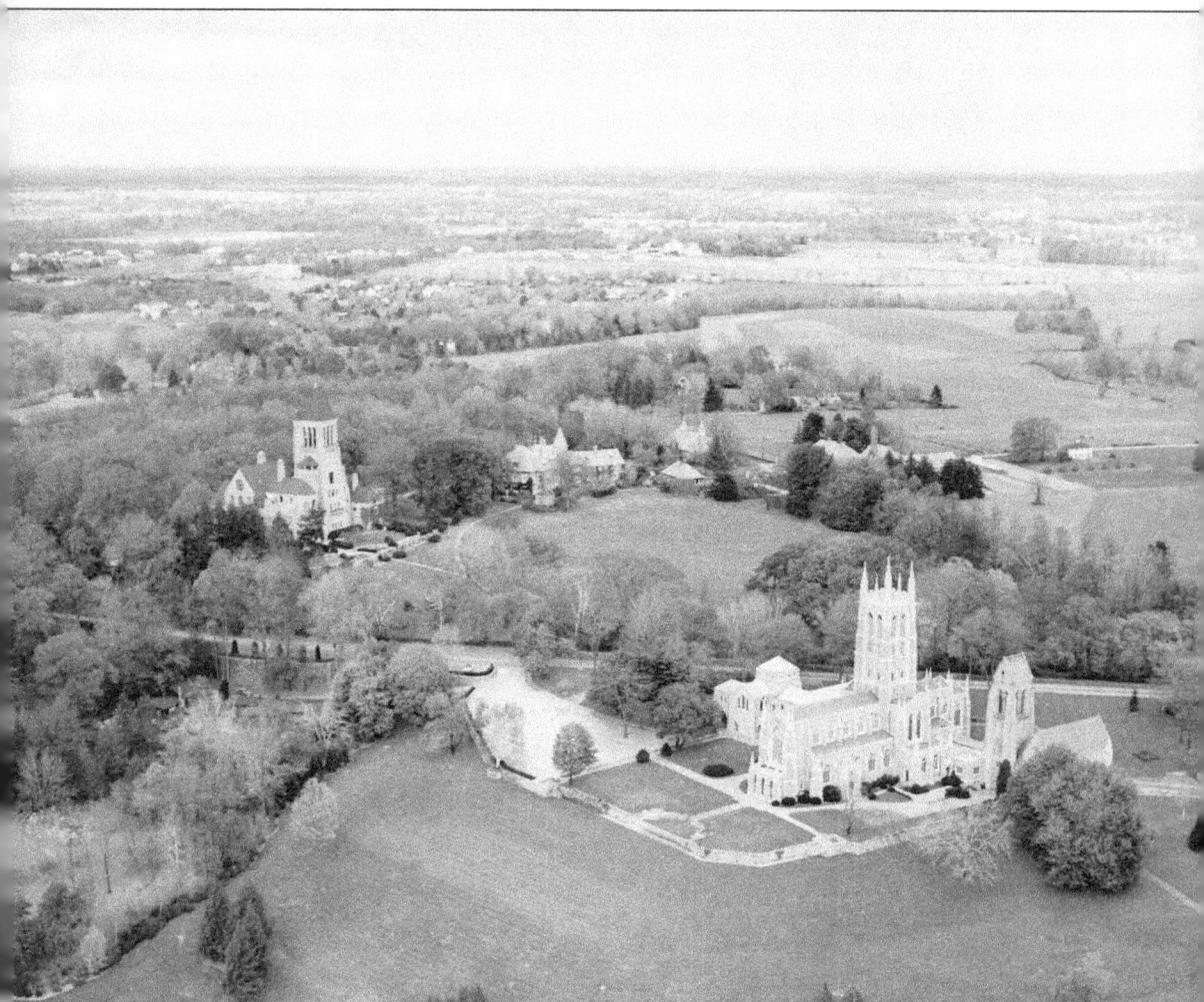

The Bryn Athyn Historic District, recognized as a National Historic Landmark in 2008, includes the renowned Bryn Athyn Cathedral and three former Pitcairn family residences. Cairnwood (center), a 19th-century country house in the Beaux-Arts style, was built by John and Gertrude Pitcairn. Bryn Athyn Cathedral (lower right), a medieval-style house of worship, was dedicated in 1919. Glencairn (left), completed in 1939, was once the home of Raymond and Mildred Pitcairn but now serves as a museum of religious art and history. (Cairncrest is not pictured in this photograph.) (Courtesy of the Glencairn Museum Archives.)

ON THE COVER: Stone workers pose with the Raymond Pitcairn family beside one of the pinnacles on the main tower of Bryn Athyn Cathedral around 1919. Pitcairn (far left) supervised the design and construction, and George Milne (standing in the middle) was the mason foreman. The cathedral has been called "an epoch-making masterwork of architectural art, created with joy, full of artistic conscience." (A. Kingsley Porter, *Beyond Architecture*. Boston, 1918: 190.) (Courtesy of the Glencairn Museum Archives.)

IMAGES
of America

THE BRYN ATHYN HISTORIC DISTRICT

Ed Gyllenhaal and
Kirsten Hansen Gyllenhaal

ARCADIA
PUBLISHING

Published by Arcadia Publishing
Charleston, South Carolina

Library of Congress Control Number: 2010935100

For all general information, please contact Arcadia Publishing:
Telephone 843-853-2070
Fax 843-853-0044
E-mail sales@arcadiapublishing.com
For customer service and orders:
Toll-Free 1-888-313-2665

Visit us on the Internet at www.arcadiapublishing.com

This book is dedicated to our bookish children,
David Nils, Rebecca Kristina, and Annika Lucia.

CONTENTS

ACKNOWLEDGMENTS

We would like to thank the Academy of the New Church, the Bryn Athyn College Research Committee, and the Paul Carpenter Fellowship Fund for their support of the research and writing of this book.

This project required the cooperation of many people, including the members of the Bryn Athyn Historic District Council: Jim Adams, Tina Bartels, Doreen Carey, Stephen Morley, Andrew G. Nehlig, Jennifer Pronesti, and Evelyn Stephens. We would also like to express our gratitude to the following individuals who generously provided knowledge or other assistance: Lisa Parker Adams, Bret Bostock, Marvin Clymer, Joralyn Echols, Rachel Glenn, David Gyllenhaal, Brian Henderson, Gregory Jackson, Jason Klein, J. Kenneth Leap, Martha McDonough, B. Erik Odhner, Chara Odhner, David Perry, Lachlan Pitcairn, Judith Pitcairn Rhodes, Elizabeth Hollister Rogers, David Rowland, and Shannon Walko. Erin Vosgien at Arcadia Publishing was encouraging and highly professional from the very beginning.

Unless otherwise noted, all photographs in this book come from the Glencairn Museum Archives and from the Academy of the New Church Archives at the Swedenborg Library, both located on the Academy of the New Church campus in Bryn Athyn, Pennsylvania. Photographs not available in these archives were graciously provided by members of the families who once lived in the homes that now form a part of the Bryn Athyn Historic District. In particular, we would like to thank Charis Pitcairn Cole, Hilary Pitcairn Glenn, Dean Henry, Mable Henry, Nelson Henry Jr., Brent Pendleton, Beatrice Pitcairn, Duncan Pitcairn, Jocelyn Pitcairn, and Judith Pitcairn Rhodes. Special thanks go to Andrew G. Nehlig, who was instrumental in assembling the group of photographs for the Cairncrest section. Photographs provided by individuals not listed above have been credited in the captions.

Over the years, most of the gardens at Cairncrest have been removed and very few photographs of the original landscape have survived with the Pitcairn family. However, while researching the Cairncrest chapter, we found a cache of 17 photographs of the house, grounds, and gardens at the Pennsylvania State Archives. They were taken in June 1931 by Mattie Edwards Hewitt, a well-known home and garden photographer. The three photographs chosen for this book are retained within collection MG-380 at the Pennsylvania State Archives in Harrisburg as images 29695, 29700, and 29705.

Finally, we would like to thank the donors, employees, volunteers, and other supporters who over many years have served as excellent stewards of these historic buildings and their contents. The recognition of this remarkable site in Bryn Athyn as a National Historic Landmark District in 2008 was well deserved.

INTRODUCTION

Bryn Athyn, Pennsylvania, located in southeastern Montgomery County, was founded as a religious community in the late 19th century by members of a Christian denomination known as the New Church. This small borough is home to some of the most remarkable architecture in the Philadelphia area, including buildings that reflect the religious faith and vision of the community's earliest residents. The Bryn Athyn Historic District, officially recognized as a National Historic Landmark in 2008, comprises Bryn Athyn Cathedral and three former residences of the Pitcairns, a prominent New Church family.

Cairnwood, an 1895 country house in the Beaux-Arts style, was designed by the New York firm of Carrère and Hastings for John Pitcairn (1841–1916), one of America's leading industrialists. Bryn Athyn Cathedral, dedicated in 1919, is renowned for the old world craftsmanship used to create its distinctive architecture and magnificent stained glass windows. Cairncrest, built between 1926 and 1928, was the home of John's youngest son, Harold F. Pitcairn (1897–1960), a pioneer in the field of aviation. Glencairn, a castle-like mansion completed in 1939, was built by John's oldest child, Raymond Pitcairn (1885–1966), as a home for his family and art collections. New Church beliefs and practices were central to the life of each of these buildings.

The origins of the New Church lie in 18th-century Sweden, with the theological writings of Emanuel Swedenborg (1688–1772), a scientist, philosopher, and Christian theologian. Swedenborg, the son of a Lutheran bishop, was born in Stockholm and educated at the University of Uppsala, where he studied philosophy, mathematics, and science, as well as Hebrew, Greek, and Latin. He went on to publish a series of books that established his reputation in Europe as a scientist and philosopher.

At the age of 55, after experiencing a series of religious visions, Swedenborg shifted his focus away from science and philosophy and began writing what eventually became 25 volumes of theology, grounded in the Bible. Swedenborg's theological works portray the Bible as a unified system of theological thought, with no inherent conflict between faith and reason. To Swedenborg, true faith is not just a matter of knowledge or belief but comes from living a life of usefulness to one's family, community, nation, and church. He called this approach to Christianity the New Church. Swedenborg never attempted to found a religious organization, but his readers began to establish congregations shortly after his death in 1772.

Swedenborg's writings were well received in 19th-century America and were familiar to many leading intellectuals of the day. His ideas influenced the work of the writers Ralph Waldo Emerson and Henry James, as well as the art of George Inness, the landscape painter, and Hiram Powers, the sculptor. John Chapman, better known as Johnny Appleseed, preached New Church ideas and distributed copies of Swedenborg's writings while planting apple orchards in the Midwest for the advancing pioneers.

Philadelphia was one of the earliest centers of New Church activity in the United States. The first New Church place of worship in the city, dedicated in 1817, was designed by William

Strickland, a member of the New Church who became the most famous Philadelphia architect of his day. In 1876, the Reverend William Henry Benade (1816–1905), together with John Pitcairn and a small group of supporters, established the Academy of the New Church in Philadelphia. The first classes took place the next year in the church building of the Advent Society on Cherry Street. Pitcairn, who had amassed a considerable personal fortune through his involvement in Pennsylvania railroads, oil, and coal, was key to the success of Benade's educational activities. Over the next few years their dream of a comprehensive system of New Church education was realized, as the Academy of the New Church developed a theological school for training ministers, a college, a boys' school, and a girls' school.

During the late 19th century, Philadelphia, like other big cities, experienced the effects of the Industrial Revolution. Pollution, disease, and traffic congestion made cities less attractive to families, and the increase in the number of rail lines and streetcars allowed people to live outside of Philadelphia and commute to work from newly formed suburbs such as Media and Ardmore. In the late 1880s, some members of the Philadelphia New Church congregation spent their summers in the Huntingdon Valley countryside along the Pennypack Creek, near the Alnwick Grove stop on the Philadelphia-Newtown rail line. The decision was made in 1891 to move the Academy of the New Church to Huntingdon Valley. The move, which took place in 1897, was carefully planned, with the Pitcairns purchasing enough farmland to accommodate both the growing New Church community and a campus for the Academy of the New Church. In 1899, the village association named its new community Bryn Athyn, or "Hill of Unity," but it was not until 1916 that Bryn Athyn was officially recognized as an independent borough.

John Pitcairn's son Raymond took many of the photographs published in this book. Raymond became a serious amateur photographer in his early 20s and continued to enjoy photography as a hobby throughout his lifetime. It was in connection with this hobby that he undertook his first architectural project: designing a photographic studio above the garage across the street from his home at Cairnwood. The studio featured a large room with skylights, where he posed his subjects, and an adjoining darkroom. In 1913, one of his posed studio photographs took second prize in a popular annual photography exhibition held by John Wanamaker in Philadelphia. (One of the judges was Alfred Stieglitz, remembered today as the father of modern American photography.) A large archive of photographic prints and negatives from the Pitcairn collection—including thousands of glass negatives—is now stored in the Glencairn Museum Archives. While it seems likely that Pitcairn took most of these photographs himself, the authors of this book have rarely been able to attribute specific images to him with absolute certainty. Photographs taken by one of his sons, Michael Pitcairn, have also been reproduced here. Michael was an official US Army photographer during World War II, covering assignments in Australia, New Guinea, and the Philippines. After the war, he became a professional photographer.

While photographs by their very nature can tell only one part of a story, we hope these images serve to inspire a new generation of students and scholars to further explore the rich and fascinating history of the Bryn Athyn Historic District.

One

CAIRNWOOD

On his 14th birthday, John Pitcairn left home to earn his own living, with a copy of the Bible and one of Emanuel Swedenborg's books, *True Christianity*, in his knapsack. Beginning as a telegraph operator, he worked his way up to the position of superintendent on a branch of the Pennsylvania Railroad and began investing his savings in Pennsylvania coal, oil, and gas. Pitcairn made his fortune during the Pennsylvania oil boom of the 1870s in oil production, refining, and the newly developing pipelines. Later in life, he also became involved in manufacturing and was a cofounder of the Pittsburgh Plate Glass Company.

In 1884, Pitcairn married Gertrude Starkey, a woman from a New Church family in Philadelphia. At about this time, the Philadelphia New Church congregation they attended began to discuss the possibility of moving the church, school, and their own homes from the city to a more healthy and restful atmosphere in the country. In 1889, the Pitcairns purchased 84 acres in Huntingdon Valley for a New Church community and for their own personal estate, which they named Cairnwood.

Charles Eliot was hired to design the grounds of Cairnwood on the location of the old Knight farm. Soon afterward Eliot became a partner in the Brookline, Massachusetts, firm of Frederick Law Olmsted. Regarded today as the father of American landscape architecture, Olmsted had earlier designed Central Park in New York City. The firm also developed an ambitious plan for the rest of the New Church settlement, later named Bryn Athyn.

The house and outbuildings at Cairnwood were designed by Thomas Hastings, a partner in the prominent New York architectural firm of Carrère and Hastings. Both men studied at the famous École des Beaux-Arts in Paris. Cairnwood was their first large country house commission, and in time the firm developed a reputation as designers of country houses for the so-called "captains of industry." Cairnwood became the sole residence of the John and Gertrude Pitcairn family when it was completed in 1895.

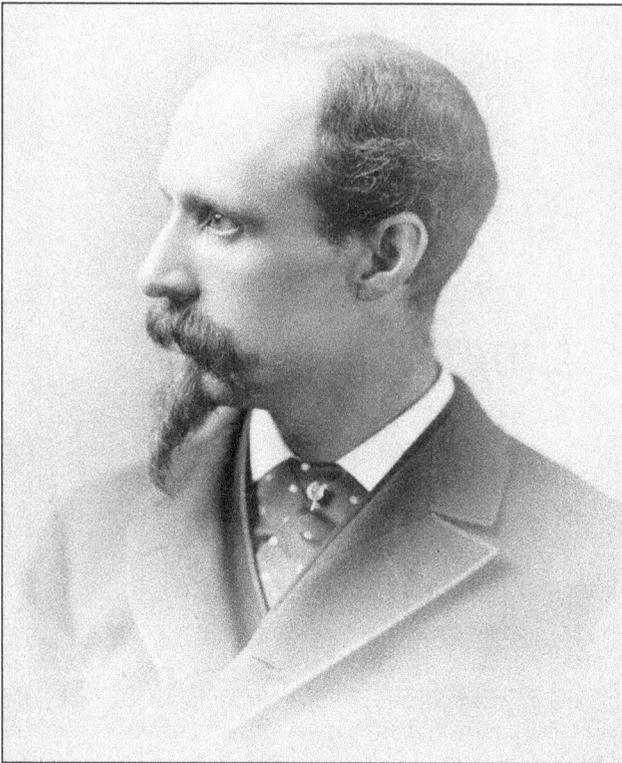

John Pitcairn was born in Scotland in 1841. His family immigrated to Pittsburgh, Pennsylvania, when he was five and soon afterward the entire family was baptized into the New Church. The New Church is a Christian faith founded on the writings of Emanuel Swedenborg, an 18th-century Swedish theologian. Pitcairn attended a New Church Sunday school and sang in the choir with Andrew Carnegie. Like Carnegie, Pitcairn became a self-made man and captain of industry.

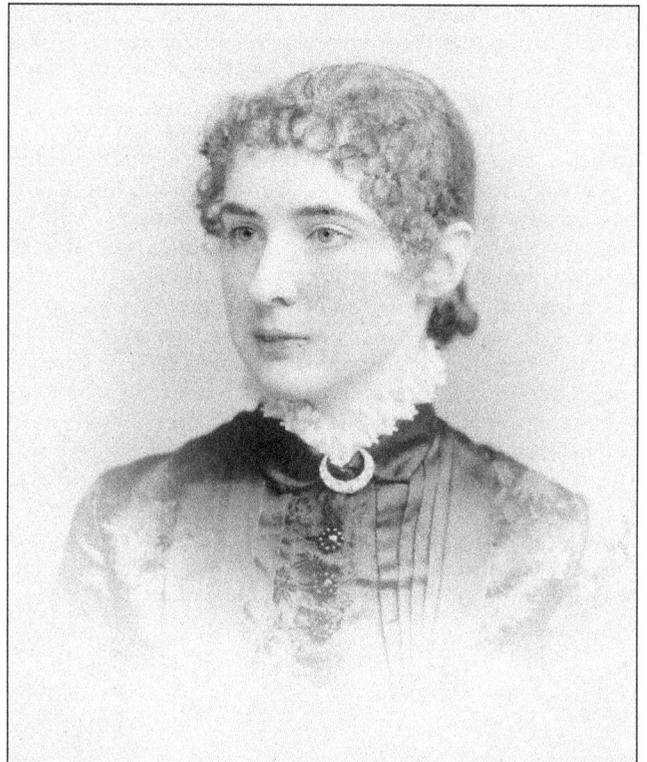

In 1884, after a long courtship, John Pitcairn married Gertrude Starkey, the daughter of a Philadelphia doctor. They shared a strong interest in the New Church and their letters to each other reveal a deep mutual affection and admiration. The Pitcairns lived in Philadelphia on Spring Garden Street. It was there that five of their six children were born.

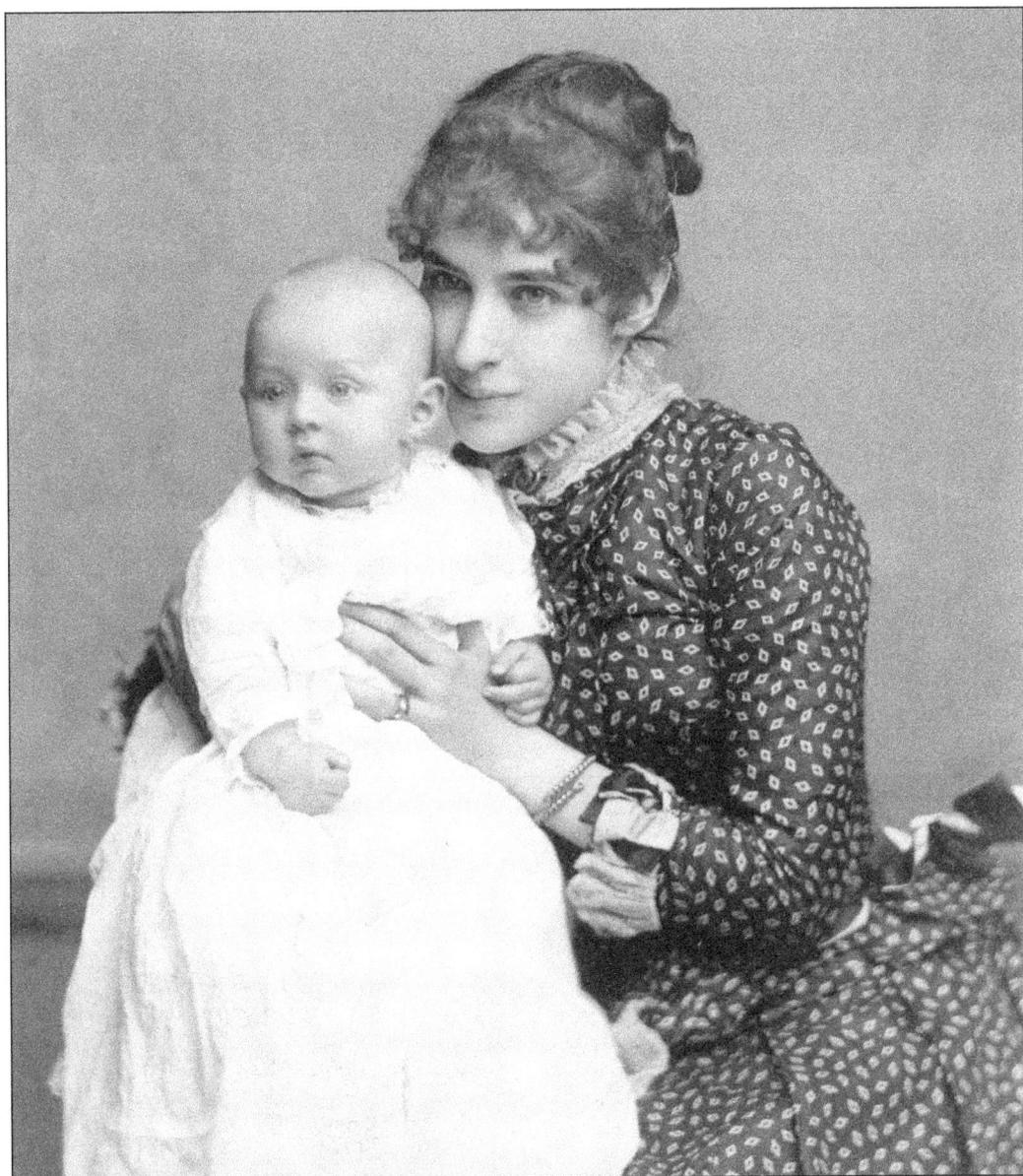

Raymond Pitcairn, shown here with his mother, was born in 1885. His parents took him abroad regularly from the age of three, and during these visits they took trips to the great cathedrals and art museums of Europe. These experiences made a deep impression on the boy, who in time developed a passion for medieval architecture. As an adult, Pitcairn supervised the construction of both Bryn Athyn Cathedral and Glencairn. In a letter written to John T. Comes on May 10, 1920, Pitcairn described how his mother encouraged his love of architecture, "My training was not of the professional variety. My mother was a great lover of architecture and landscape gardening, and started me in this line by cutting out pictures of churches, houses and monumental buildings, which as a child I pasted in scrapbooks." Gertrude died unexpectedly in 1898 when Raymond was 12 years old. At a memorial meeting in her honor, one of the attendees spoke of Gertrude's "exceptional love of the beautiful, in nature and in art." (Glencairn Museum Archives; *New Church Life*. Bryn Athyn, May 1898: 74.)

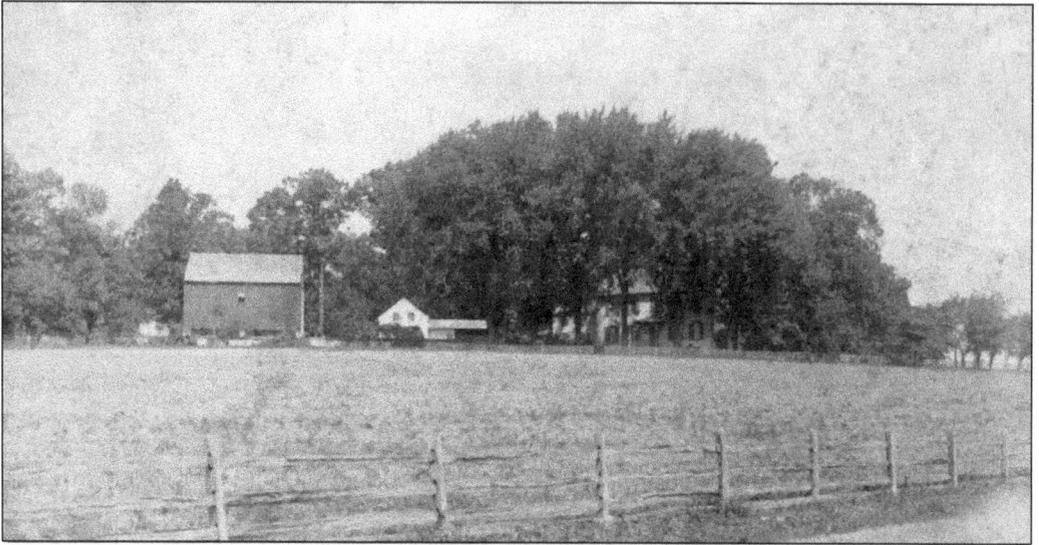

During the 1880s, the Philadelphia congregation the Pitcairns attended began to talk about moving to the countryside where worship services, school activities, and social events would be easier to organize, and New Church principles could be carried out in community life. In 1889, the Pitcairns purchased 84 acres in Huntingdon Valley, which was then a mixture of rolling Pennsylvania farmland and lush woods along the Philadelphia-Newtown rail line. The purchase included the Knight farm (above).

In the 1890s, the congregation began holding summer worship services on Knight's Hill (above), the future site of Cairnwood, Bryn Athyn Cathedral, and Glencairn. The Pitcairns eventually purchased some 550 acres for the New Church community and school. Plans for the settlement were drawn up by Charles Eliot of the prominent landscape architecture firm of Olmsted, Olmsted, and Eliot. In 1899, the village association voted to name the new community "Bryn Athyn," two Welsh words intended to mean "Hill of Unity."

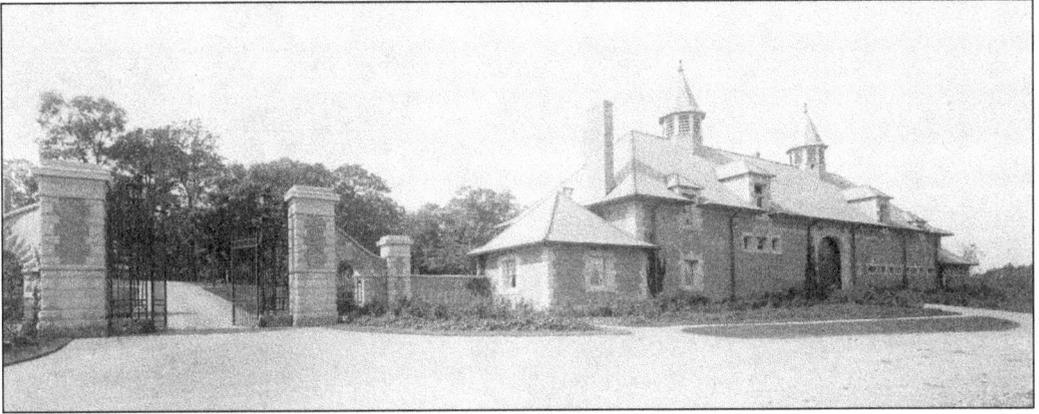

Cairnwood, the Pitcairn family estate in Bryn Athyn, was the first large country house commission for John Carrère and Thomas Hastings, whose architectural firm came to be identified with Beaux-Arts classicism. Ground was broken in 1892 and construction continued until the home was finished in the spring of 1895. This photograph shows the carriage house and entrance gate to Cairnwood on the Huntingdon Turnpike around 1900.

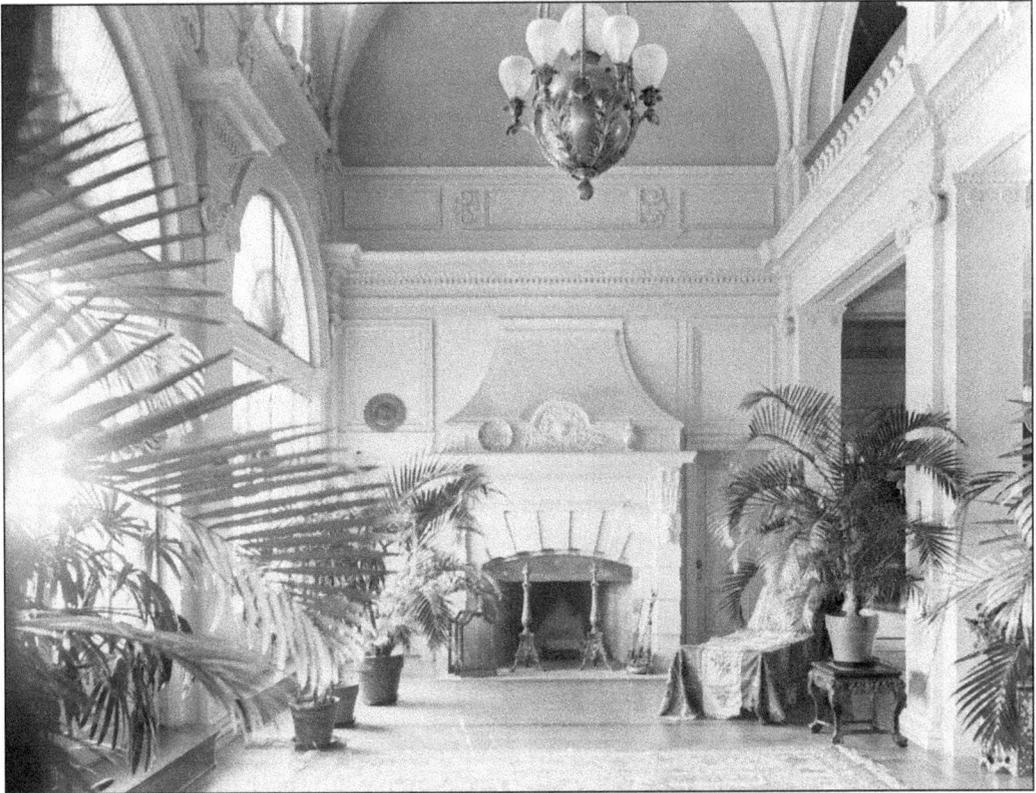

The center of the house was a two-story parlor hall with French doors leading to the terrace and spacious lawn. A French influence can also be seen in the vaulted ceiling and the fireplace with its hooded mantle. This photograph was taken around 1900.

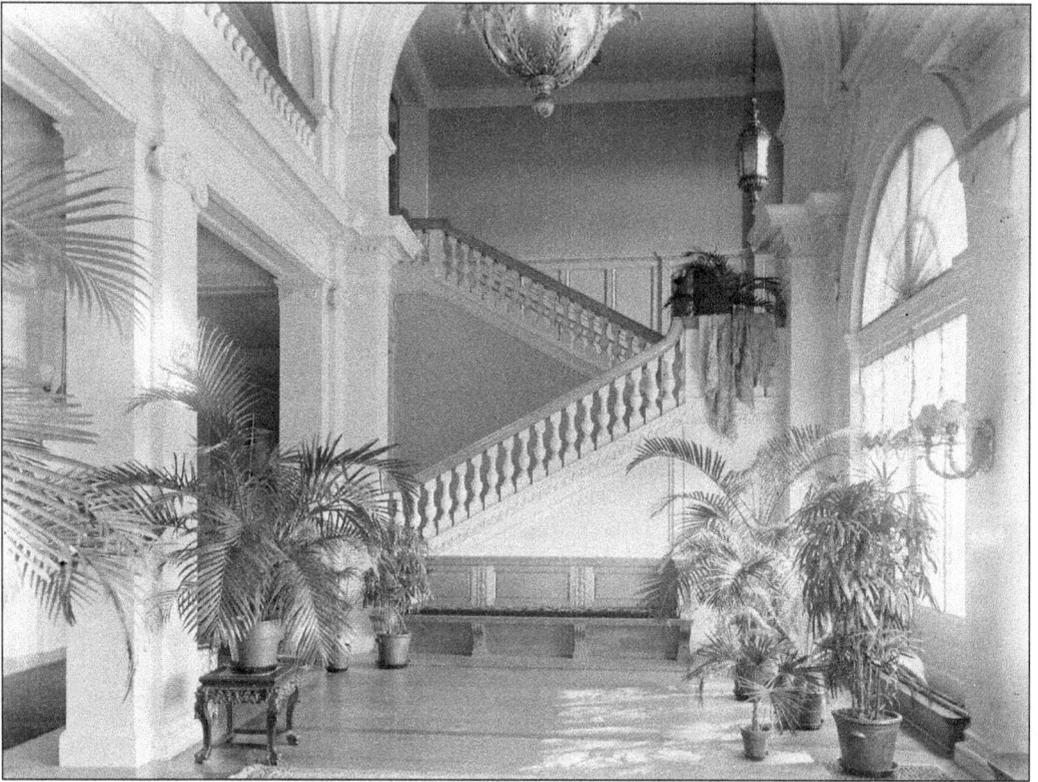

The main staircase led to the nursery and a number of bedrooms along the balcony. At the turn of the 20th century, the parlor hall of Cairnwood was decorated with a single Oriental rug, potted plants, and very little in the way of furniture. A classical flavor is apparent in the moldings and the ionic capitals crowning the pilasters.

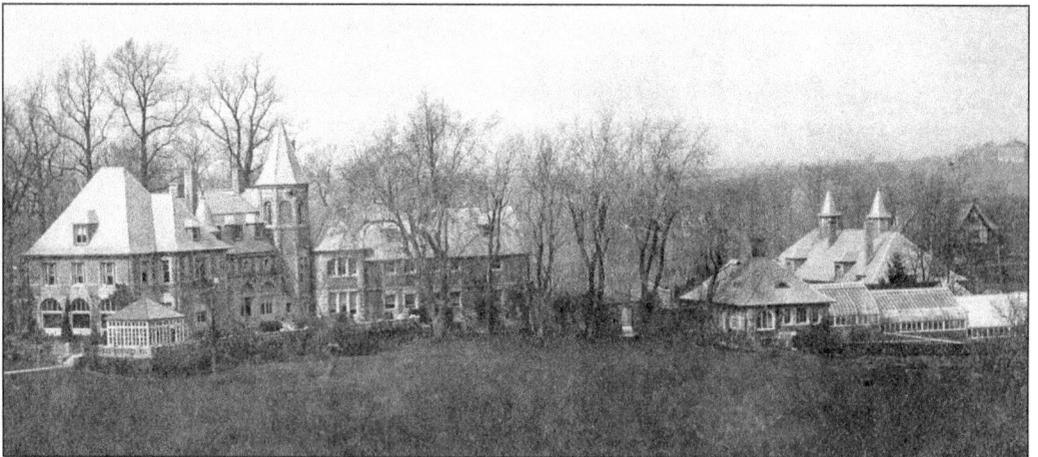

A large country estate, Cairnwood included the main house, an adjacent courtyard, and a formal garden with a garden house, greenhouses, and a pergola. Perhaps the most striking feature of the exterior of the house was an octagonal tower with a high pitched roof. At the top of this tower was the family's chapel, placed at the highest point in the house and designed so that worshipers face east.

14

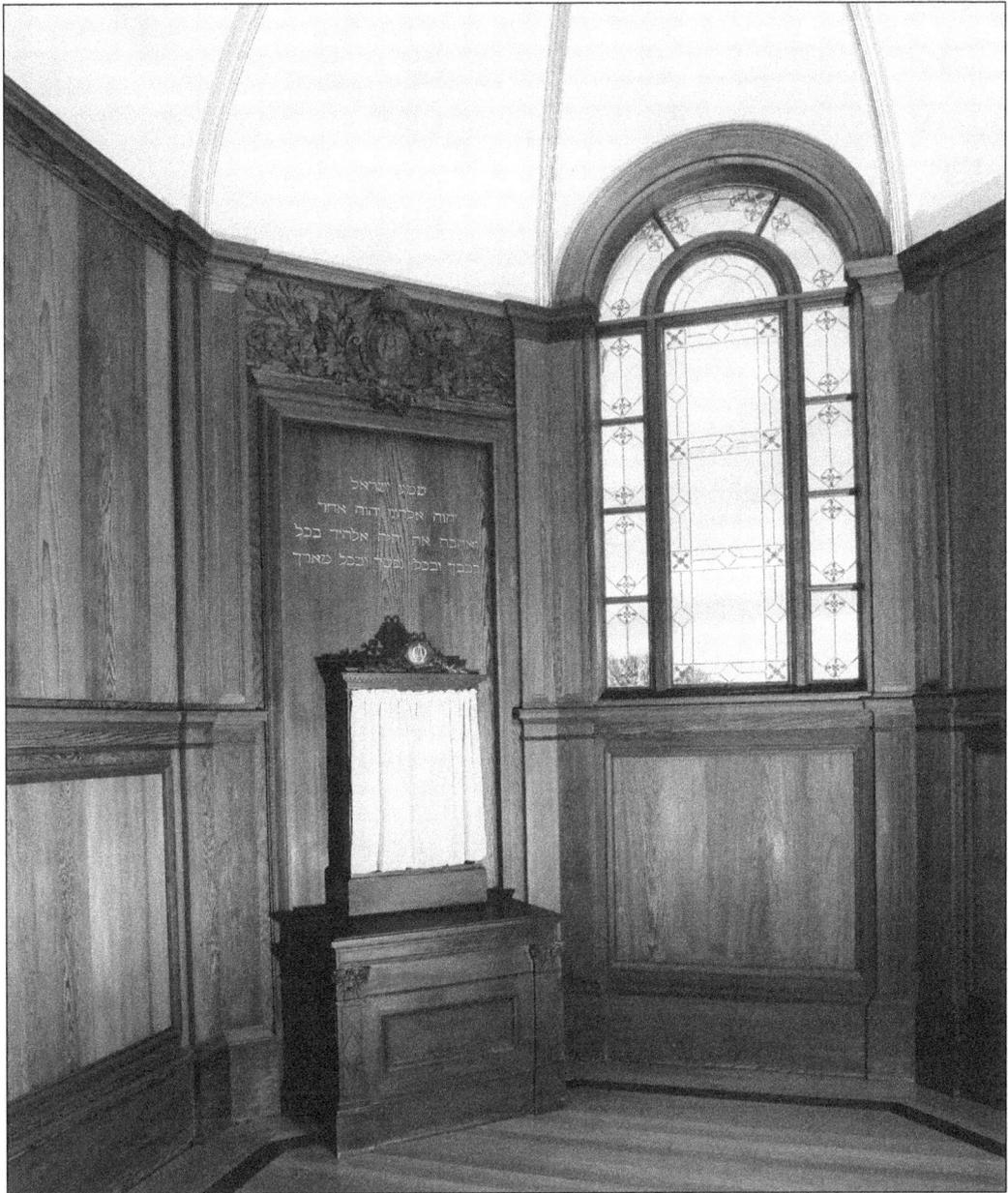

Cairnwood was dedicated on May 22, 1895, in a service led by Bishop William F. Pendleton. Because the chapel could accommodate only about 25 people, a number of guests were seated just outside in the vestibule and corridor. The chapel's Bible cabinet came from the Pitcairns' home in Philadelphia, where it hung on one of the walls of the parlor. The chapel is lined with California redwood, and the octagonal ceiling is finished in blue, with ribs of gold. The wall above the Bible cabinet is carved with Alpha and Omega, the first and last letters of the Greek alphabet. Below this carving, the wall is painted with a Hebrew inscription in gilded letters; the text is Deuteronomy 6:4–5, "Hear, O Israel: The Lord our God, the Lord is one." (Photograph by David Hershy.)

15

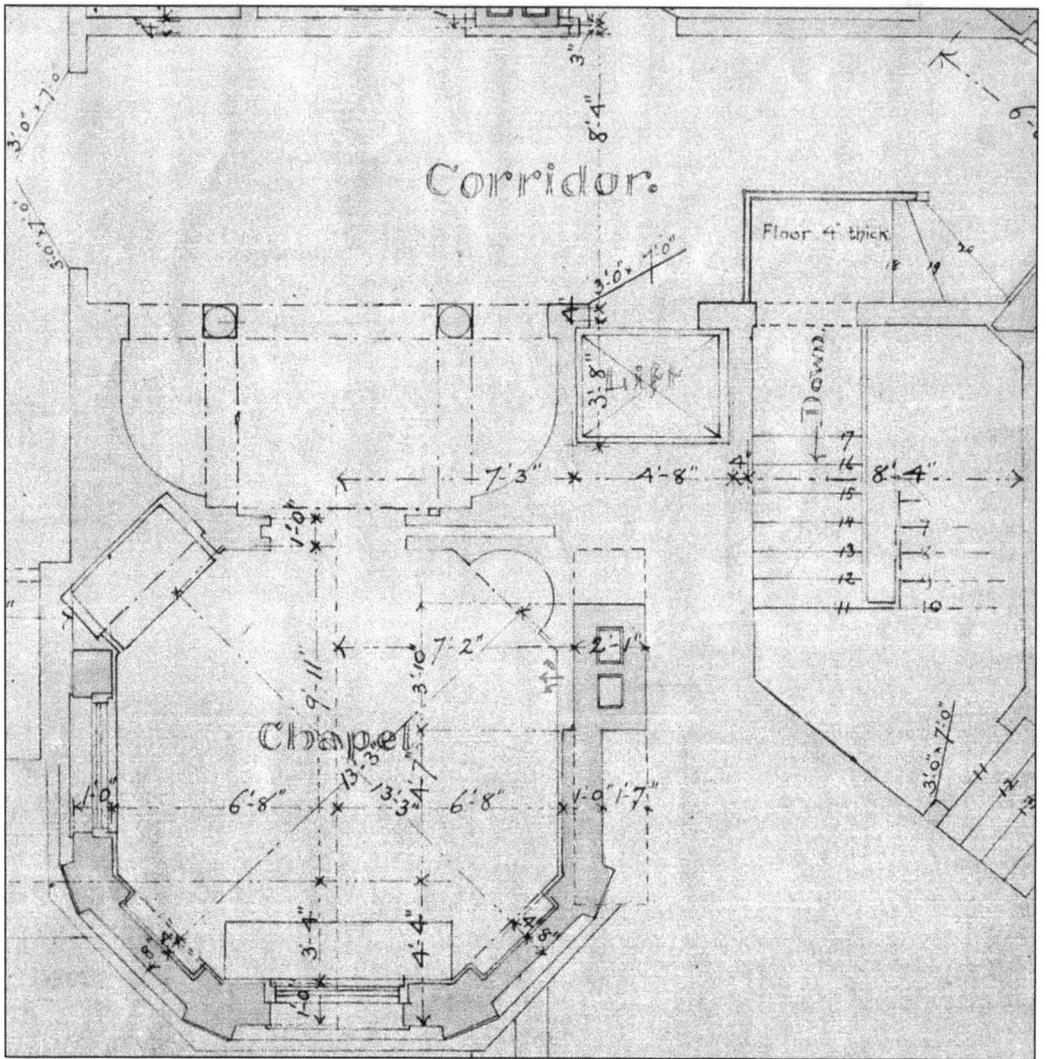

Corridor.

Floor 4" thick

Chapel

When John and Gertrude Pitcairn's son Raymond married Mildred Glenn in 1910, the couple moved into Cairnwood and began raising a family. Family worship has been an important part of New Church religious practice since the late 19th century. After breakfast, those of Raymond and Mildred's children who were too young to go to school had a worship service in the chapel with their mother. After lighting candles, Mildred read a story from the Bible and explained it to the children in simple words. Sometimes they also sang hymns accompanied by Mildred on a small organ located in a niche at the back of the chapel. The chapel is entered between two columns of wood, beneath an architrave painted with words from *True Christianity* (¶ 508), a book written in Latin by Emanuel Swedenborg: *Nunc licet intellectualiter intrare in arcana fidei* (Now it is permitted to enter with understanding into the mysteries of faith). (Drawing by Carrère and Hastings, August 1892.)

16

John and Gertrude Pitcairn hired Charles Eliot, a noted landscape architect, to design the grounds of Cairnwood (seen at right and below). Soon afterward, Eliot became a partner in the firm of Frederick Law Olmsted, who is regarded today as the father of American landscape architecture. Gertrude, who took a special interest in Cairnwood's landscaping and gardens, enjoyed meeting Olmsted. In a letter written to John on March 13, 1893, she described him as "a genial fatherly old gentleman." In addition to designing the grounds of the Cairnwood estate, the firm also developed a plan for the rest of the New Church settlement, including spaces for the Academy of the New Church's schools, library, and dormitories, as well as more than 80 lots for individual residences. (Glencairn Museum Archives.)

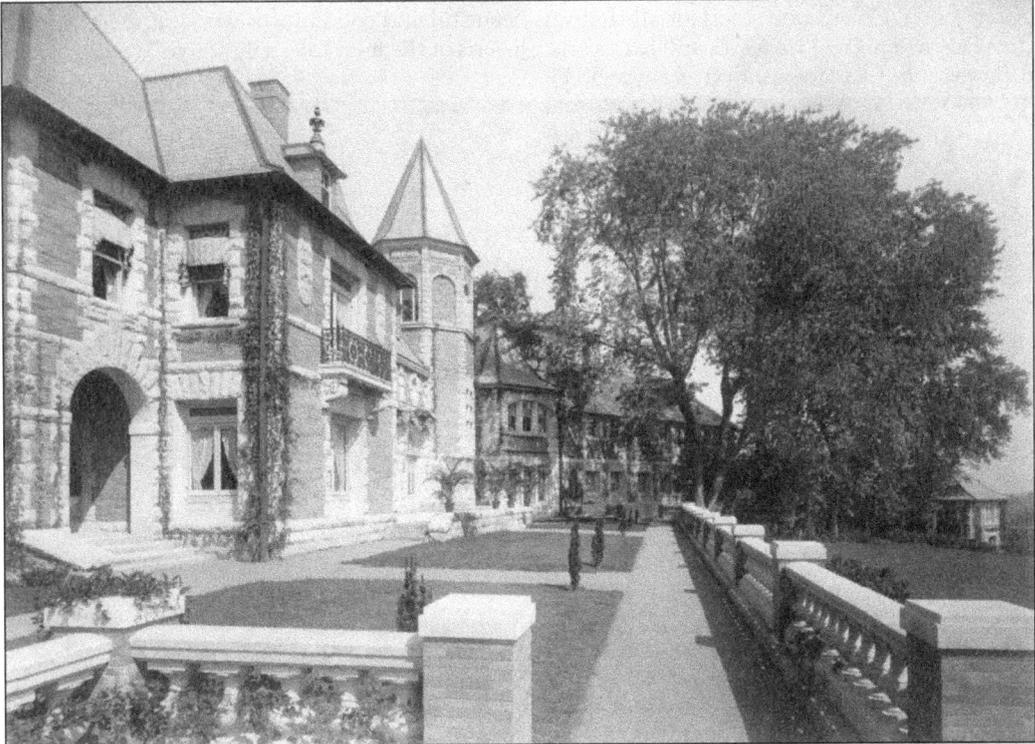

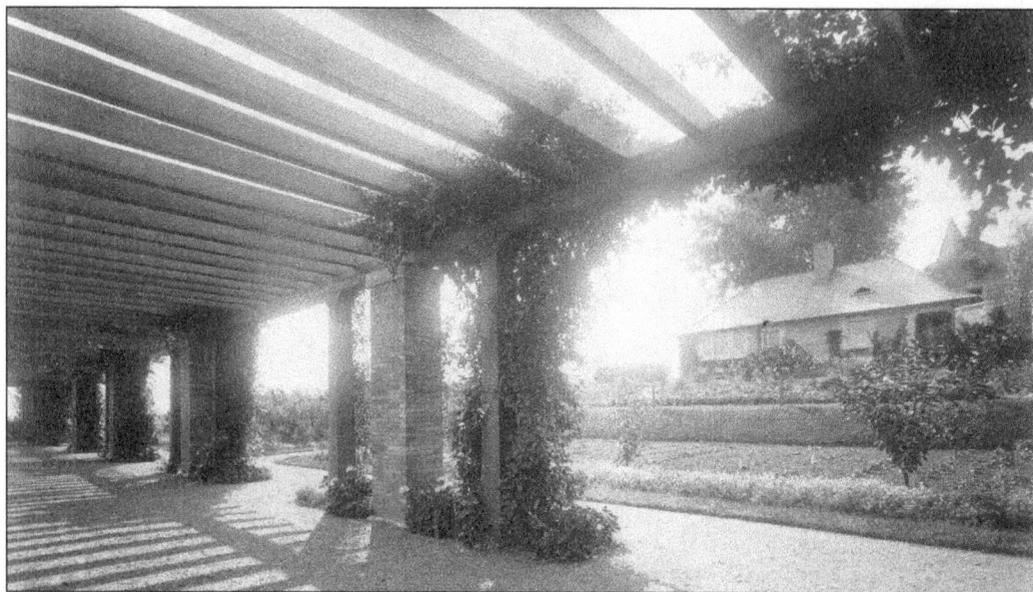

The formal garden at Cairnwood included a pergola (above). Below, Vera Pitcairn (seated), daughter of John and Gertrude, and a few of her cousins pose by the garden house around 1897, which was designed with a playroom for the children. In the summertime, plays were produced on the lawn using the woods as a backdrop. On one occasion a production of A *Midsummer Night's Dream* was staged with Vera as Titania, Queen of the Fairies. According to one visitor, who was a young girl at the time, "The stage crew had worked out a contraption so that she could enter, flying through the air . . . To many of the children growing up at that time, without cars, movies or television, Cairnwood stood for all that was beautiful and good in this world. It seemed to be the place where the Princesses and Kings and Queens of the fairy tales might live." (Viola Heath Ridgway, *The Old Houses*. Bryn Athyn: 58.)

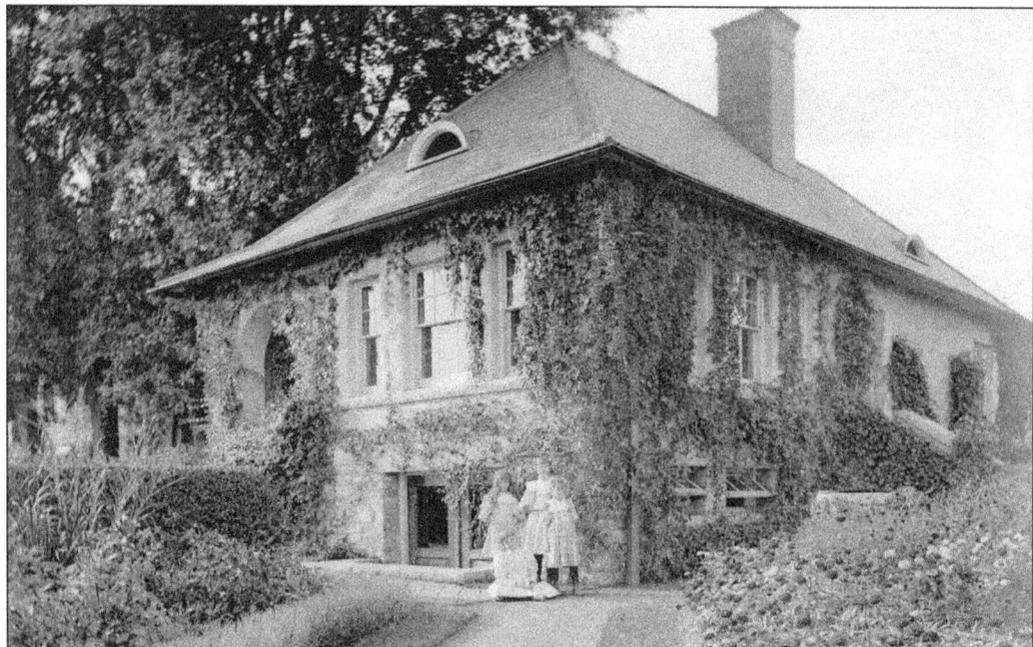

Harold F. Pitcairn, John and Gertrude's youngest child, was born at Cairnwood in 1897. This photograph of Harold and his mother was taken on the north terrace. The orange iron-spot Roman brick and rough-cut stonework visible on the wall behind them were used on the exterior of all the buildings on the estate.

Theodore Pitcairn, pictured at Cairnwood with his father, grew up to become a New Church minister. In his early 20s, Pitcairn developed a special interest in missionary work. In the summer of 1916, he and another student embarked on a missionary tour of Pennsylvania and New York in the "New Church Book and Bible Car." As a young minister, he became the first superintendent of the General Church Mission in South Africa.

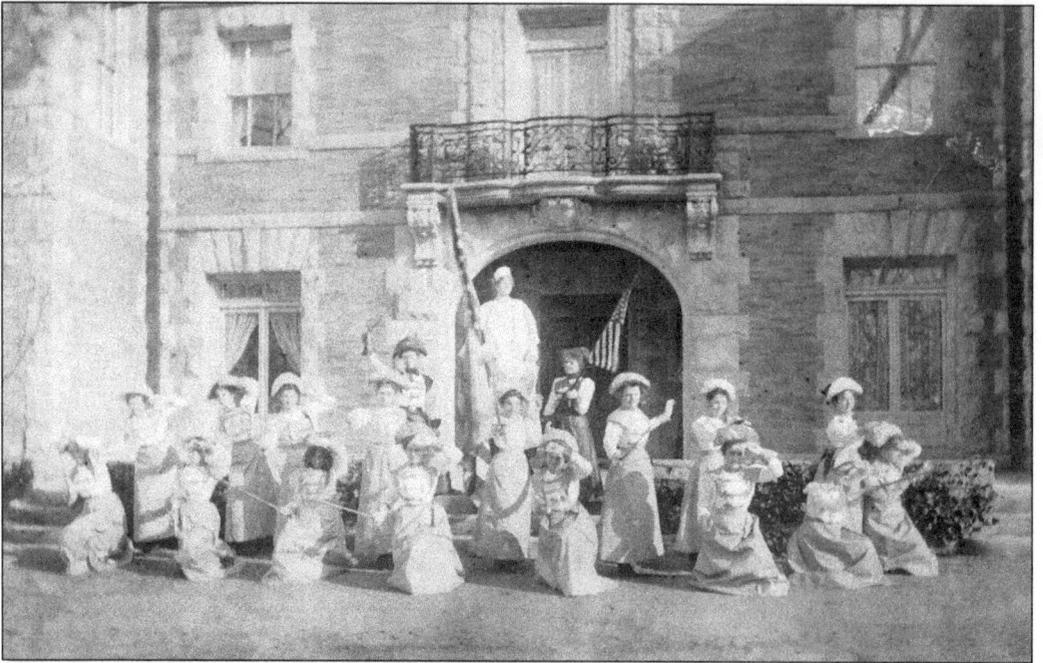

The pages of *New Church Life* are filled with reports about events that took place at Cairnwood, the largest and most impressive house and property in the young community. Cairnwood hosted a wide variety of church- and school-related activities, including official meetings, wedding receptions, socials, plays, musical events, and lawn parties. For many years, an annual Founders' Day banquet was held in the dining room to commemorate the beginning of the Academy of the New Church. The photograph below, which shows Cairnwood's dining room decorated with streamers and a framed painting of the school seal, may have been taken on Founders' Day.

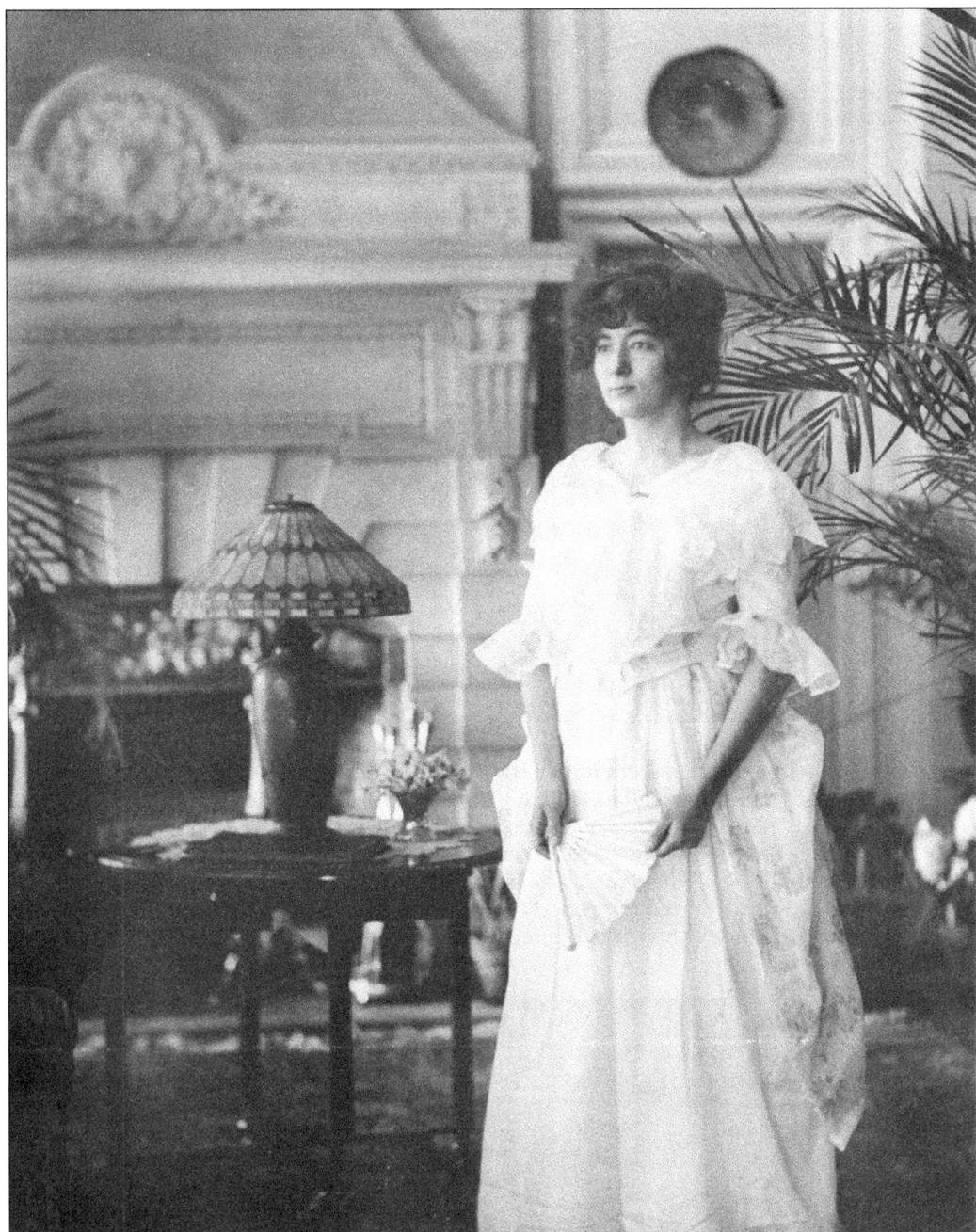

Volita Wells, one of John and Gertrude Pitcairn's nieces, poses in costume with a folding fan in Cairnwood's parlor hall. Wells sang soprano, and this photograph may have been taken in connection with a musical or theatrical production. In later years, she became a teacher in New Church elementary schools. Roy Wells, her brother, was the first resident of Bryn Athyn to give his life for his country, dying of wounds received at the Battle of Picardy in 1918.

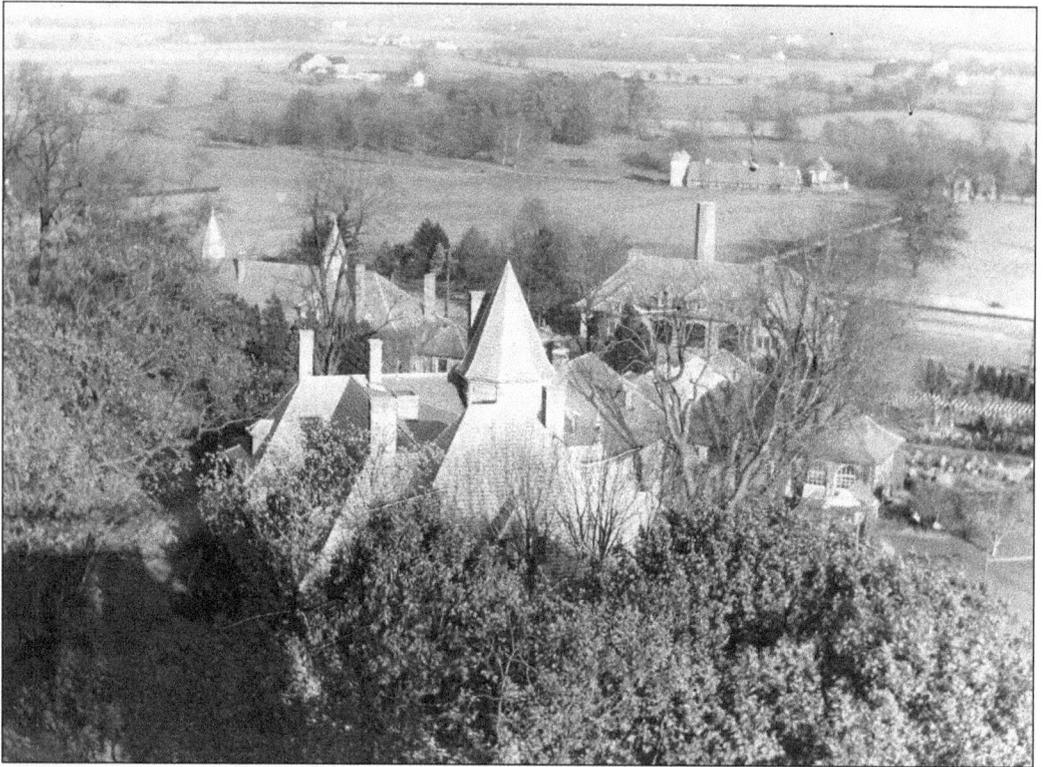

This view looks across the main buildings of the estate to Cairnwood Farms, on the other side of the Huntingdon Turnpike. For half a century, Cairnwood Farms provided Cairnwood and other homes in Bryn Athyn with milk, eggs, produce, and grains. The dairy barn (top right) can be seen just north of the little road leading to the farm. South of the dairy farm was a barn for hay and horses (below, around 1913). There was also a poultry farm and an orchard with apples, pears, and plums. Records show that during the period from 1895 to 1900 as many as 60 men were needed to work the estate and farm, though in winter months the number dropped off to 10 or 15.

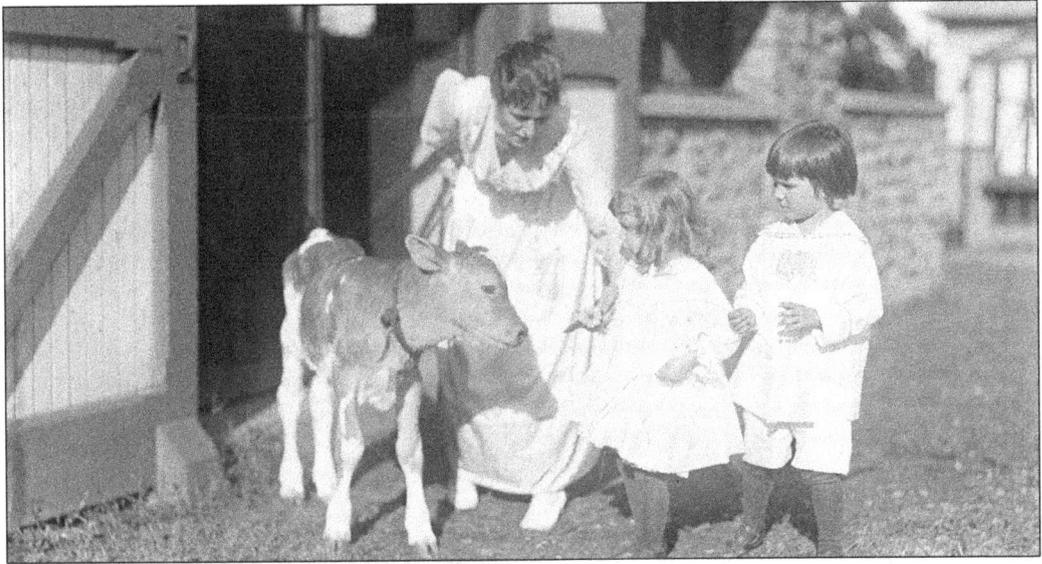

Mildred Pitcairn had a special interest in the dairy farm. Each afternoon she visited the barn, usually together with her smaller children, to drink fresh milk. According to her daughter Karen, "There were thirty or forty black-and-white Holstein cows, along with one Jersey and one Guernsey to make the milk a little richer . . . And at night on the sleeping porch, all the way up to Cairnwood, we could hear the bull bellowing, and it gave me nightmares!" (Karen Pitcairn Cole, "Recollections of Cairnwood Dairies." In *Penickpacka Historical Society Bulletin*, 1985: 20.)

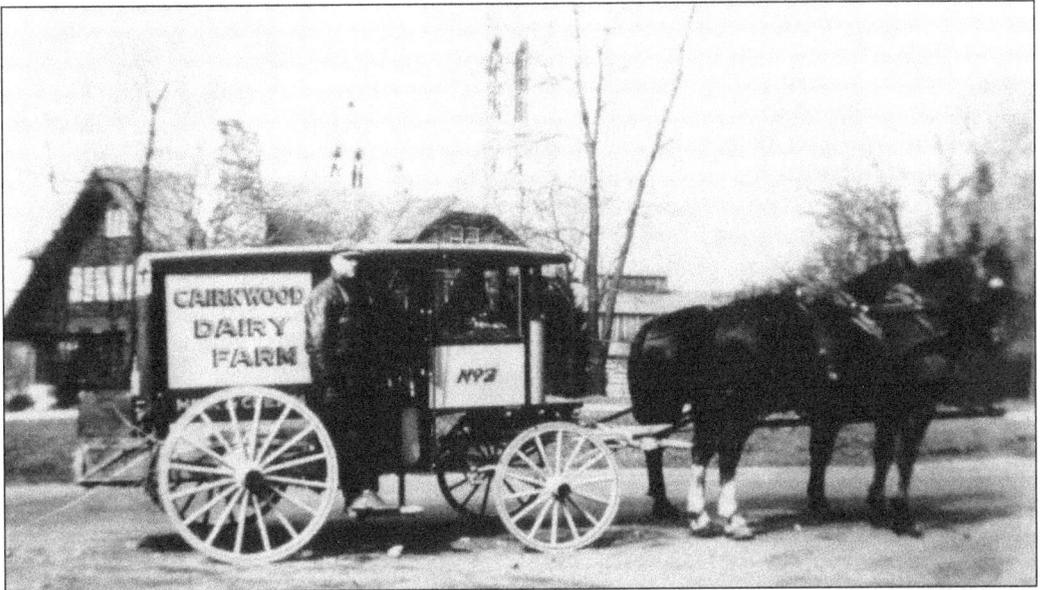

Milk was cooled and bottled at the Cairnwood dairy and then delivered to customers in a horse-drawn wagon by Joseph P. Conard II (above). Bryn Athyn families benefited from having a local dairy, but there was one disadvantage in the era of grass-fed cows. Karen Pitcairn Cole remembers, "Each spring when the garlic came up and the milk was flavored with it, sales fell off until the flavor was back to normal, but our family always had to drink our milk, garlic flavor or no." (Karen Pitcairn Cole, "Recollections of Cairnwood Dairies." In *Penickpacka Historical Society Bulletin*, 1985: 20.)

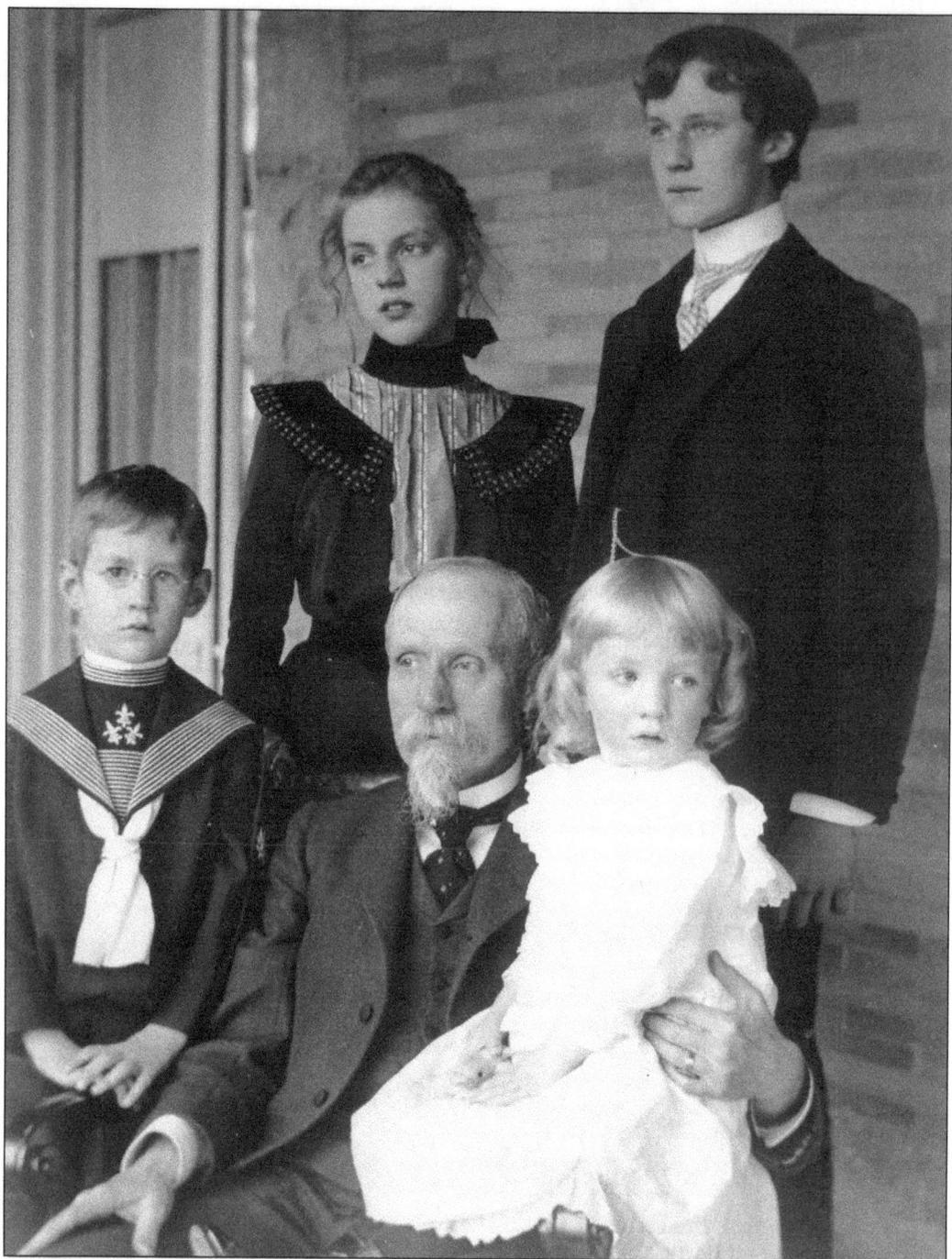

Pictured from left to right are (first row) Theodore, John, and Harold; (second row) Vera and Raymond. In 1898, when Harold was just nine months old, his mother died of a sudden illness. After living in Cairnwood for only three years, Gertrude Pitcairn left behind three sons and a daughter. John was heartbroken, but he was comforted by the New Church belief that married couples who truly love each other remain as husband and wife to eternity in heaven. John never remarried, believing that he and Gertrude would be together again after his own death.

This photograph of Harold Pitcairn (above) was probably taken by his older brother, Raymond. Harold had lost his mother in infancy, and as a boy he endured the loss of his only sister. Vera Pitcairn (right), shown here in the music room of Cairnwood, died from appendicitis at the age of 23. As an adult, Harold built his own home, Cairncrest, just across the road from Bryn Athyn Cathedral, and went on to achieve national recognition as one of the developers of the Autogiro, a precursor to the helicopter.

This photograph of the "Cairnwood Girls" (above), a group of young women hired to do housework, was taken around 1896. In 1894, shortly before moving into Cairnwood, Gertrude Pitcairn placed an advertisement in *New Church Life*. It read, "A New Church family, expecting soon to move into a new home, and wishing to have the household composed entirely of members of the New Church, invites applications from young women desiring employment. The services of four New Church young women have been secured, and two more are needed—one to cook and one to wait on table and do other light work." In 1913, Beatrice Ashley (below), a young New Church woman whose parents had just died, came from England to be the nanny for Raymond and Mildred Pitcairn's children. This photograph was taken on July 4, 1917. (*New Church Life*. Bryn Athyn, July 1894: 112.)

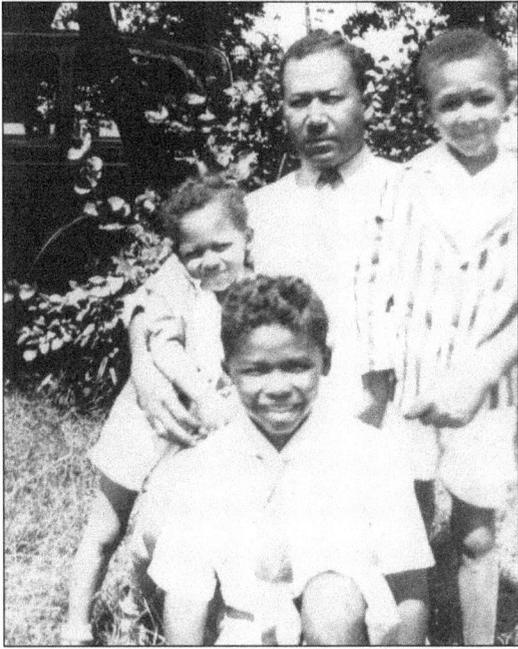

Nelson and Lucile Henry (above), originally from the Germantown section of Philadelphia, answered a 1929 advertisement for employment at Cairnwood. They moved into the gatehouse, where they raised a family of seven children. Lucile cooked meals for the stable hands and did the laundry, which was hung to dry in the courtyard. The children (below) often played there while their mother worked. Nelson worked as a post office clerk in Philadelphia and did the heavier work on the estate, such as stoking the boilers, with the help of his older sons. The Henrys lived at Cairnwood for more than 40 years until Lucile died in 1970. (All courtesy of Nelson Henry Jr.)

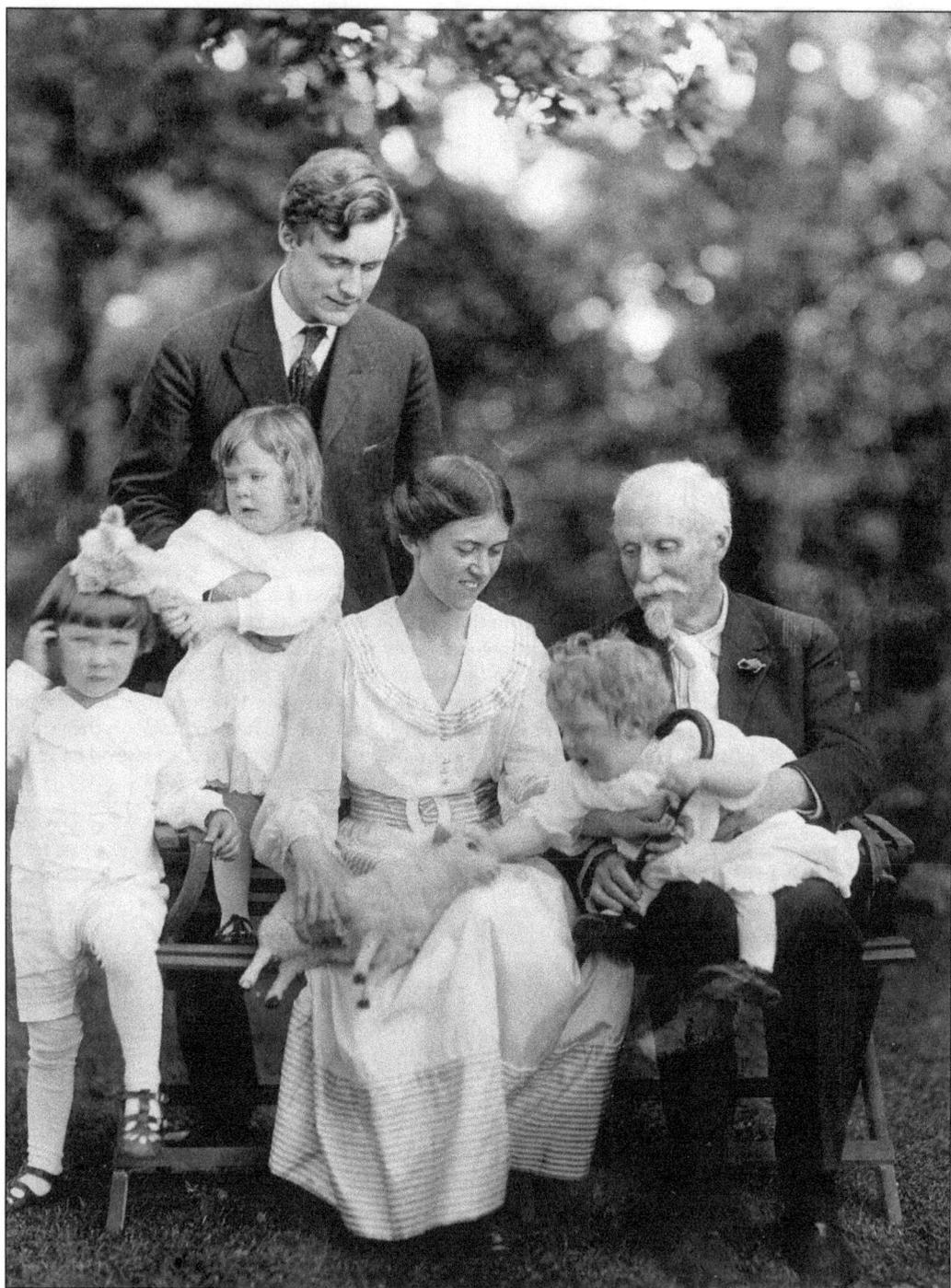

Raymond and Mildred Pitcairn lived at Cairnwood from the time they were married in 1910 until they moved into Glencairn in 1939. All nine of their children were born at Cairnwood. John Pitcairn spent his final years there surrounded by grandchildren. He was still actively managing his business interests and heavily involved in church matters. This photograph was taken in 1916, the year he died.

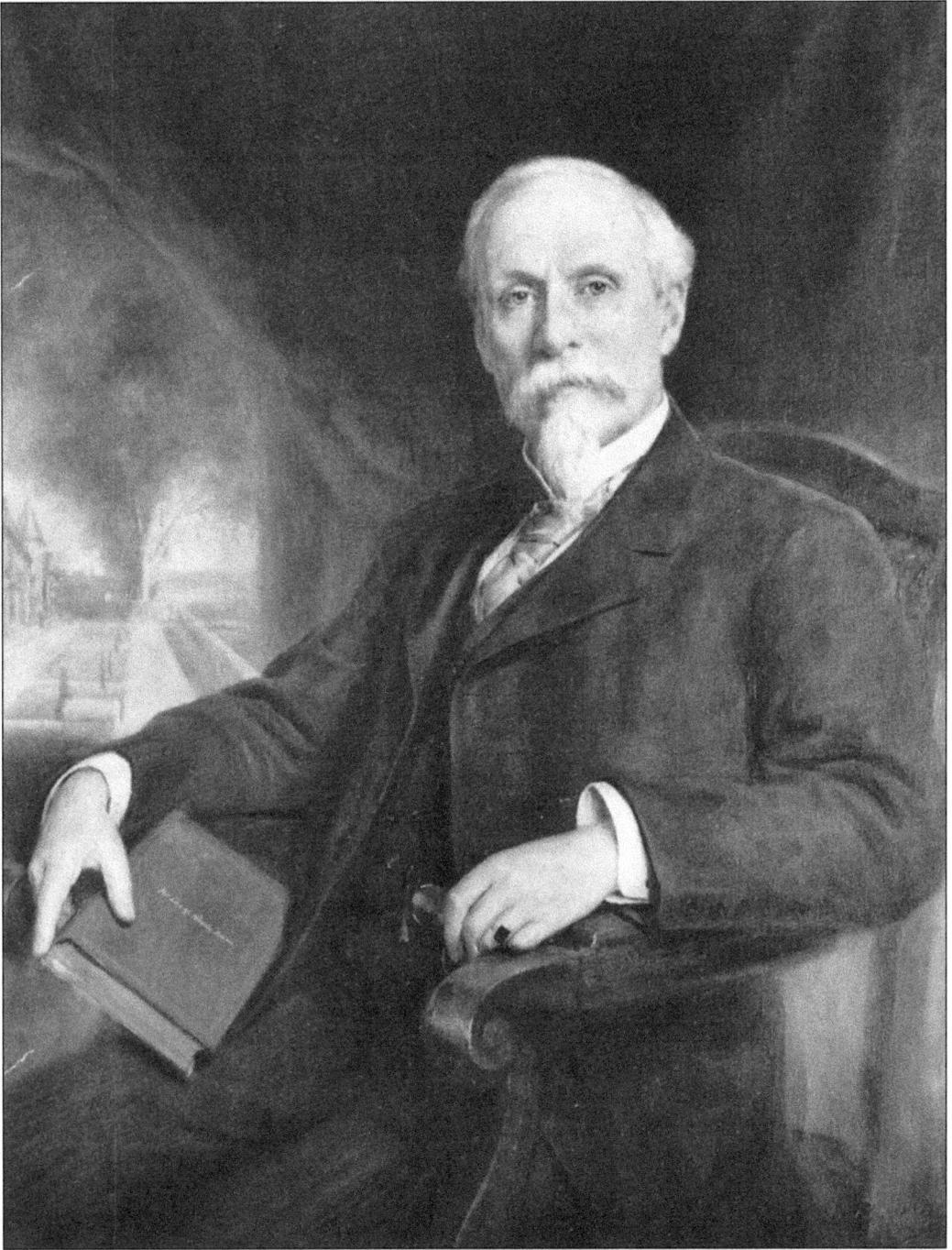

John Pitcairn made his fortune during the Pennsylvania oil boom of the 1870s and later became one of the founders of the Pittsburgh Plate Glass Company. Although a highly successful industrialist during an age of "robber barons," Pitcairn earned a reputation for fair play. He died at Cairnwood in 1916 at the age of 75, a few months after the official incorporation of Bryn Athyn as a borough. This portrait was painted by the Swiss artist August Benziger in 1908. In his right hand, Pitcairn holds a book by Emanuel Swedenborg. The Cairnwood estate is shown in the background.

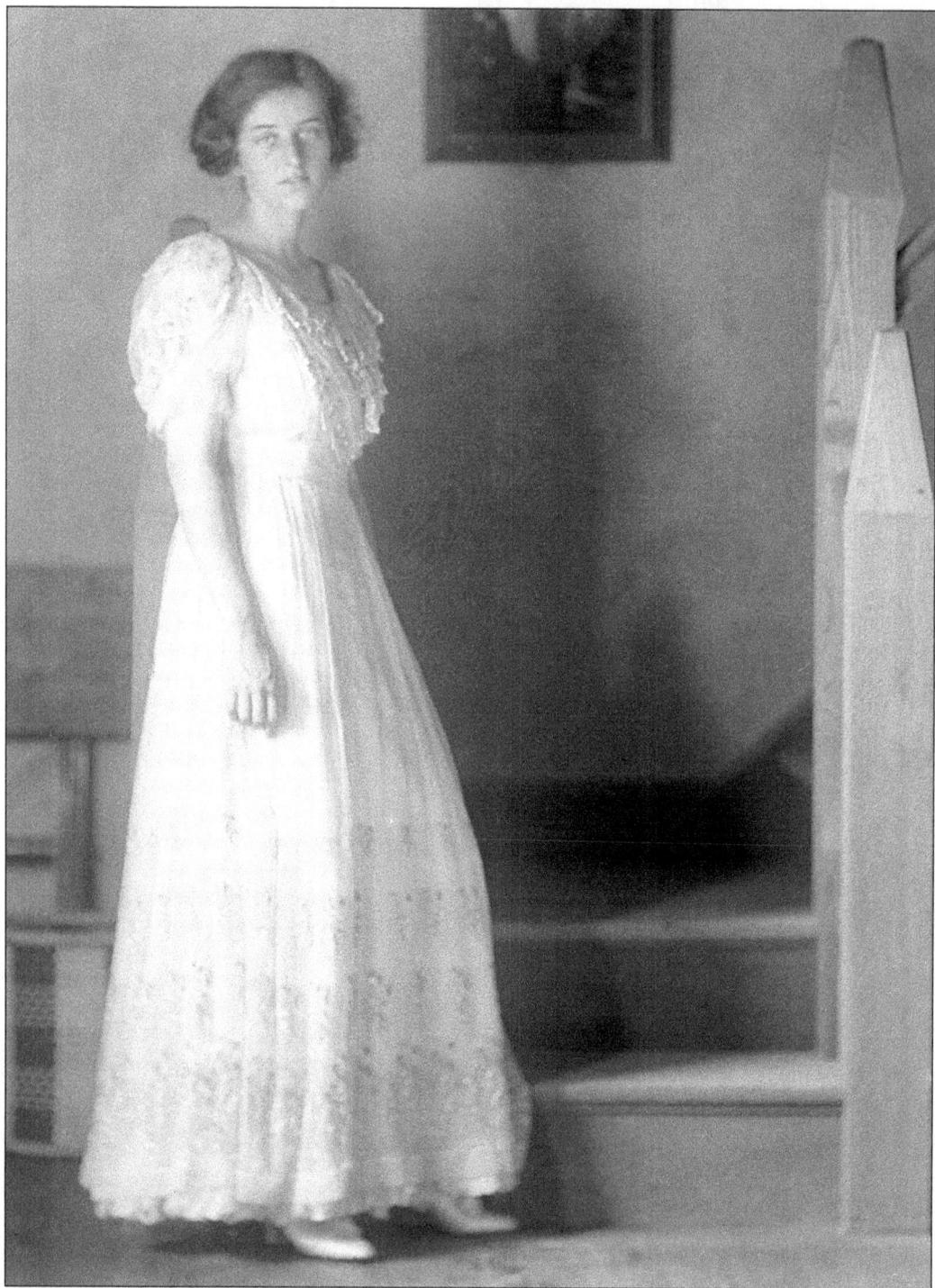

Raymond Pitcairn was a serious amateur photographer. It was this hobby that led him to undertake his first architectural project: designing a photographic studio above the garage across the street from Cairnwood. Pitcairn's photograph of Carina Glenn, his sister-in-law, took second prize in the Eighth Annual Exhibition of Photographs held by John Wanamaker in Philadelphia in 1913.

Several years after Bryn Athyn was founded, the local residents, who had been holding worship services in the chapel of the Academy of the New Church, began a church building fund. In 1908, John Pitcairn made a substantial donation to make this project possible. The land adjacent to Cairnwood, which had the best view of the valley, was chosen as the location. Ground was broken for Bryn Athyn Cathedral in 1913, and Raymond Pitcairn poured much of his personal energy into the project. Scale models of the cathedral were kept in Cairnwood's billiard room, and the garden house was converted into a studio for designing, painting, and storing stained glass windows. This photograph of the building site was taken from the roof of Cairnwood. Below, the tower rises in the background as Ivan, Gabriele, and Nathan Pitcairn, shown from left to right, make daisy chains on "cathedral hill."

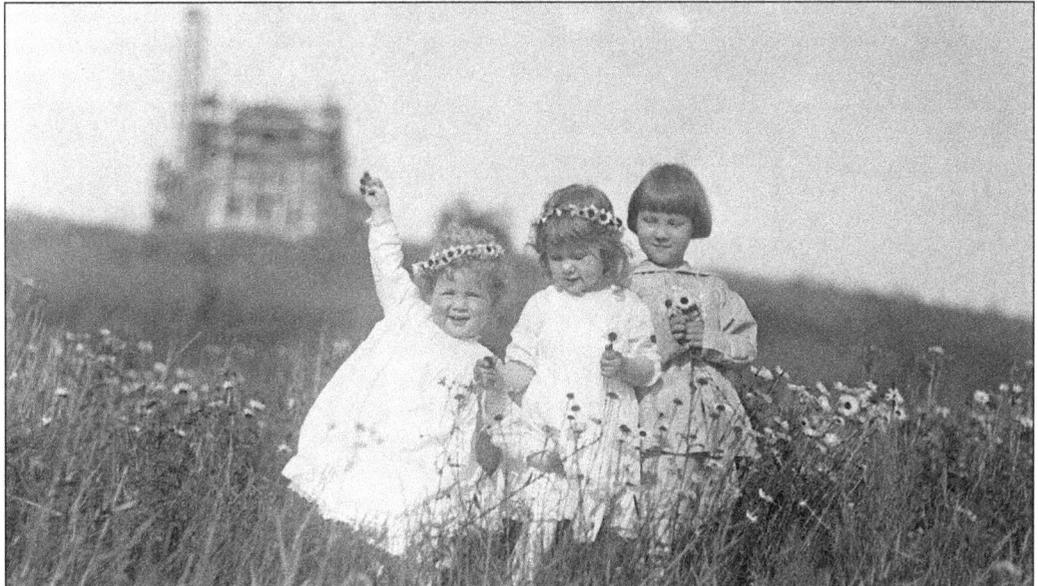

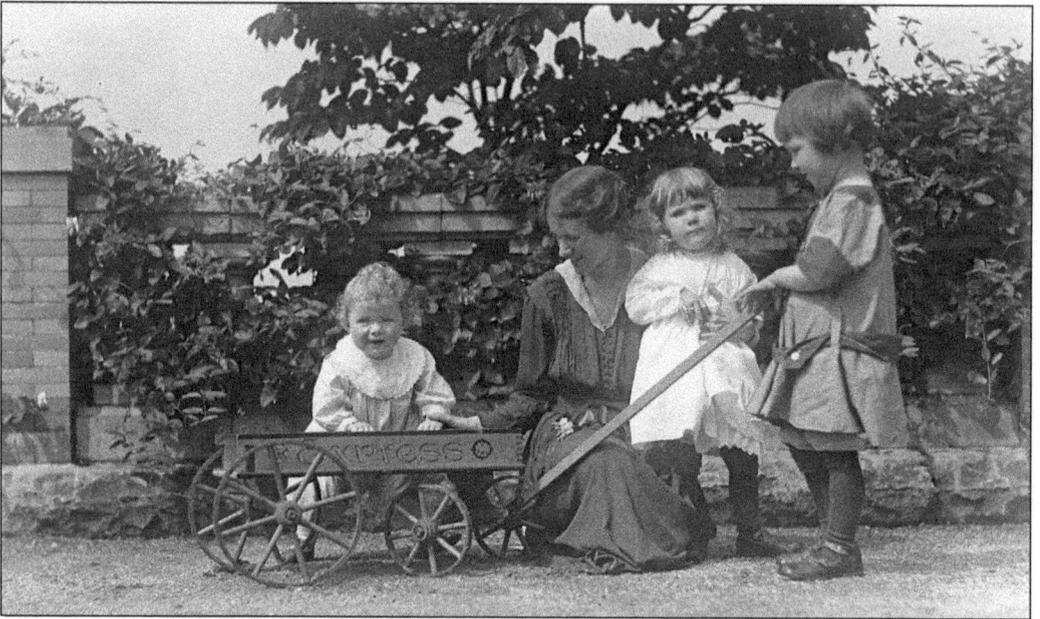

Ivan goes for a ride on an "Express" wagon beside one of Cairnwood's balustrades. Pictured from left to right are Ivan, Mildred, Gabriele, and Nathan Pitcairn. This photograph was taken in June 1916.

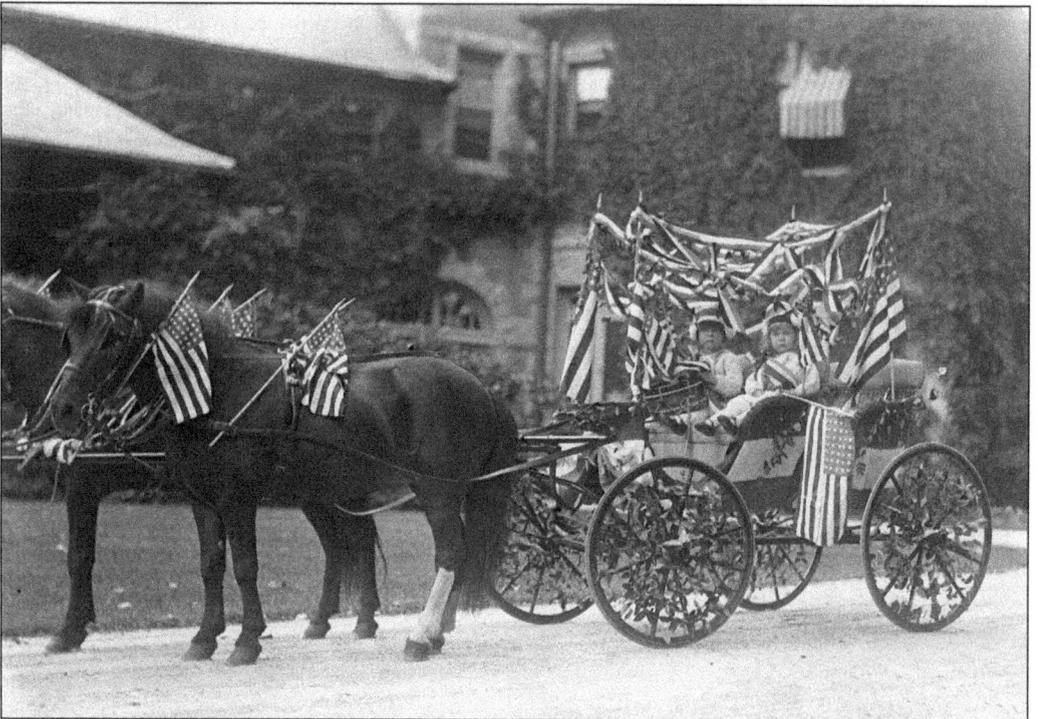

Gabriele Pitcairn carries a flag and her brother Nathan holds a drum while riding in a pony surrey on July 4, 1916. The spokes of the wheels are decorated with ivy.

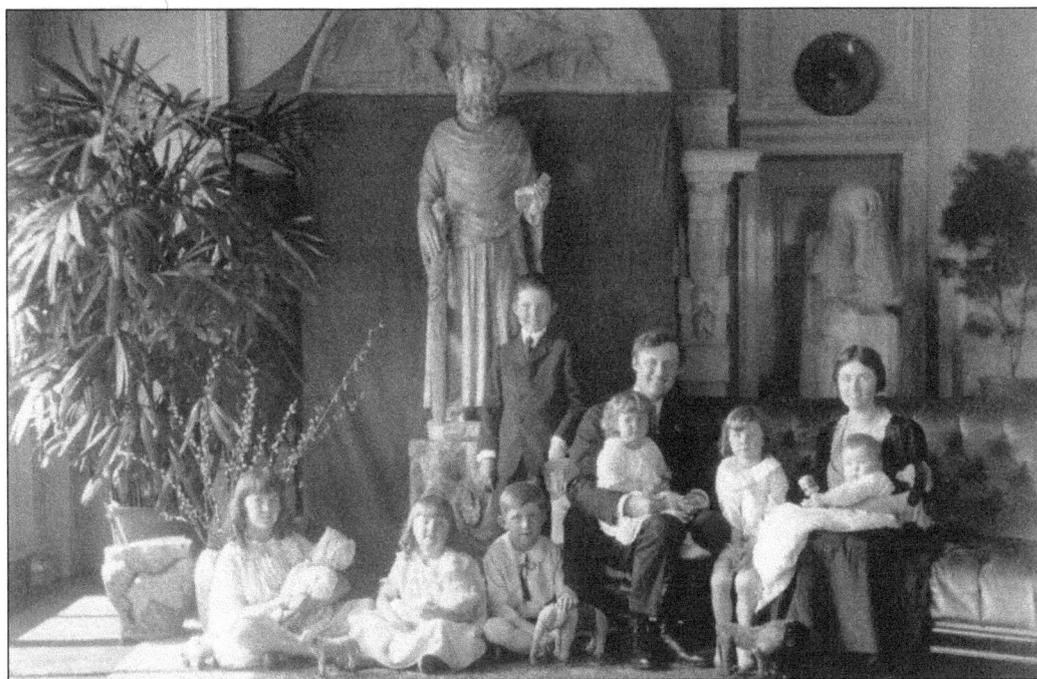

Raymond Pitcairn began collecting medieval art in order to inspire Bryn Athyn Cathedral's stone carvers and stained glass artists with some of the finest artworks of the period. However, as his art collection grew larger, Pitcairn began to face the problem of where to put it all. Early photographs reveal the increasing awkwardness of the situation. Above, the fireplace in Cairnwood's parlor hall is concealed behind a curtain to serve as a backdrop for an arrangement of medieval sculptures. Below, a haloed queen from the doorway of a 12th-century church is tied to a column, in dangerous proximity to the ping-pong table. In the early 1920s, Pitcairn began planning a new building project, which he variously referred to as a "cloister studio," a "castle studio," or a "little castle."

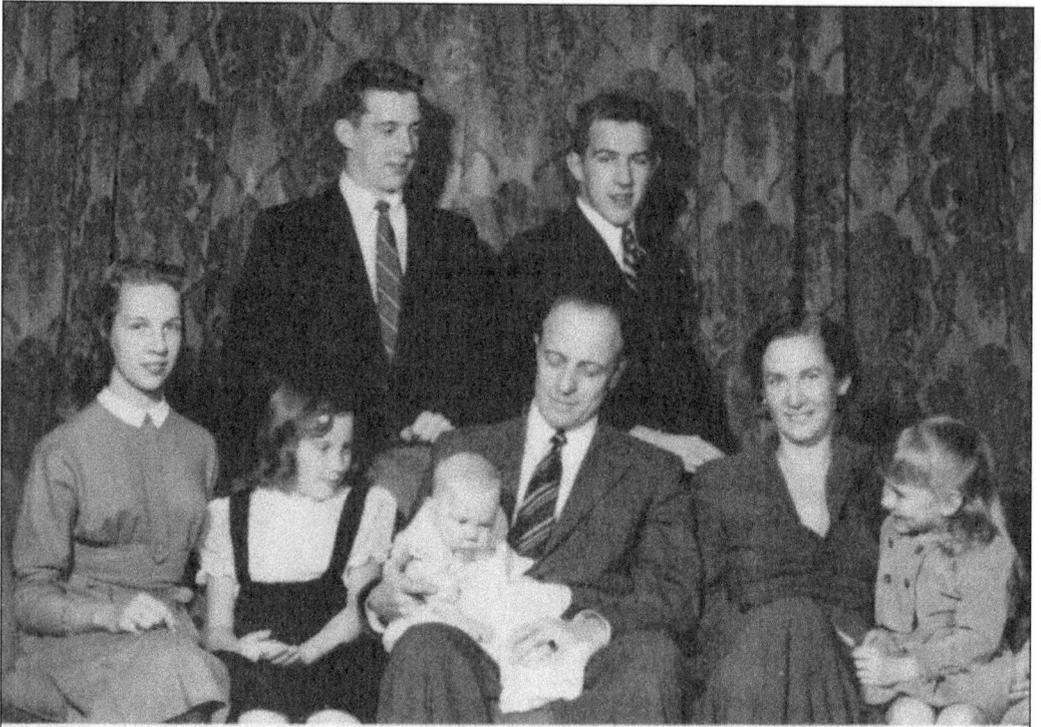

Kirk Brent

Kerry Willard Gay

Jill

LAIRD JOAN

When the Pitcairns moved to Glencairn in 1939, Cairnwood stood unoccupied for several years. Family life returned to Cairnwood in 1945 when Gabriele, Raymond and Mildred Pitcairn's eldest daughter, moved back to her childhood home with her husband, the Reverend Willard D. Pendleton, and their children. This Christmas card was sent out by the Pendletons shortly after their last child was born in 1955. In 1962, Pendleton became the fourth bishop of the General Church of the New Jerusalem, a position he held until 1976. During these years, Cairnwood continued to serve as an active center for New Church social life, as it had during two previous generations of Pitcairns. The Pendletons lived at Cairnwood until 1980 when it was gifted, together with Glencairn, to the Academy of the New Church. (Courtesy of Brent Pendleton.)

Two

BRYN ATHYN CATHEDRAL

Bryn Athyn Cathedral, a magnificent Gothic- and Romanesque-style complex, is the episcopal seat of the General Church of the New Jerusalem. It has been an active house of worship since its dedication in 1919. Before the cathedral was built, the congregation in Bryn Athyn had worshiped in a number of temporary locations, including the "club house" (a simple wood-frame building) and the chapel on the Academy of the New Church campus. Construction of the cathedral began in 1913 under the noted Boston architectural firm of Cram and Ferguson, but Raymond Pitcairn soon became the key figure in the project. Pitcairn, a lawyer with no formal training in architecture, loved medieval art and believed that "paper architecture," with its T-squares and triangles, had led to a decline in craftsmanship in the modern era. In a desire to achieve a level of craftsmanship worthy of the best medieval churches in Europe, he adopted unusual methods in order to build "in the Gothic way."

Workshops began to spring up around the building site: an architectural studio, stone shop, woodworking shop, modeling shop, metal shop, stained glass studio, and glass factory. The best available natural materials, many of them procured locally, were worked by skilled craftsmen, who were encouraged to share their ideas with the designers. Scale and full-sized models were used to evaluate designs, resulting in frequent changes to blueprints. Pitcairn's eagerness to solicit creative input from the craftsmen, and his emphasis on using natural materials, reveal his acceptance of certain ideals from the American Arts and Crafts Movement that were popular at the time. He oversaw all aspects of the construction and made use of his growing collection of medieval stained glass and sculpture, as well as his personal library, to further the design process.

While the architectural form of Bryn Athyn Cathedral is medieval, its decorative program was intended to convey New Church beliefs, as expressed in the Bible and the theological writings of Emanuel Swedenborg. During the years of its construction, a symbolism committee, whose members included both ministers and laymen, met regularly to discuss the content of the stained glass windows and the artworks in stone, metal, and wood.

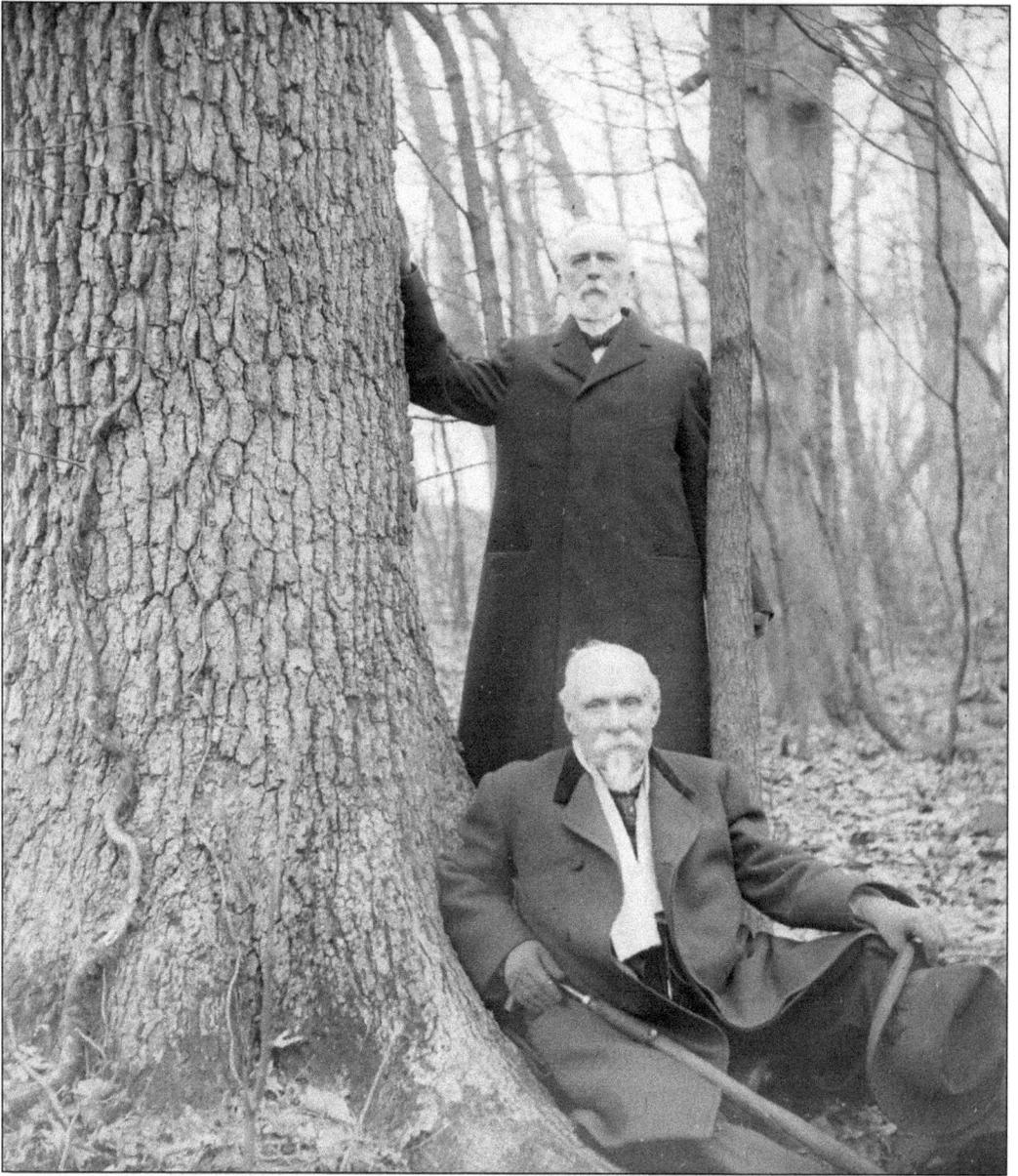

Raymond Pitcairn took this photograph of his father, John Pitcairn (seated), and William F. Pendleton beside a large white oak used in the construction of Bryn Athyn Cathedral. John Pitcairn welcomed the appointment of his son Raymond to oversee the project, having complete faith in his artistic judgment. Pendleton, the first bishop of the General Church of the New Jerusalem, is credited with proposing a church in the Gothic style, as well as developing the main symbolic elements of the chancel area. He retired from his position as bishop in 1915 and was succeeded by his brother Nathaniel D. Pendleton. John Pitcairn, whose donation to the church building fund made the project possible, passed away in the summer of 1916, several years before the cathedral's completion.

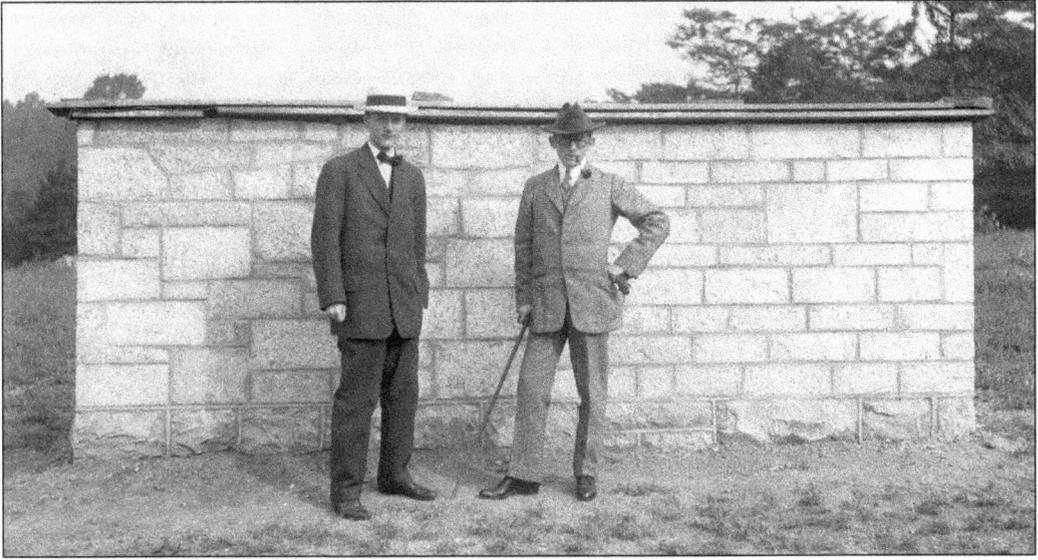

Raymond Pitcairn (left) and Ralph Adams Cram strike a pose in front of a sample wall constructed in 1913. Pitcairn had asked Cram to be the architect of the project in 1912. The firm of Cram and Ferguson accepted the commission, but serious artistic differences developed between Pitcairn and Cram, leading to Cram's dismissal in 1917. This left Pitcairn, who had no formal architectural training, fully in charge of both design and construction.

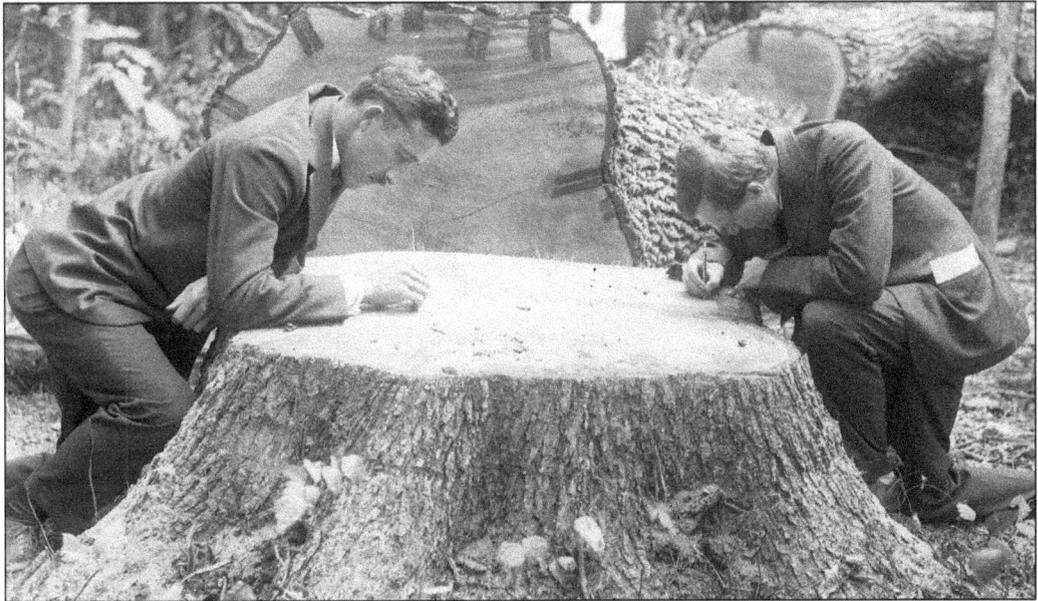

Edwin T. Asplundh (left) and Raymond Pitcairn count the rings on the stump of a large white oak. According to their calculations the tree was 347 years old when it was felled on November 18, 1916, on a farm about 12 miles from Bryn Athyn. Asplundh, a member of the Bryn Athyn congregation, was the cathedral's building superintendent until 1917, when he left to serve in World War I.

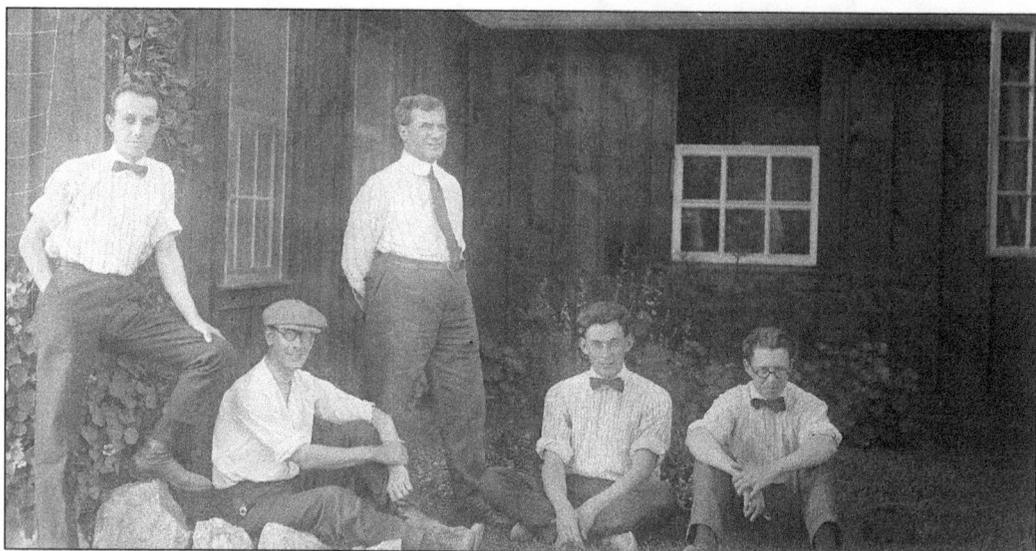

Pictured around 1916 outside the Bryn Athyn architectural studio are, from left to right, Frank Parziale, John Walker, Charles Sifferlin, Edward Davis, and Harold T. Carswell. The architects, Parziale, Walker, and Carswell, worked out of the Boston firm of Cram and Ferguson. However, as more of the designing and redesigning of the cathedral began to take place in Bryn Athyn, it became necessary to establish a studio on site.

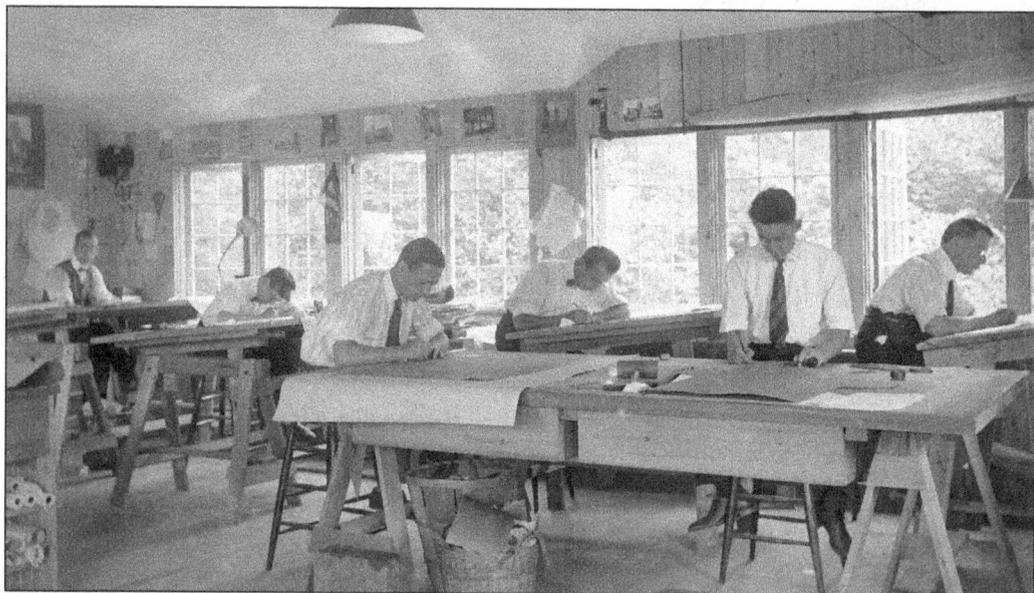

Architects and draftsmen work at their drawing tables inside the architectural studio around 1916. The building was located on the eastern edge of the construction site. Members of this department worked cooperatively on different parts of the building and were encouraged to give their own creative input. However, Raymond Pitcairn had complete oversight of the design, using photographs in books as well as verbal descriptions to convey his wishes for design changes.

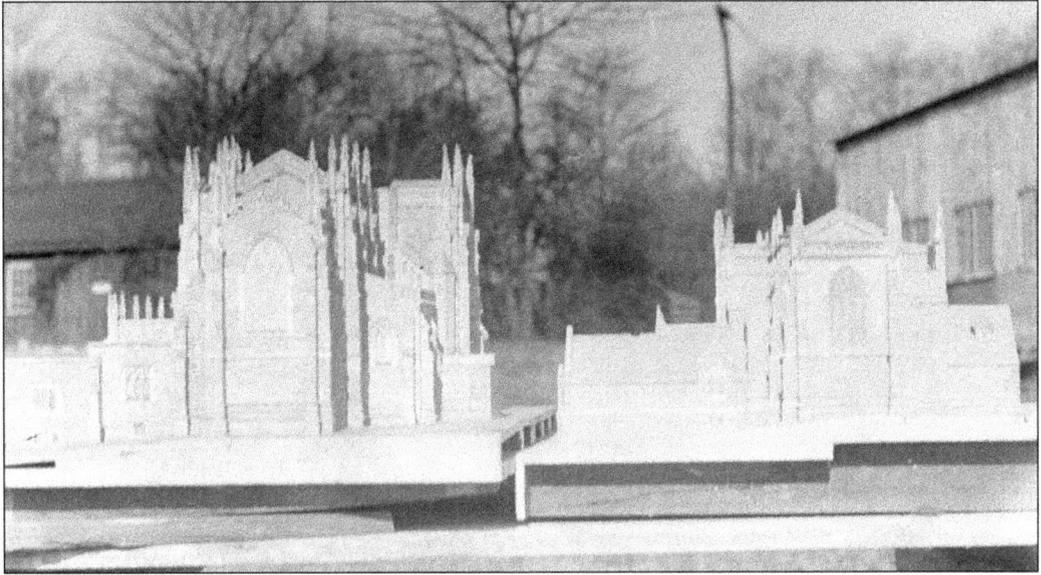

These early scale models of the cathedral were just the beginning in a long series of design changes. Three-dimensional models allowed Pitcairn, who was unable to read architectural drawings, to fully participate in the design work. The model on the right was delivered by Cram and Ferguson in February 1914. Pitcairn eventually set up his own modeling department in Bryn Athyn, which produced the model on the left.

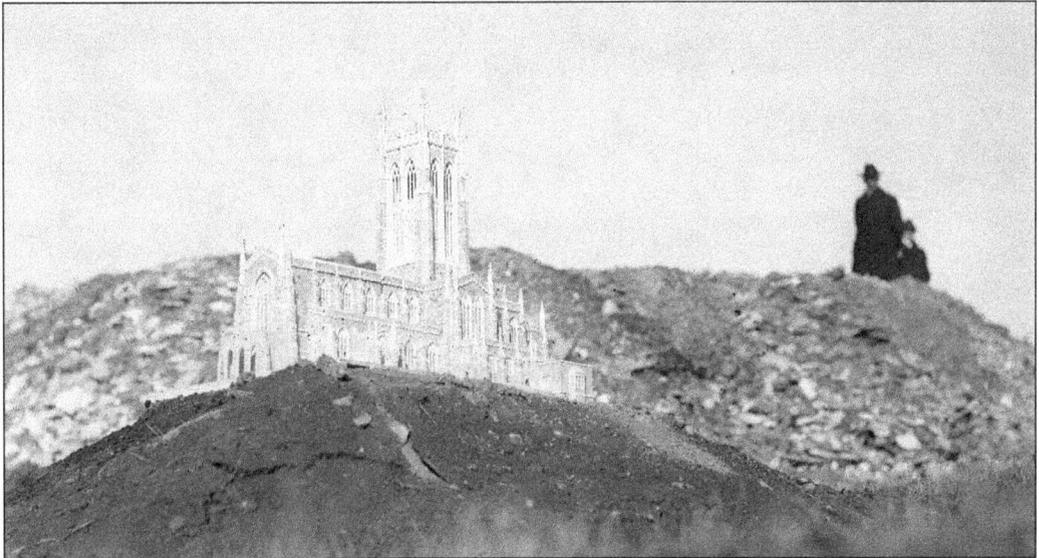

Dramatic changes in the height and general proportions of the cathedral can be seen by comparing this scale model to the ones above. It has been placed outside on a mound of construction debris. If not for the presence of the two men in the background, the detailed model in this photograph might be mistaken for the actual building. The model is viewed from the southwest with the mound providing, in miniature, the sloping topography of the cathedral site.

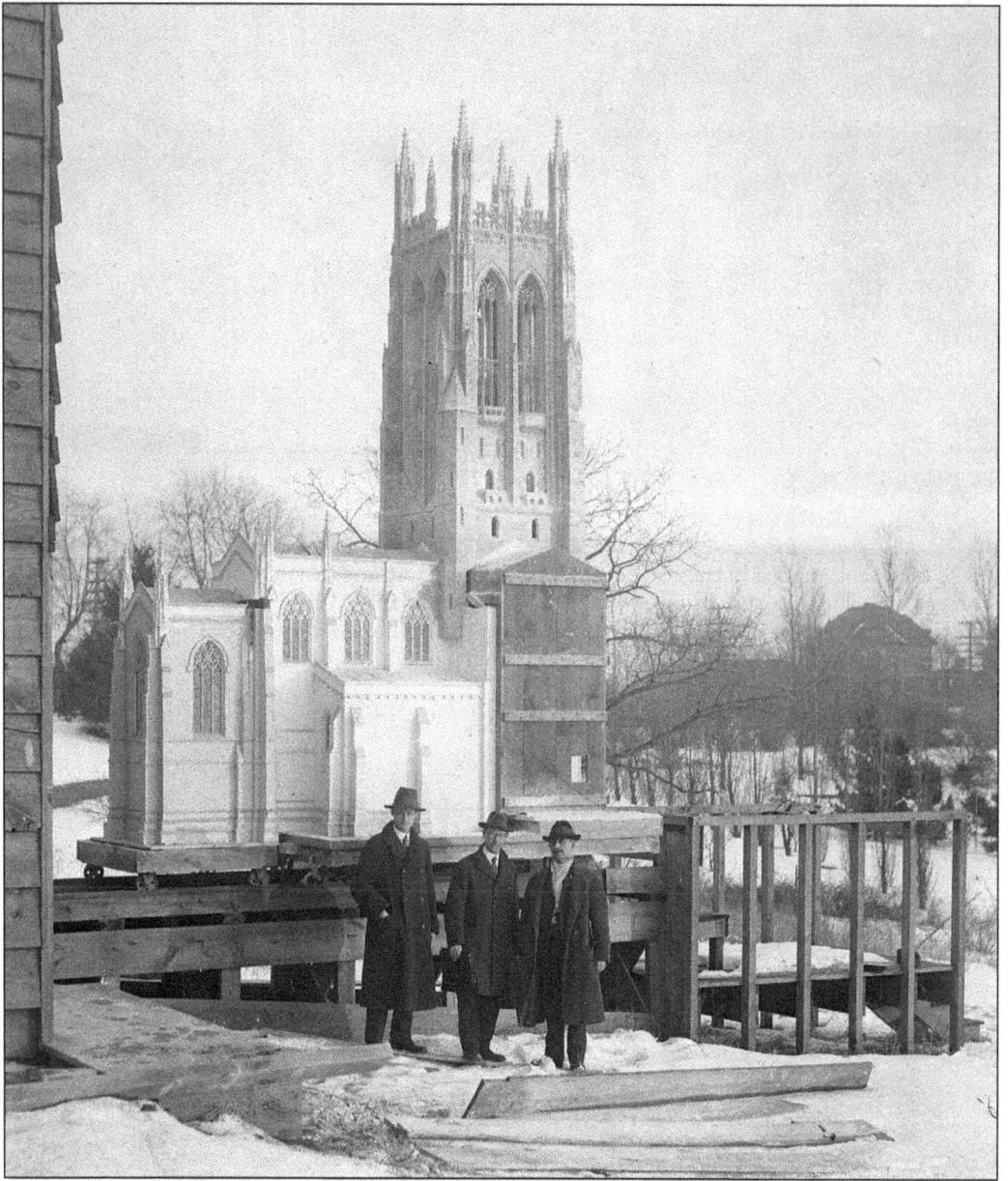

Perhaps the most dramatic example of the use of scale models during construction was this large model of the cathedral's tower, chancel, and sanctuary, painted to resemble stone. It was placed on rails so it could be wheeled outside and studied in natural light at different times of day. From left to right are Raymond Pitcairn, John Walker, and Leonard Gyllenhaal. The buildings of the Academy of the New Church are visible in the background. Walker, an architect, was involved in drawing up final plans for the tower. Gyllenhaal served as treasurer for both the General Church of the New Jerusalem and the Academy of the New Church in Bryn Athyn.

Architect E. Donald Robb adopts a whimsical pose on top of an unfinished chancel column with Raymond Pitcairn looking on around 1916. Robb, who originally worked out of the offices of Cram and Ferguson, came to the Bryn Athyn architectural studio in 1915, focusing on designs for the chancel and sanctuary. He also designed the Immanuel Church and school building for the New Church congregation in Glenview, Illinois, and worked on the National Cathedral in Washington, DC.

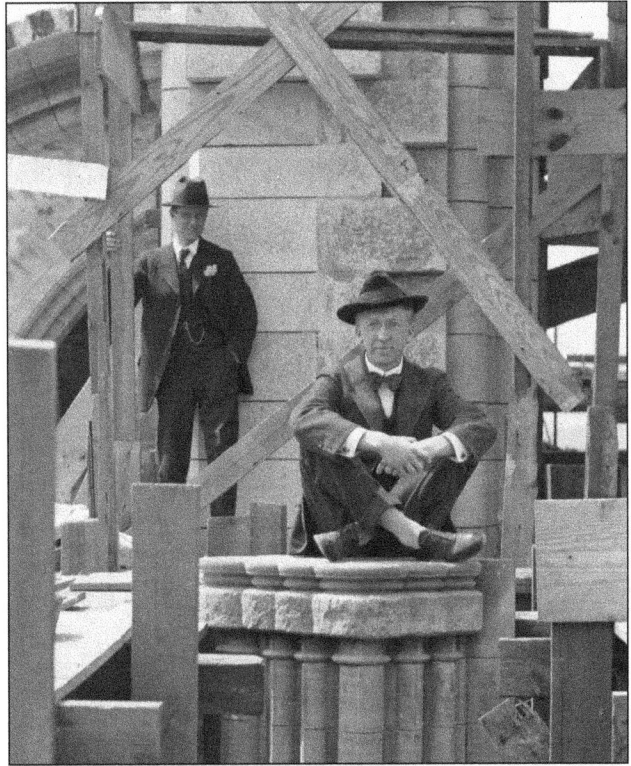

In an effort to build "in the Gothic way," craftsmen were assembled to work side by side in stone, wood, metal, and stained glass workshops surrounding the cathedral. A view of the construction site from the south shows a portion of the woodworking shop on the right, with the blacksmith shop next door. A stonecutting shed (left) is located close to the scaffolded walls of the nave.

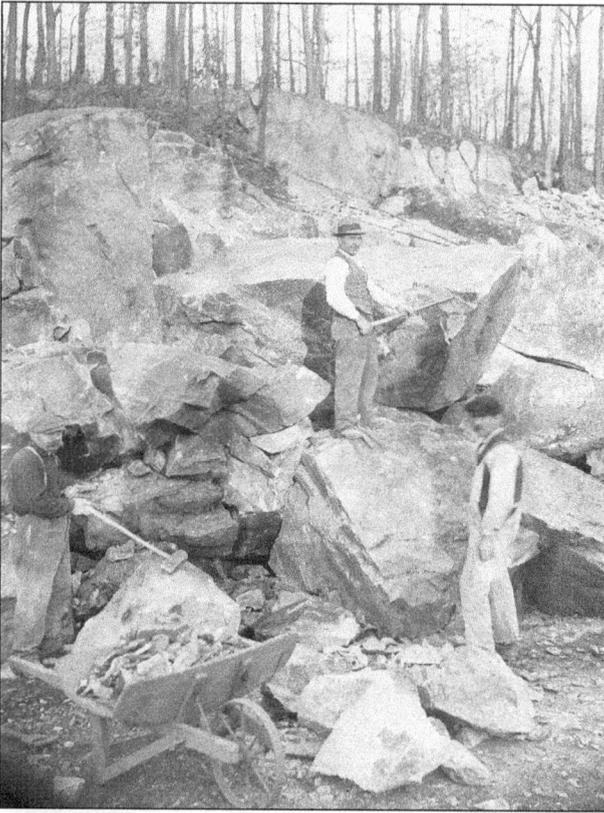

The Bryn Athyn quarry, located less than a mile from the cathedral, opened in the winter of 1914. It provided granite for the exterior walls of the nave, portions of the north and south wings, and some of the fine carving. The road that curves below the cathedral, originally built to move stone from the quarry to the construction site, today bears the name Quarry Road.

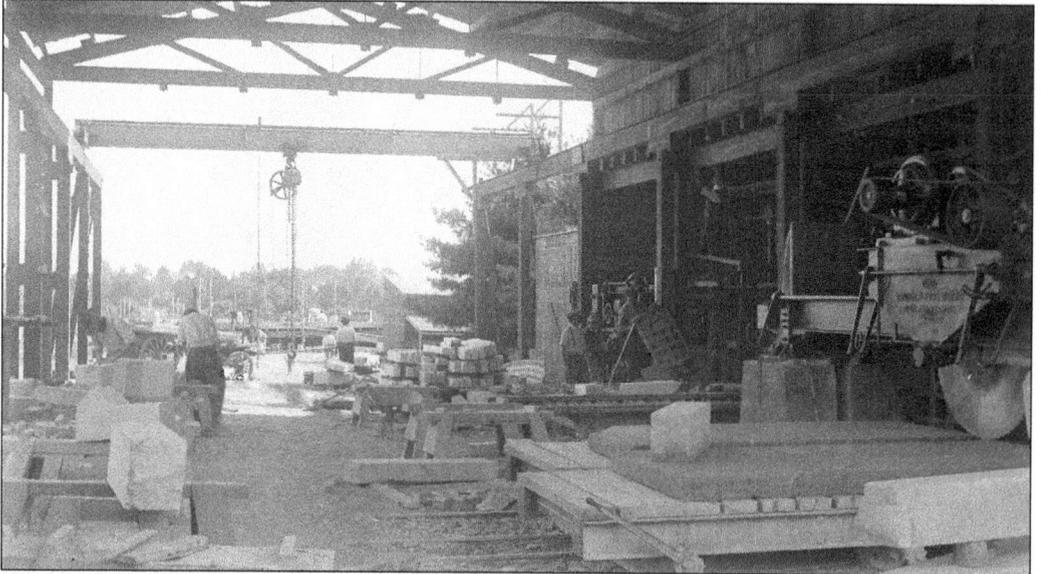

Pieces of equipment and scattered blocks of unfinished stone are strewn across the inside of the stonecutting shop. The three main varieties of stone used in the cathedral were granite, limestone, and sandstone. Stone was carefully chosen from quarries in several states, including Pennsylvania, New York, Massachusetts, and Kentucky. Quarry owners were encouraged to take part in the search to locate the finest stone available.

On June 19, 1914, the Bryn Athyn congregation took part in a cornerstone laying ceremony for the cathedral. A stationary crane was set up to lower the seven-ton unhewn granite block into place. The block had been found in the woods near the Bryn Athyn quarry. Pictured from left to right are (first row) Raymond Pitcairn; (second row) Edwin T. Asplundh, Robert Tappan, Albert C. Perry, and Pringle Borthwick.

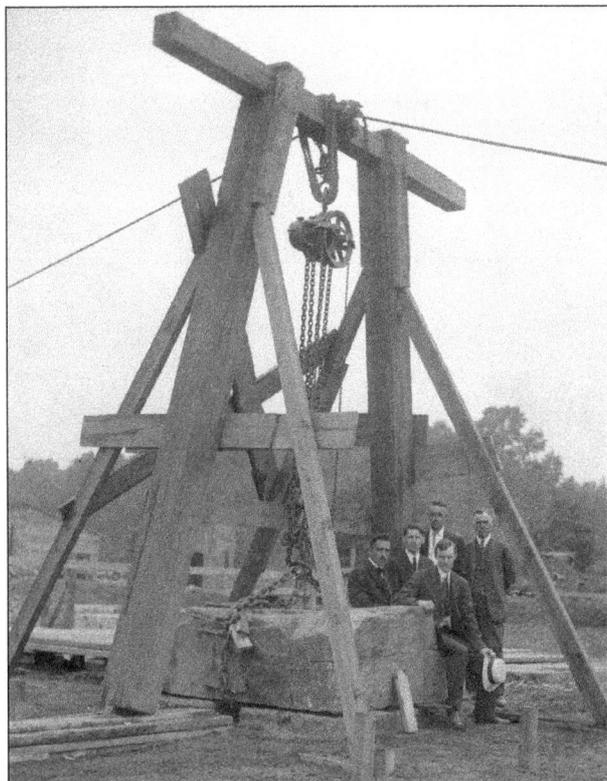

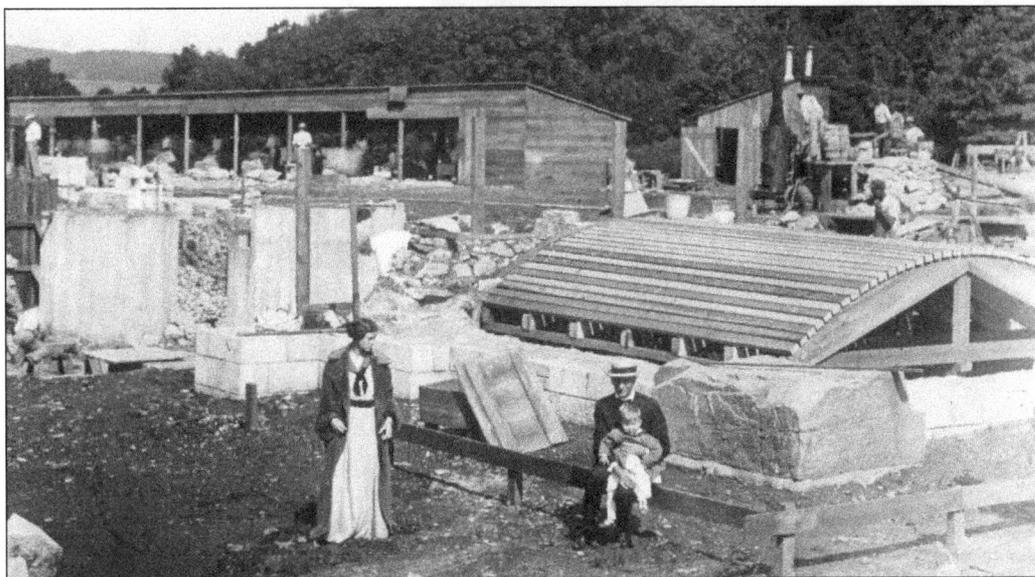

Mildred and Raymond Pitcairn visit the cornerstone with their son Nathan during the summer of 1914. Bishop William F. Pendleton wanted the stone to remain visible, thus it forms the foundation of two buttresses and part of the wall on the southeast corner of the sanctuary. It is visible from the exterior, carved with the Hebrew words, "the head of the corner," from Psalm 118:22. The curved wooden structure in the photograph was a temporary frame used to construct an arched stone ceiling under the sanctuary.

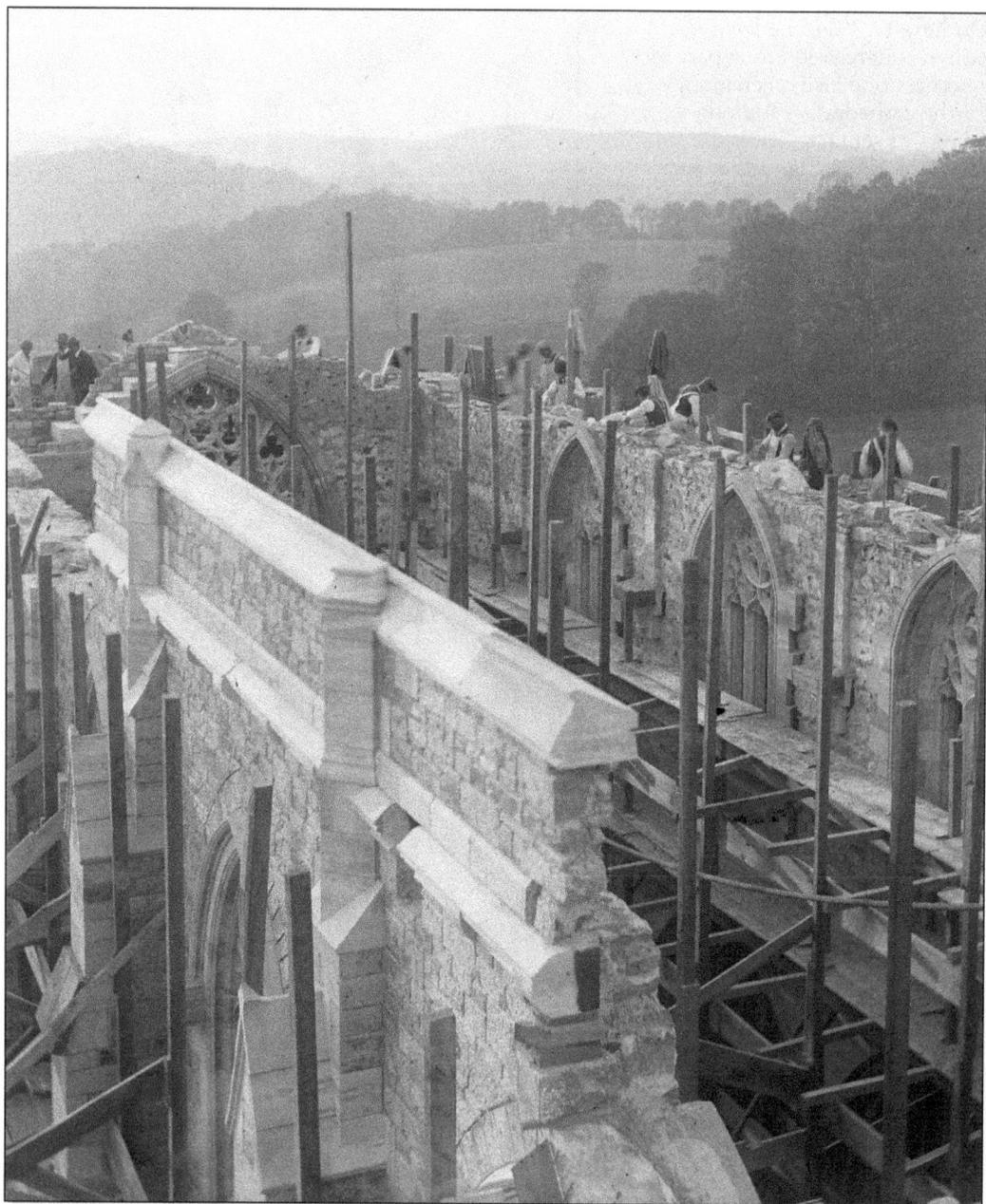

Stonemasons work high atop the north side of the nave clerestory walls. The arch forming the top of the west window can be seen at the far end. Bryn Athyn Cathedral was built on a hill descending to the Pennypack Creek valley. Today much of the view from the west end of the cathedral remains wooded and undeveloped, providing a vista that draws small crowds at sunset during the warmer months of the year.

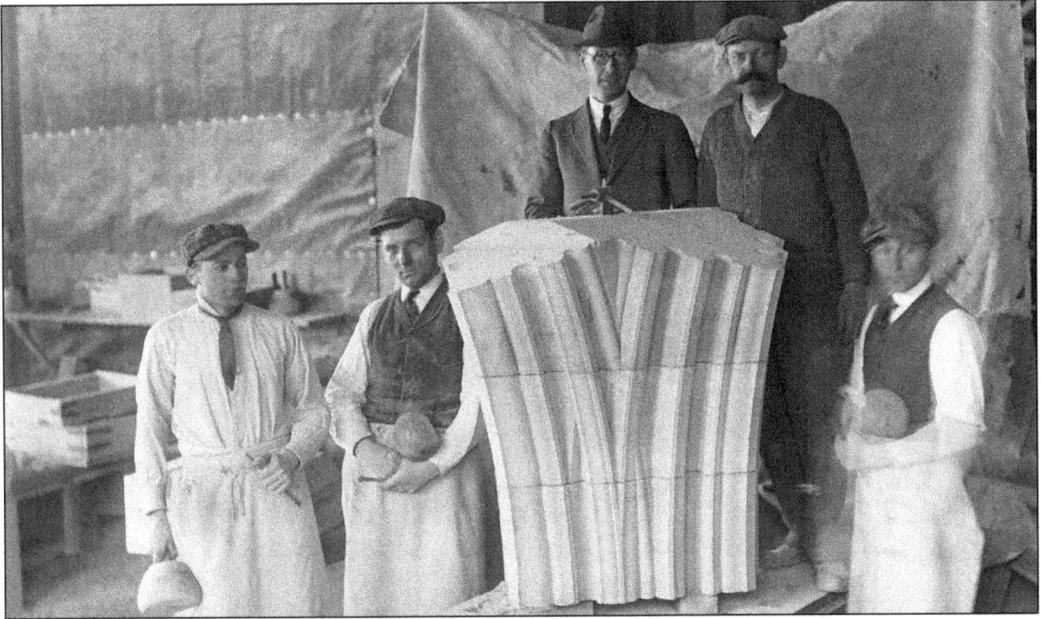

John Walker (center) and four unidentified stone carvers pose with part of a sandstone chancel column. The delicate interlacing on the carved stone forms the beginning of two separate arches. Some of the carvers came from Europe, which has a rich tradition of stone carving. Walker, an architect from the offices of Cram and Ferguson, came to work in Bryn Athyn in 1914, eventually acting as superintendent of the architectural studio.

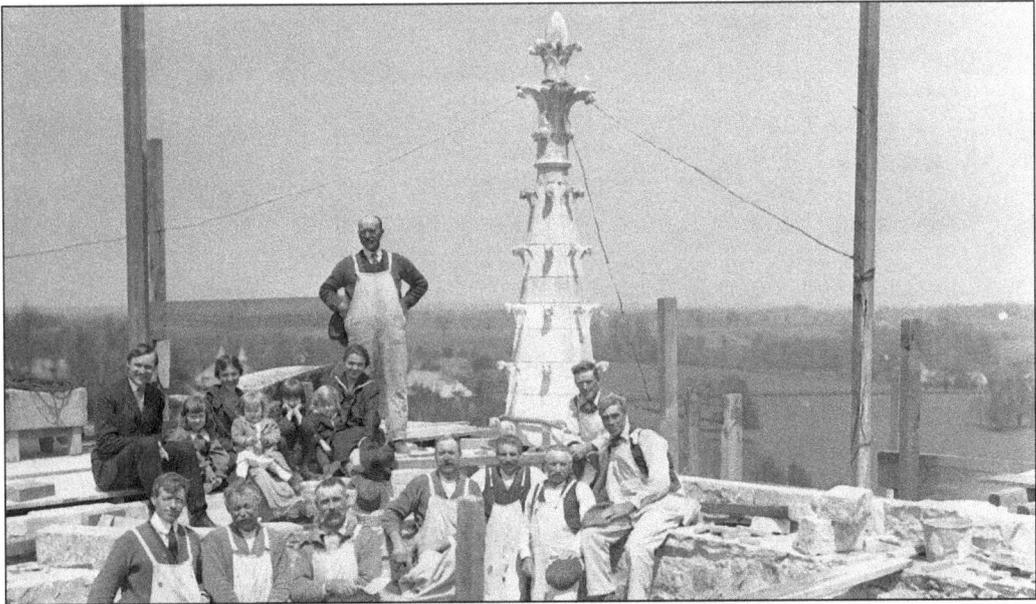

A tower pinnacle and the surrounding countryside form the backdrop for a group photograph around 1919. George Milne, the mason foreman, stands with workmen seated in front. The Pitcairn family members pictured from left to right are Raymond, Gabriele, Mildred, Karen (on her lap), Nathan, Ivan, and nanny Beatrice Ashley.

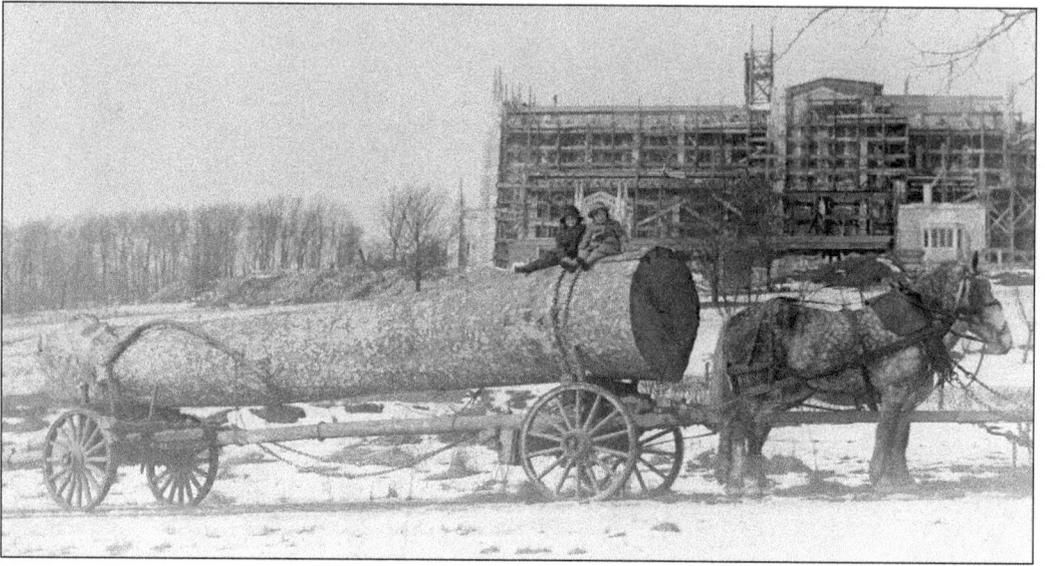

A team of horses takes a rest from pulling a large log up Quarry Road on a winter's day. Sitting on top are two of Raymond and Mildred Pitcairn's children. The large white oak trees used for the cathedral's timber roof were cut down in the forests surrounding Bryn Athyn. The wood was carved on site in a woodworking shop located on the east side of the church.

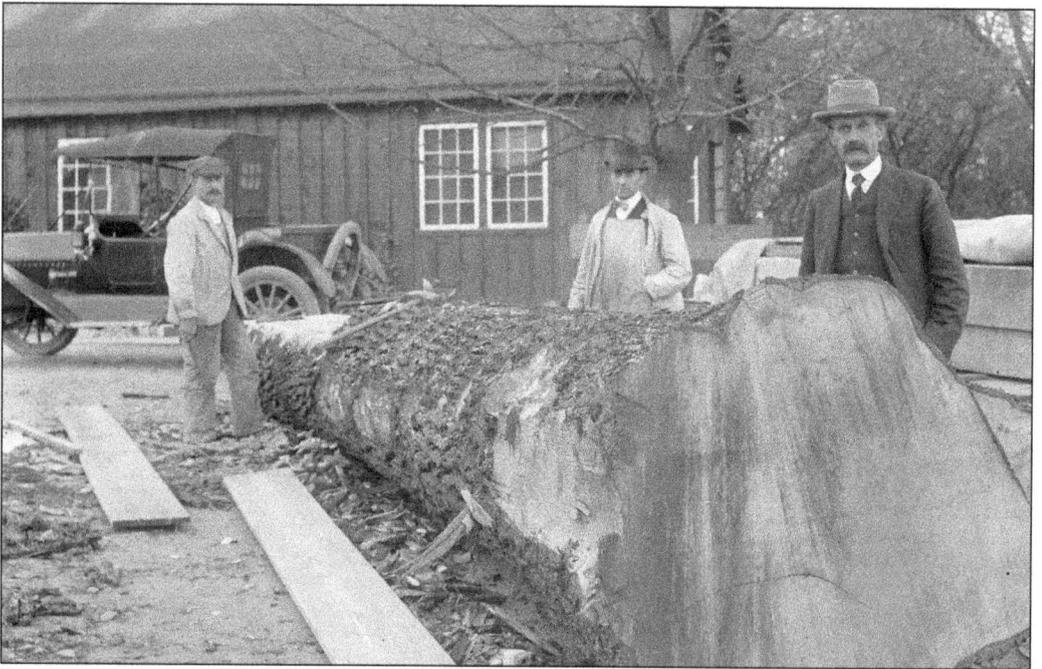

Harry Bowman (front) and two unidentified men stand beside a large oak log outside the architectural studio. The men square the log by hand before taking it to the woodworking shop for further carving. Bowman was first hired to head up the woodworking crew; later he assumed the role of building superintendent when Edwin T. Asplundh left to serve in World War I in 1917.

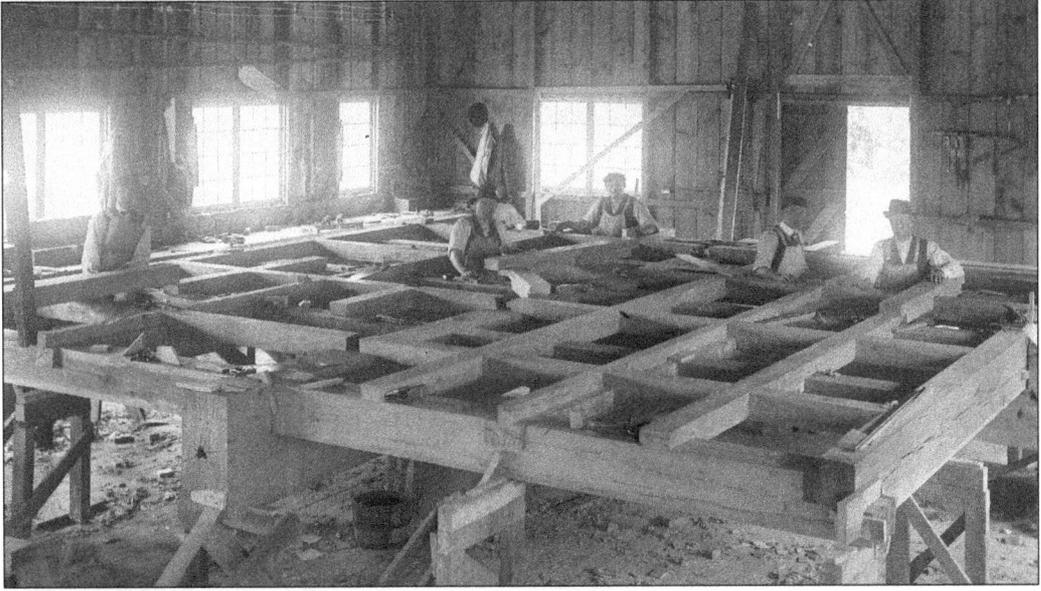

Using hand joinery techniques, carpenters assemble a section of the cathedral's oak roof in the woodworking shop. On May 28, 1915, everyone working on the project was brought together in this shed for a historic luncheon, at which both Ralph Adams Cram and Raymond Pitcairn delivered speeches. The large structure remained on the cathedral grounds until 1950 when it was used for the last time as a meeting place during a church assembly. Shortly afterward, it was taken down.

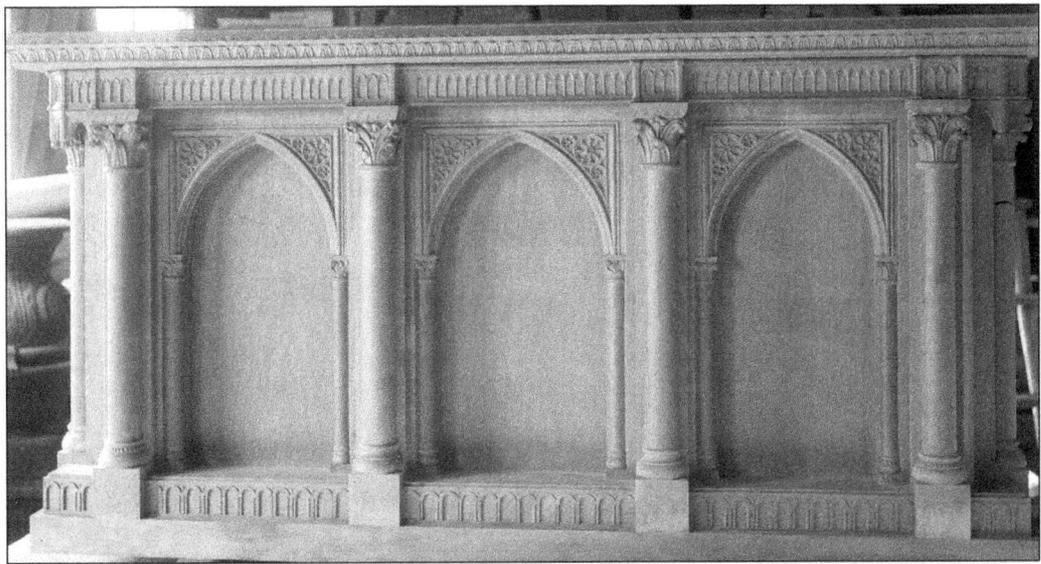

The altar for the cathedral's chapel, designed to hold a copy of the Bible during services, was photographed in one of the workshops before being moved to its permanent location. It was hand carved from cherry wood and serves as an example of the intricate and detailed woodcarving found throughout the building. The chapel, situated in the south transept, provides an intimate space for small services.

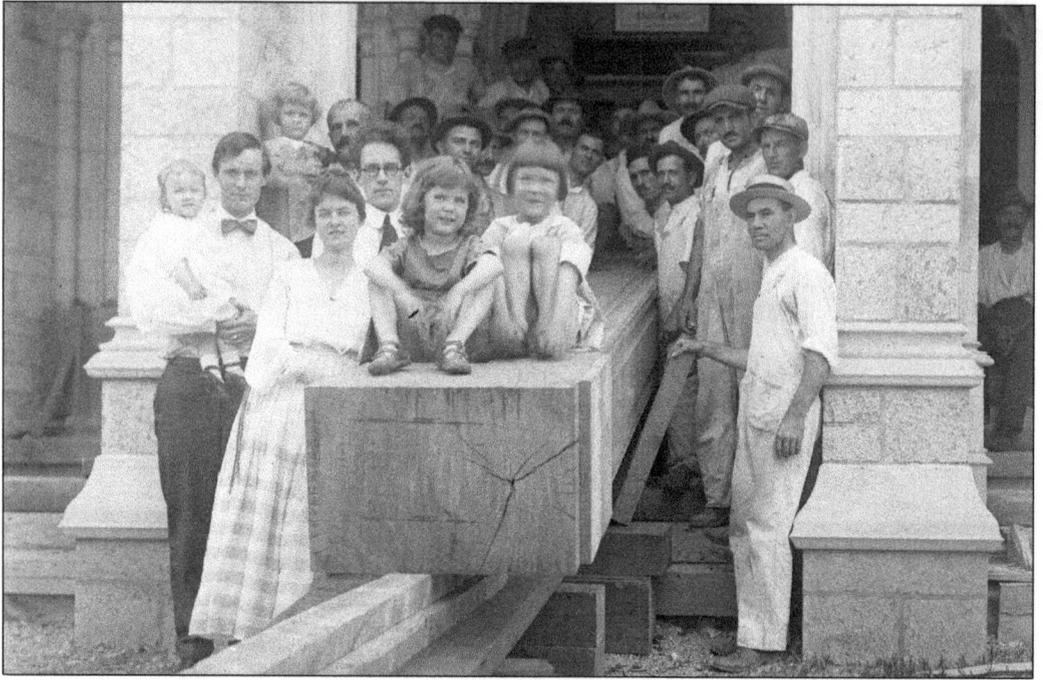

The cathedral project was not without its dramatic moments. This photograph, taken on July 24, 1918, shows Pitcairn family members and craftsmen assembled to watch a three-ton timber as it was moved into the church. Once inside, the timber was raised with ropes to provide a support for the bell deck in the tower. Although initially only one rope was planned for, it was decided that two should be used—a fortuitous decision, since one of the ropes broke during the raising.

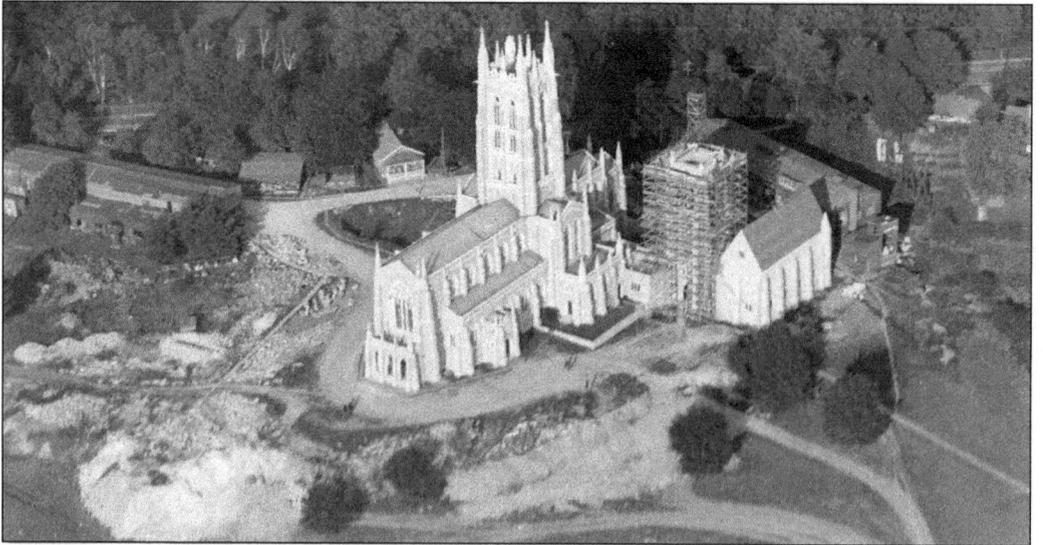

This aerial view of Bryn Athyn Cathedral is significant because of the broken pinnacle on the main tower. It was hit by a bolt of lightning on the evening of June 18, 1924. The pinnacle plunged through the cathedral's chancel roof. A wedding had taken place at the church two hours earlier; luckily no one was hurt. The pinnacle was replaced in June 1925.

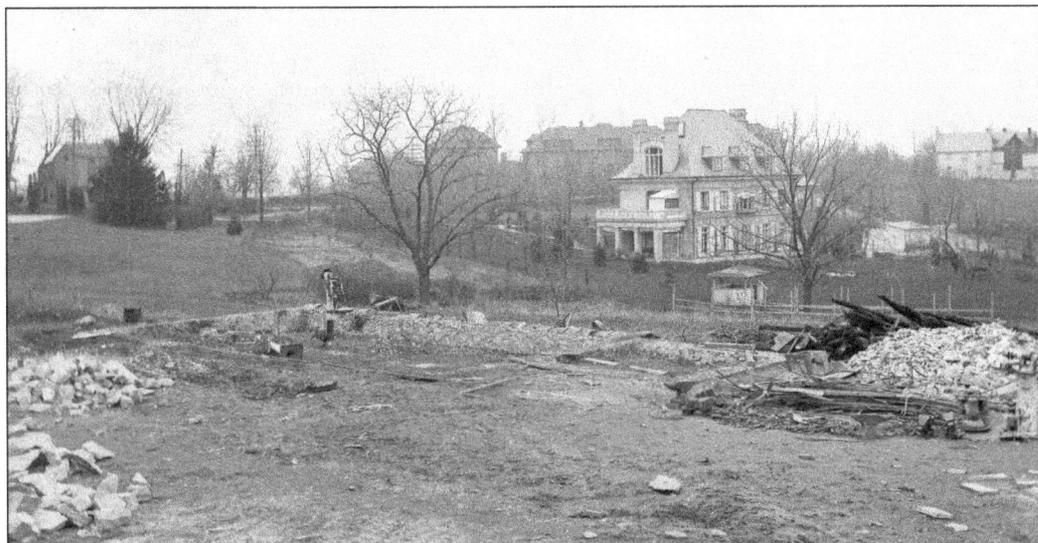

In 1916, a newly completed blacksmith shop for the metalworkers was located just off the south end of the woodworking shop. The close proximity of the two buildings proved calamitous when a fire broke out in the forge in April, destroying the blacksmith shop (above) as well as the woodworking shop. A number of important models of the cathedral were lost in the fire, as well as several completed sections of the roof. The woodworking shop was soon rebuilt in the same location (below), but it was decided that the new metal shop should be built elsewhere. At the time of the fire, the large house visible in the above photograph was owned by Regina Iungerich. The house in the photograph below was owned by Gerald S. Glenn. Both houses still stand today on the edge of the cathedral grounds.

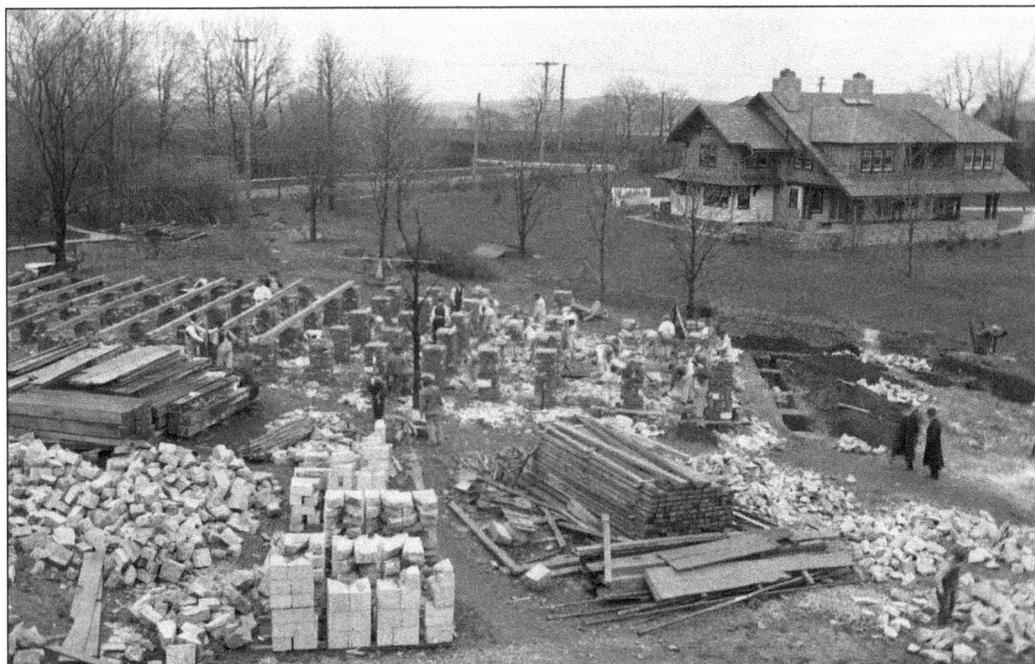

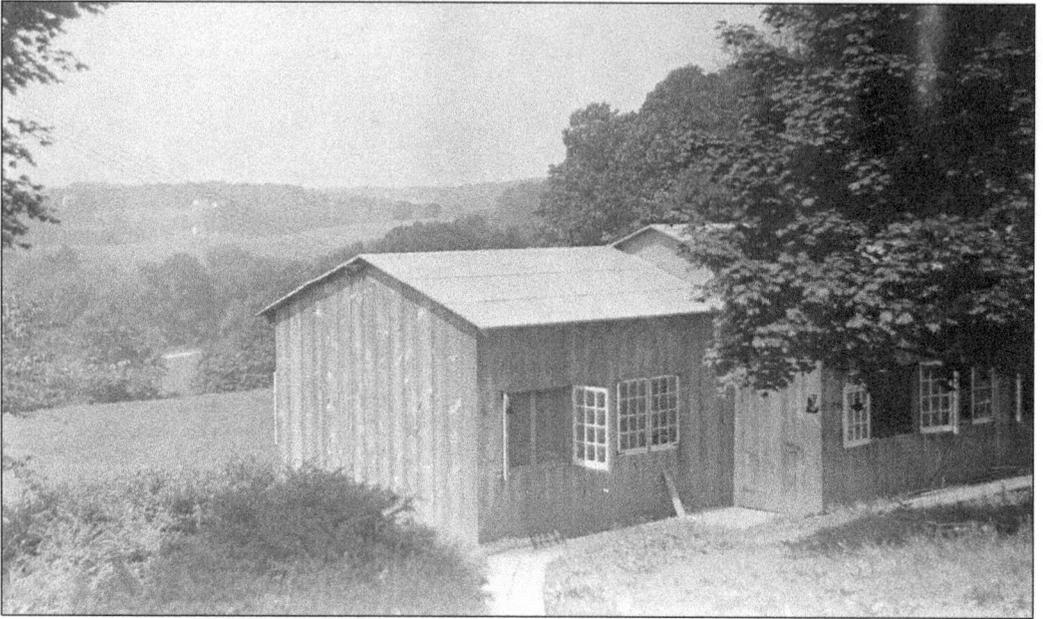

After the blacksmith shop was destroyed by fire in 1916, a new metal shop was built on the northwest side of the cathedral, far from the other buildings (above). It was constructed in sections over time and is the only original workshop still standing today. An unidentified metalworker (below) holds his tools in the interior of the shop. The walls and benches show an array of tools and intricate metalwork pieces. The forge is visible through the doorway into the next room on the left side of the photograph. This workshop produced a wealth of handwrought doors, handles, locks, railings, screens, grills, and more, all from original designs. A variety of metals were used, but the one most heavily employed was Monel, an alloy of nickel and copper.

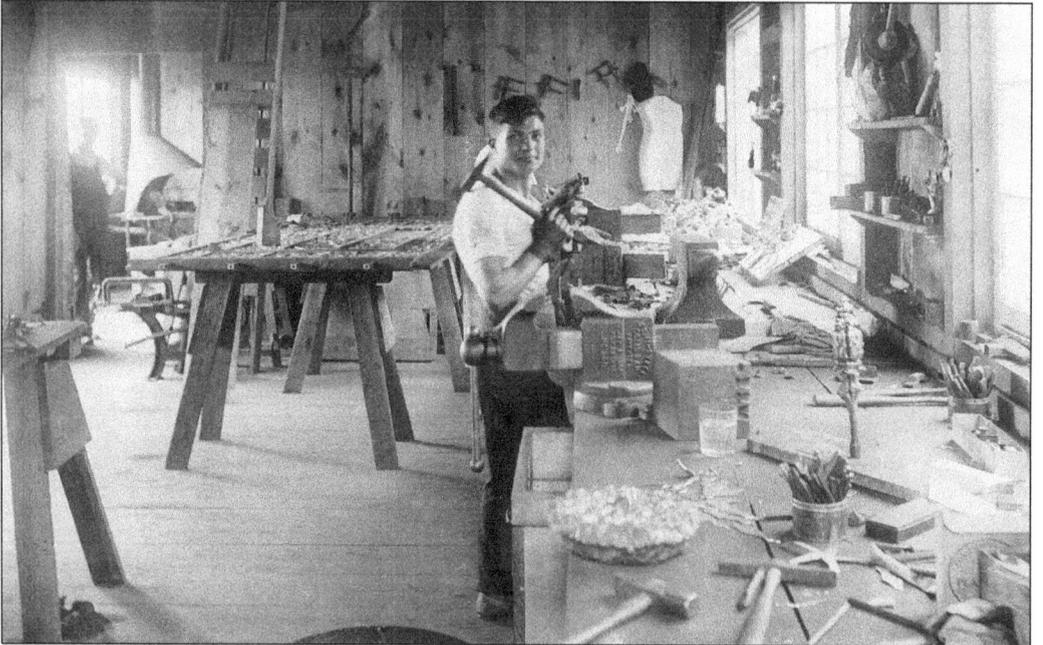

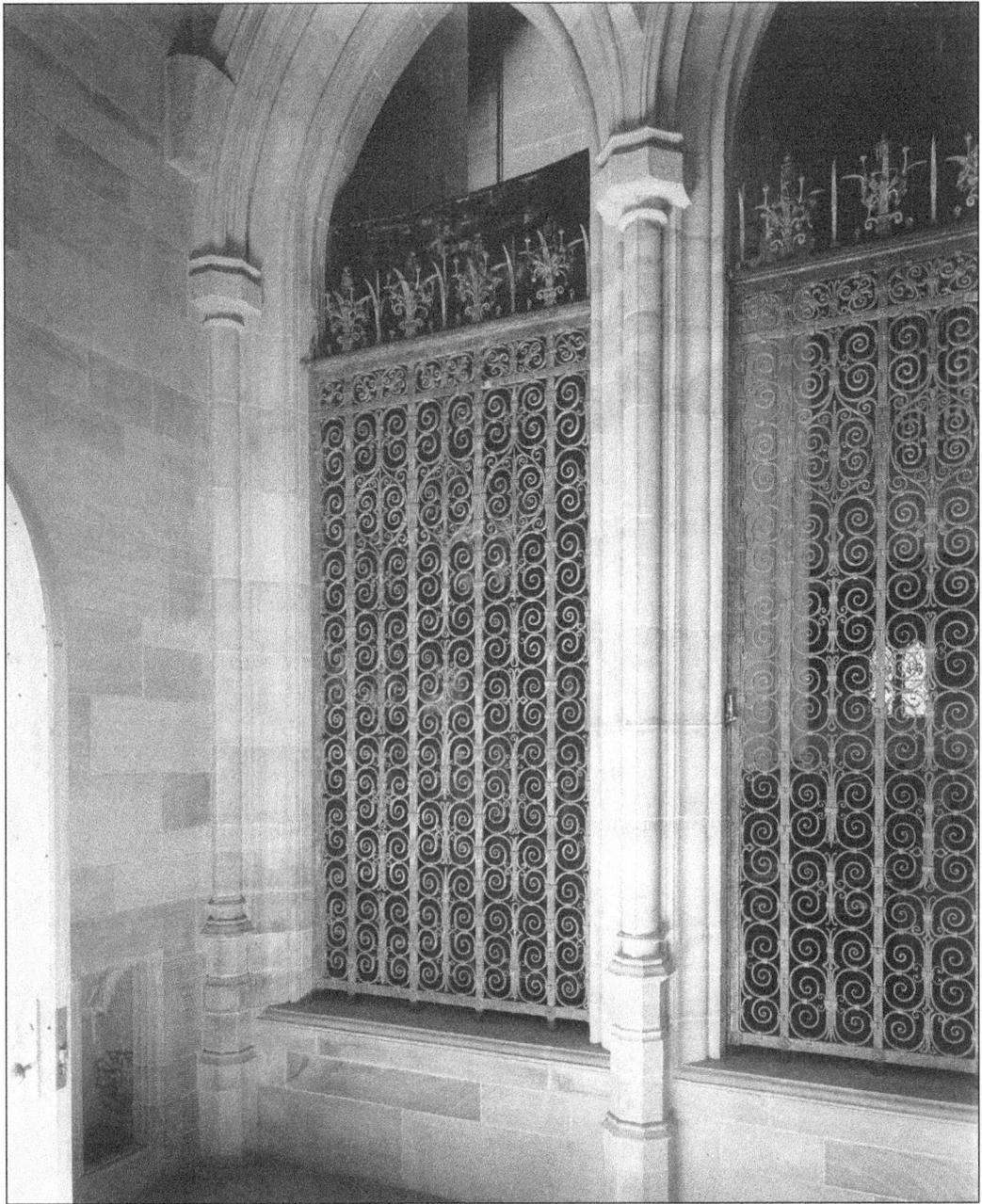

An intricate metal screen consisting of four panels (two are visible) provides a division between the nave of the church and a small chapel. It was designed by Parke E. Edwards and serves as an example of the intricate and highly skilled metalwork found throughout the building. The screen is made up of a repeating pattern of scrolls but no two are exactly alike—each spiral varies in tightness and length. It was handwrought in Monel, a nickel-copper alloy, which is much harder to work with than iron. Certain welds required the use of acetylene torches. This photograph was taken facing the back of the chapel, with the corner of the door to the outside visible on the left.

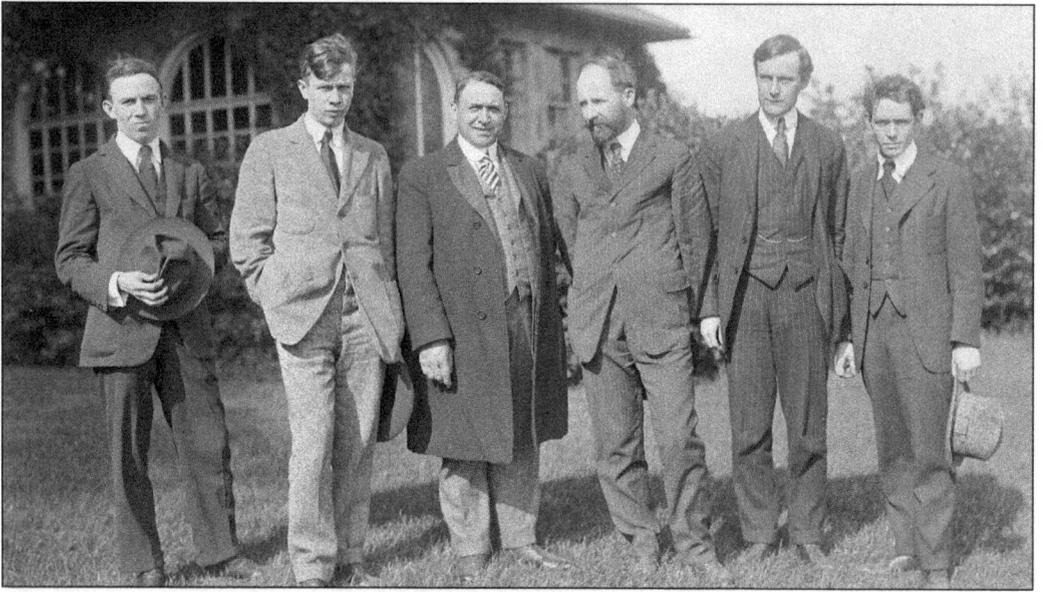

From left to right, Rowley Murphy, Paul Froelich, John Larson, Lawrence B. Saint, Raymond Pitcairn, and Winfred S. Hyatt stand in front of Cairnwood's garden house, which was used as a stained glass studio. Murphy, Froelich, Saint, and Hyatt were employed as stained glass artists. Larson managed the glass factory for the first few years of its operation. The initiative to revive the lost art of making "pot metal" glass in Bryn Athyn, in order to produce stained glass windows worthy of comparison to those made during the Middle Ages, was perhaps the most important artistic endeavor undertaken during the cathedral project. It took years of study and experimentation to produce windows such as the one in the council chamber, depicting the rider on the white horse from the New Testament's Book of Revelation (below).

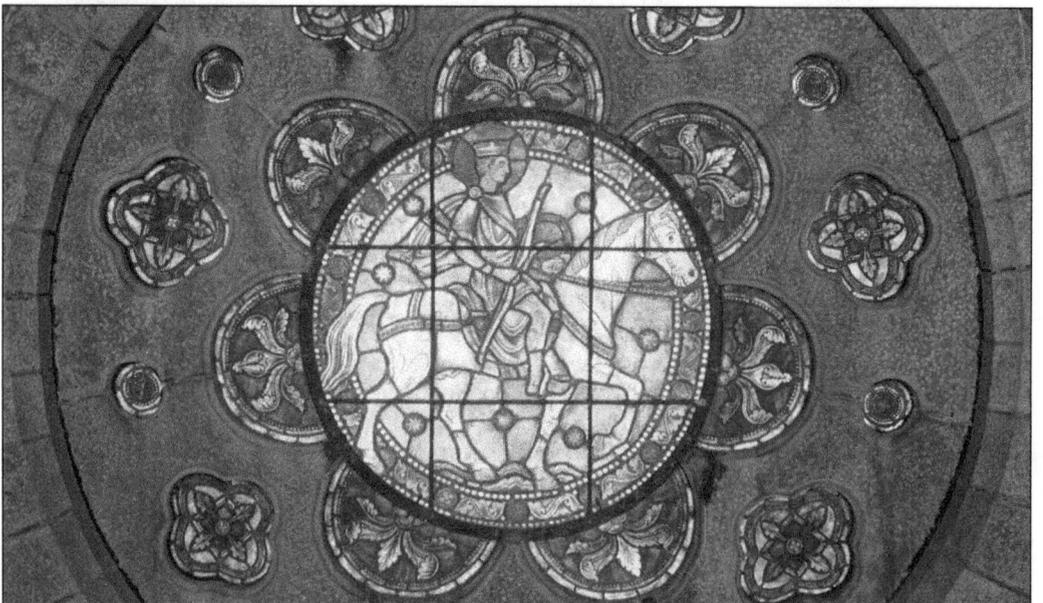

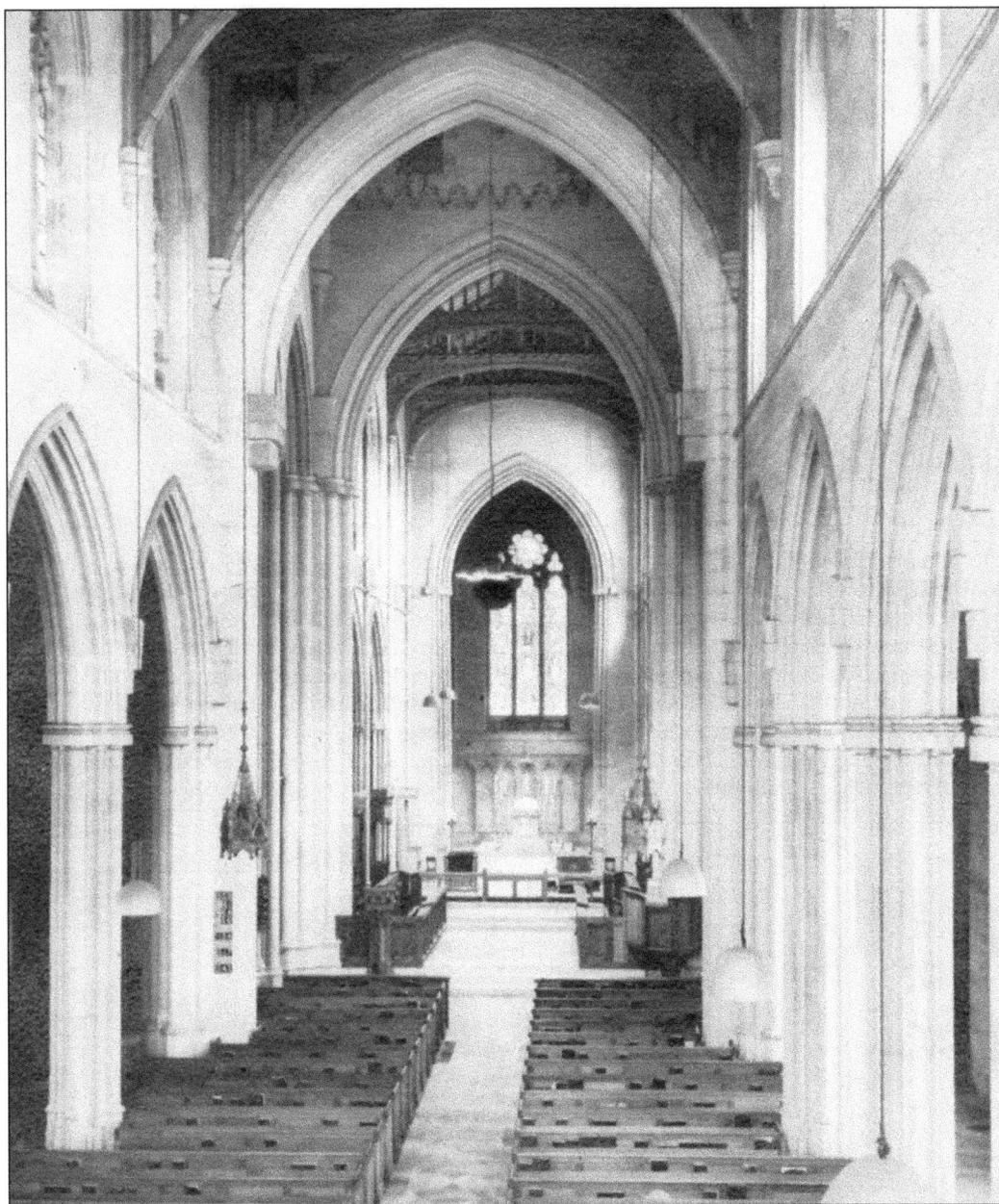

This view of the nave shows the central aisle of the cathedral looking from the west toward the chancel and sanctuary in the east. Several unusual architectural features are present in this space, including the following: the two rows of sandstone columns traveling the length of the aisle are not placed directly opposite each other and their capitals are at slightly different heights. In addition, the floor of the aisle rises gradually by about a foot from the west end to the chancel. The purpose of these minor asymmetries and imperfections is to give a sense of life to the building. Raymond Pitcairn became convinced of the merit of such features after attending a 1915 lecture by William H. Goodyear of the Brooklyn Museum. Goodyear proposed that medieval church builders had deliberately introduced these techniques, which he called "architectural refinements." There are many other examples of "refinements" throughout Bryn Athyn Cathedral.

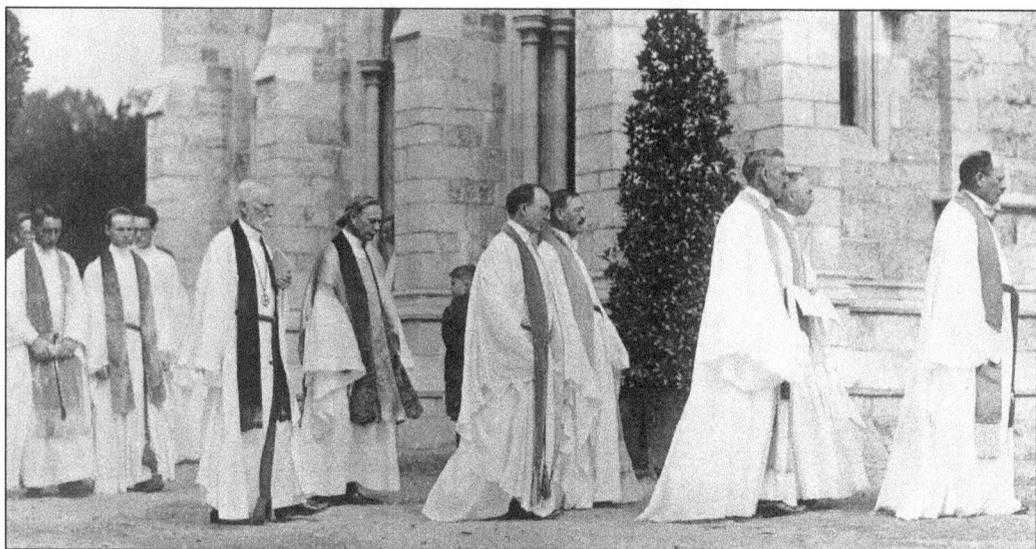

On Sunday, October 5, 1919, a formal dedication service was held in Bryn Athyn Cathedral. It took place during the 10th assembly of the General Church of the New Jerusalem, giving members of the church from around the globe the opportunity to attend. More than 2,000 people took part in three separate services during the day: a morning dedication service, an afternoon holy supper service, and an evening service of praise. In order to ensure that everyone would have a seat at the dedication service, reservation cards were printed up and handed out before the event. A procession of the clergy traveled up the nave at the beginning of the service and later walked out through the west door. Some of those who participated in the services can be seen in the photograph below, taken outside the west porch.

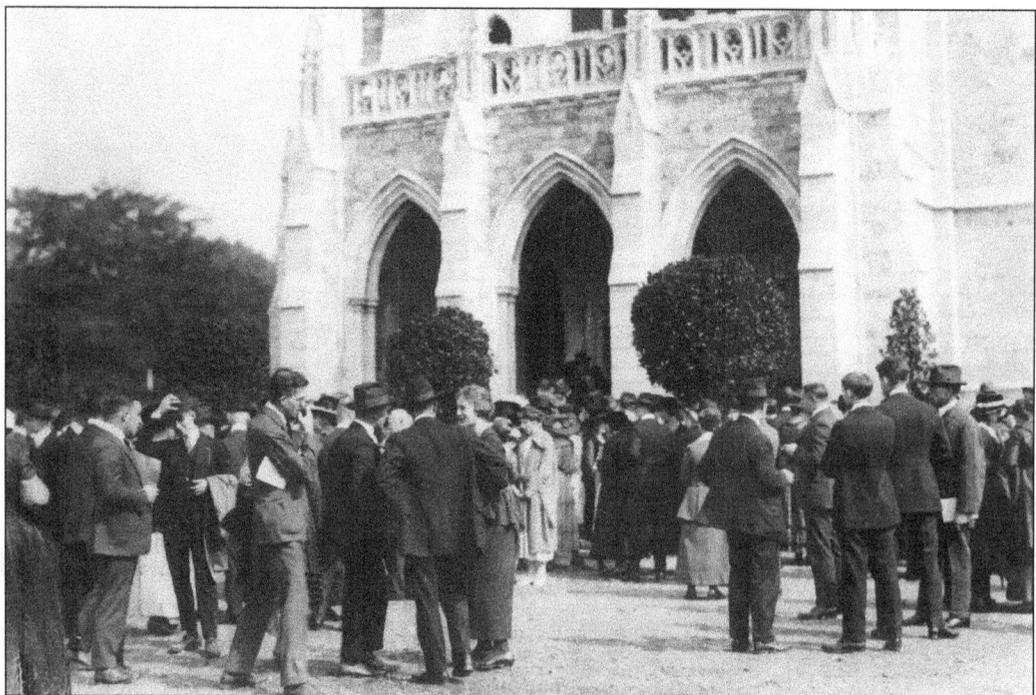

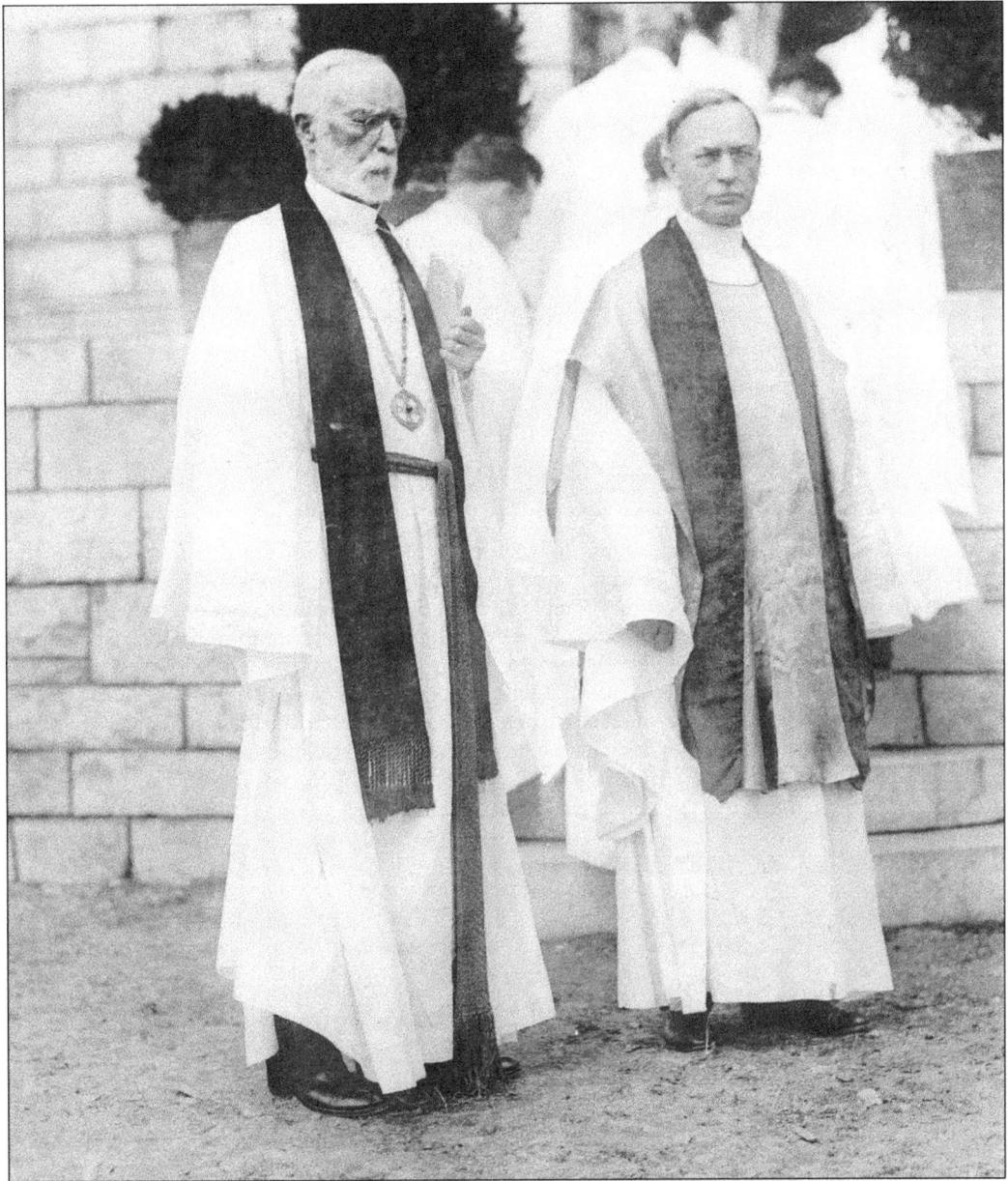

Bishop Emeritus William F. Pendleton (left) stands beside his brother Bishop Nathaniel D. Pendleton on dedication day, October 5, 1919. Nathaniel succeeded William as bishop following his retirement in 1915, but both brothers spoke during the Sunday morning dedication service. The Pendletons came from southern Georgia, and William served as a Confederate captain during the Civil War. Their father, Philip Coleman Pendleton, also served, and it was during this time that another soldier introduced him to the New Church. The chain and medallion worn by William were given to him in 1917 by members of the General Church of the New Jerusalem to commemorate his many years of service as their first bishop.

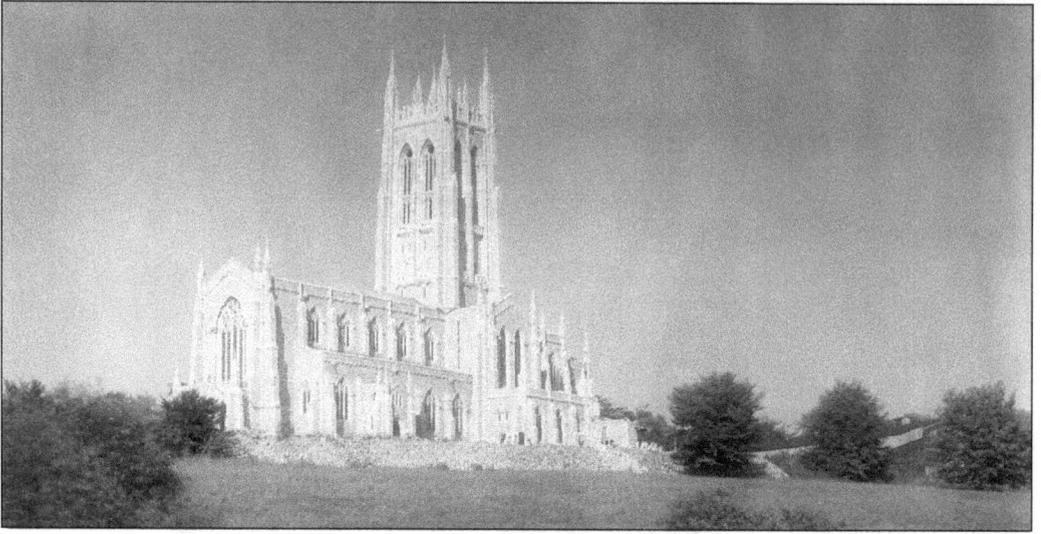

Two early views of the cathedral reveal its striking profile: a view from Quarry Road on the south side before the south wing was built (above) and an aerial shot from the northwest after its completion (below). The architectural form of the cathedral is medieval, combining features from both the Gothic and Romanesque periods. However, the symbolism contained within its stained glass windows, sculpture, and metalwork was inspired by New Church beliefs as found in the Bible and the writings of Emanuel Swedenborg. During a pre-dedication talk in 1919, the Reverend George de Charms expressed his belief that the purpose of symbolism in religious art is "to bring the Lord present in worship, that He may be present not only through the sense of hearing but also through the sense of sight." (*New Church Life*. Bryn Athyn, November 1919: 731.)

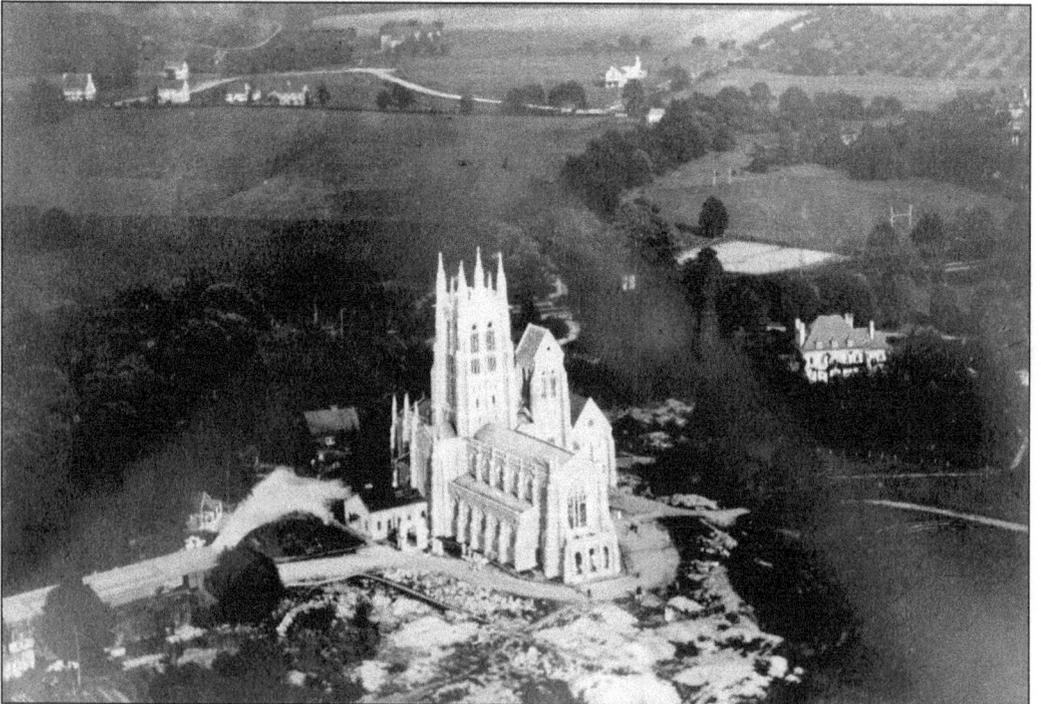

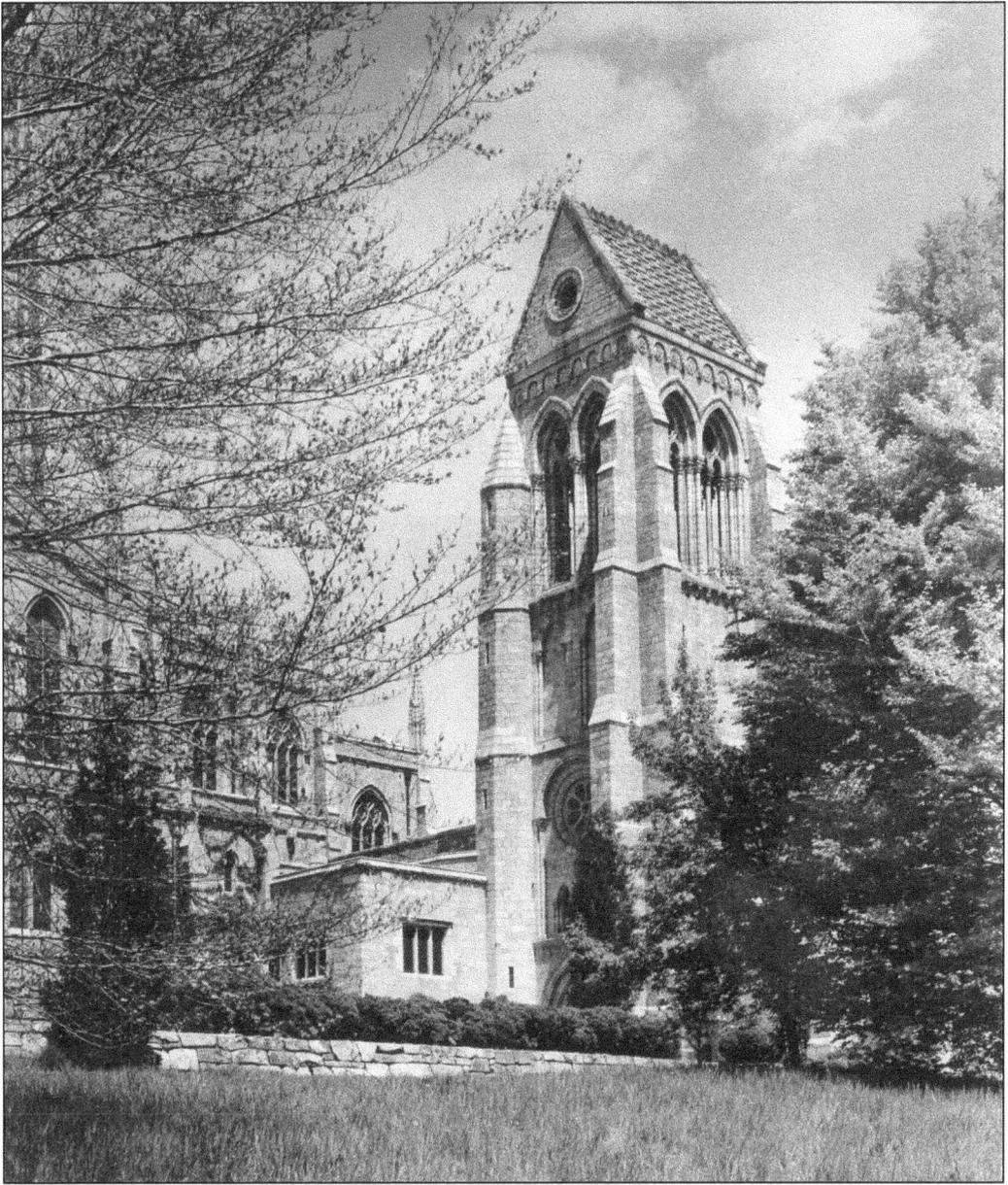

The Ezekiel tower, part of the south wing of the cathedral, was built during the 1920s. On the right of the photograph, hidden behind trees, is the council hall. Access between the inside of the main building and the council hall is through the tower at the second floor level. At ground level, an archway through the tower affords passage for those walking the grounds. The tower was given its name because of the decorative theme derived from the Book of Ezekiel, suggested by Bishop Nathaniel D. Pendleton. Both the interior and exterior decoration use symbols from Ezekiel's visions: wheels, palm trees, wings, and cherubim with the faces of a man, lion, ox, and eagle. In the writings of Emanuel Swedenborg, Ezekiel's strange visions are presented as having a deeper spiritual meaning.

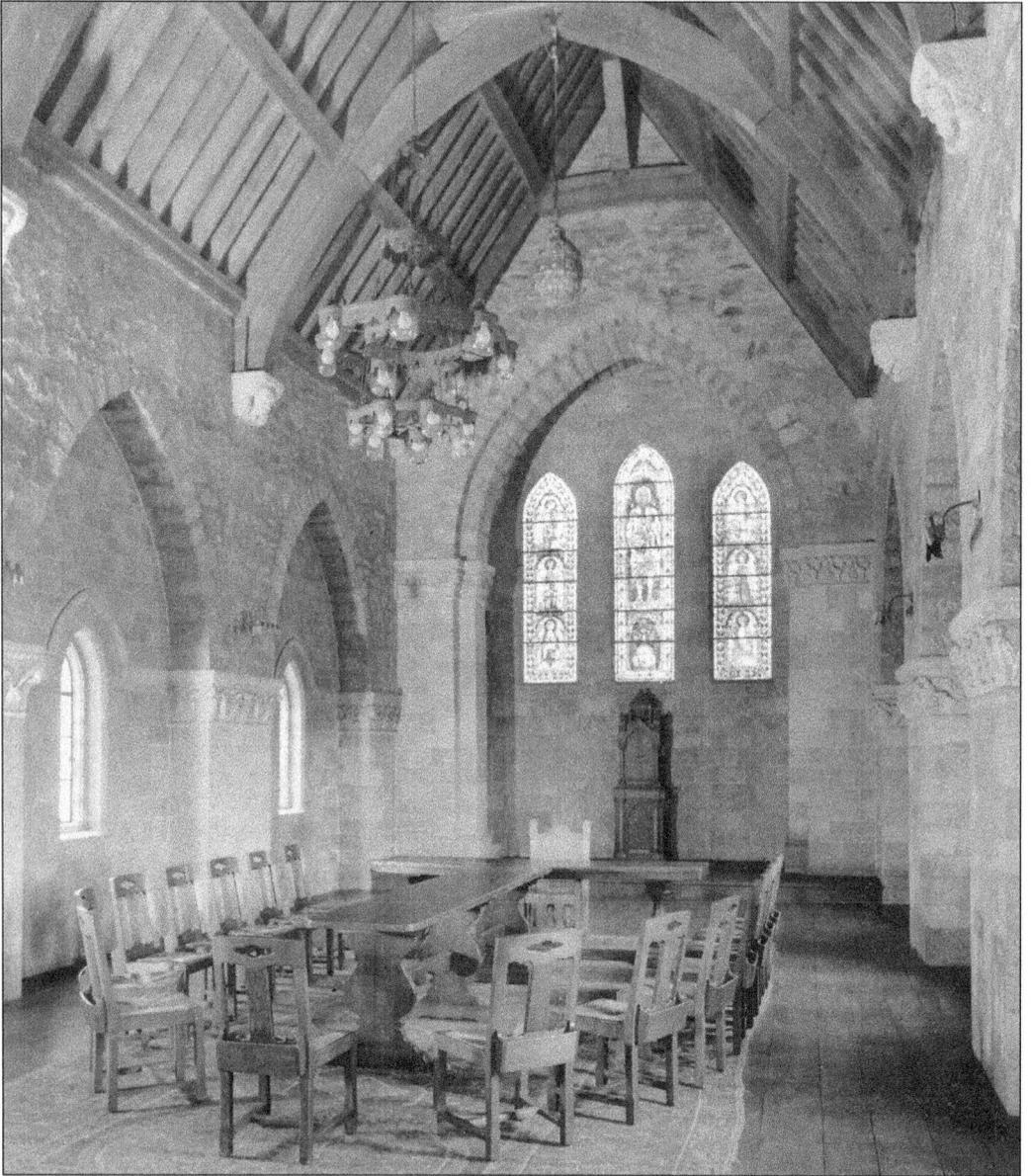

The council chamber, a steeply gabled room on the second floor of the council hall, was the site of annual meetings of the clergy of the General Church of the New Jerusalem for many years. The rough upper portions of the walls were originally intended to be finished with glass mosaic, but this was never done. The lower windows on either side of the room contain clear glass. Because of the room's administrative (rather than worship-related) function, non-scriptural symbolism was allowed in its decoration. Six stone corbels supporting oak roof beams are carved with the faces of individuals who were instrumental in the formation of the General Church and the Academy of the New Church, including John Pitcairn and Bishop William F. Pendleton. Emanuel Swedenborg is the subject of a three-light stained glass window on the east wall. Today, the room can no longer accommodate the church's worldwide clergy for meetings and is used instead as a worship space for families with small children.

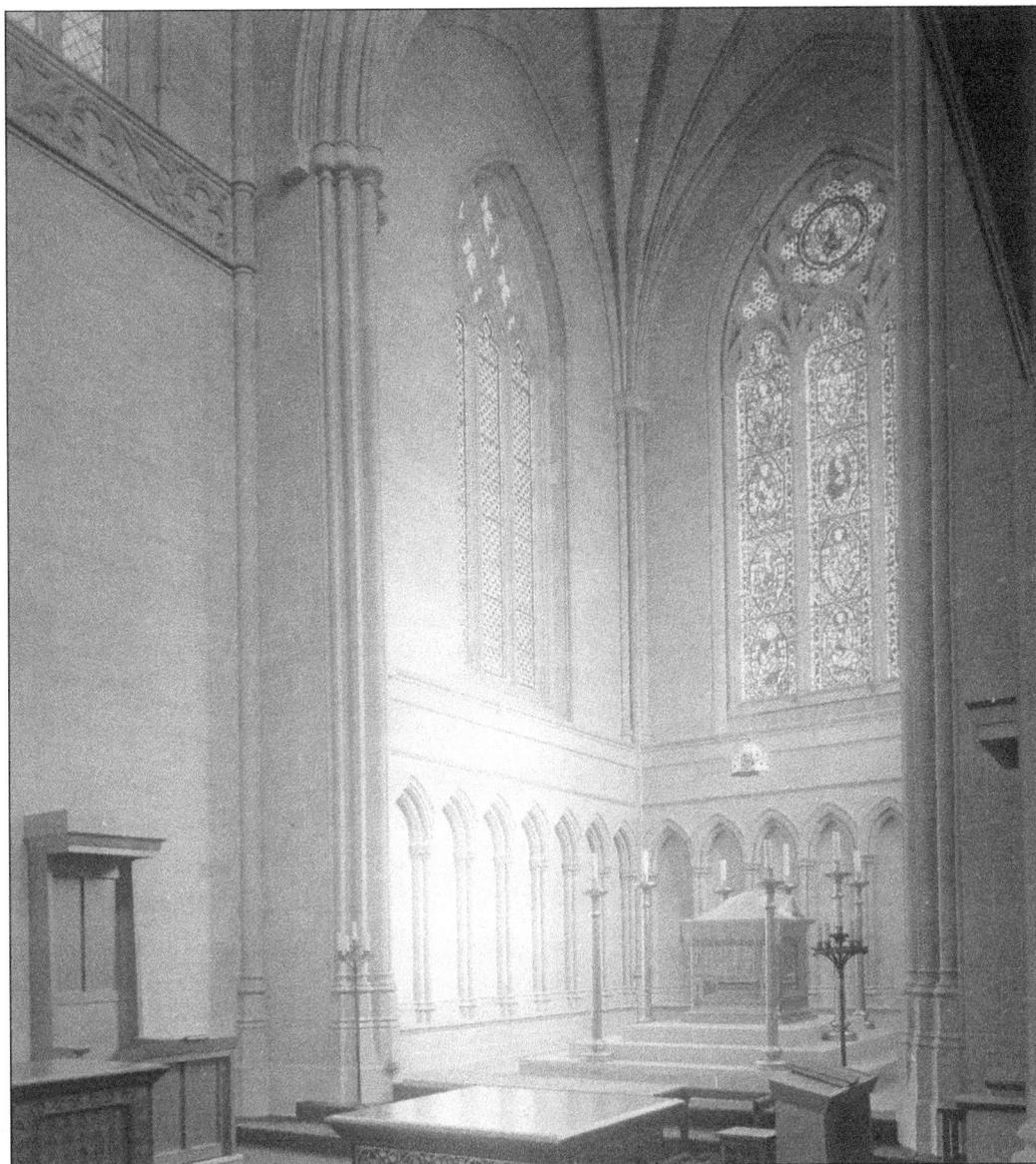

The cathedral's chancel has three sections, each serving a specific function. The outer chancel (not visible here) is for reading, preaching, and the choir; the middle chancel is for communion and baptism; and the inner chancel or sanctuary is for the Word of God (the Bible), which is placed on an altar. The Word is opened at the beginning of church services and remains open until the end. Numbers play an important role in the cathedral's symbolic program; the spiritual meanings of numbers in the text of the Bible are discussed in the theological works of Emanuel Swedenborg. From the nave to the altar platform there are a total of 12 steps. There are also 12 divisions between the ribs of the sanctuary's vaulted ceiling. The Book of Revelation is a key inspiration for the decoration: seven lampstands surround the altar and a crown of 12 stars is suspended above it (no longer in use today). The altar seen here has been replaced by a new one, carved by Jon Alley in the 1990s, with scenes from the Book of Revelation.

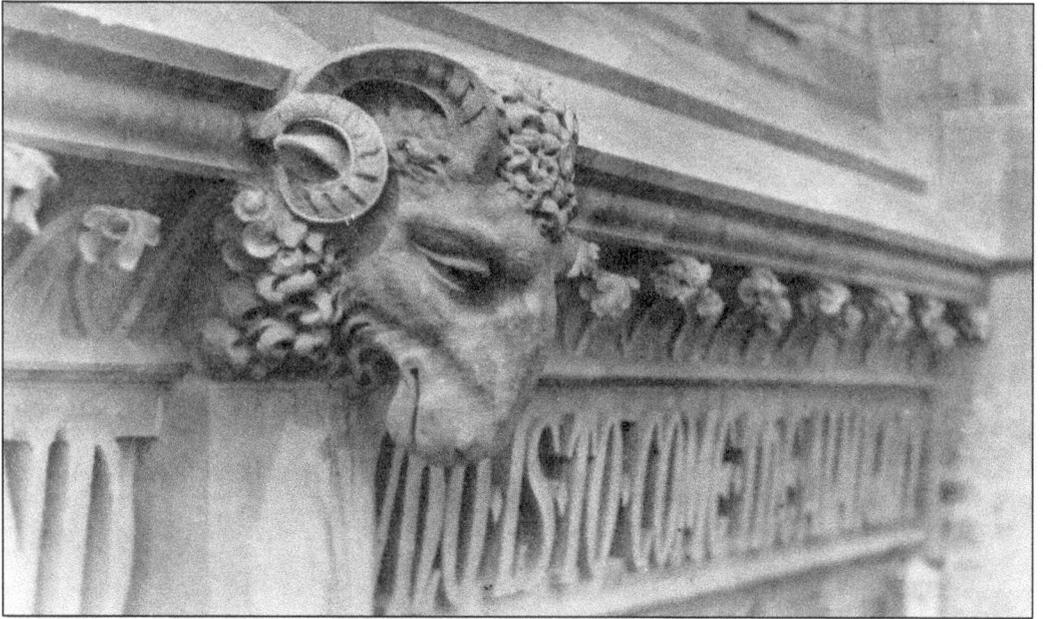

This intricately detailed stone ram was carved in place, high on the south side of the cathedral's main tower. The inscription reads, "Who is and who was and who is to come, the Almighty." This passage and the inscriptions on the other three sides of the tower are adapted from the Book of Revelation (1:6–8).

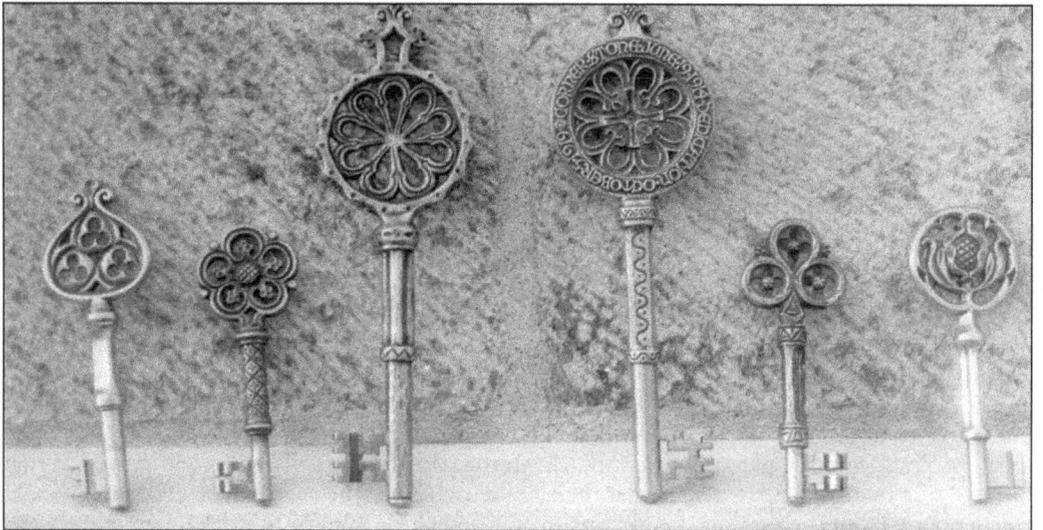

In 1920, Raymond Pitcairn delivered a speech titled, "Christian Art and Architecture in the New Church." In it he describes "the perfection of variety" in which "all things conspire to one end." The result of this principle can be seen in this selection of a few of the cathedral's Monel metal keys. The most elaborate key, designed by Parke E. Edwards (third from right), was presented by Raymond Pitcairn in his capacity as donor to Bishop Nathaniel D. Pendleton during the dedication of the cathedral in 1919. (New Church Life. Bryn Athyn, October 1920: 618.)

Three

Bryn Athyn Glass Studio and Factory

By 1913, construction on a house of worship for the Bryn Athyn community had begun in earnest, and Bryn Athyn Cathedral slowly began to dominate the local skyline. With masons and sculptors already hard at work on the structure itself, Raymond Pitcairn turned his attention to the stained glass windows he hoped would illuminate the cathedral's interior. Pitcairn's goal was to match the textures and brilliant colors of the stained glass found in the great medieval cathedrals of the 12th and 13th centuries.

Unfortunately, the arcane chemical formulas and handblown techniques used by medieval glassmakers had been abandoned by the glass factories of industrialized America. Perpetually dissatisfied with the quality of the available commercial glass, in 1915 Pitcairn hired local artists to experiment with remelting commercial glass over a bed of sand and pebbles in an effort to recreate the irregular textures that give medieval glass so much of its beauty. The experiments were a failure, but these humble attempts to imitate the special qualities of medieval glass marked the beginning of a quest that lasted for the next 30 years.

Pitcairn made national headlines in 1921 when he purchased 23 panels of medieval stained glass at an auction from the renowned collection of Henry C. Lawrence. These panels were intended as a source of information and inspiration for the growing number of artists and craftsmen he was employing in his quest to rediscover the techniques of medieval glassmakers. As progress continued on the cathedral, Pitcairn expanded his medieval glass purchases; in time his collection grew to include more than 260 panels.

In 1922, Raymond Pitcairn established a factory for producing stained glass across the street from the cathedral. The windows were designed and painted in a makeshift studio set up in Cairnwood's garden house. By the time the glass factory closed in 1942, it had produced glass for all of the windows in Bryn Athyn Cathedral, as well as stained glass and glass mosaic for Glencairn, Pitcairn's own home. Bryn Athyn's stained glass artists continued producing windows for the cathedral into the 1960s.

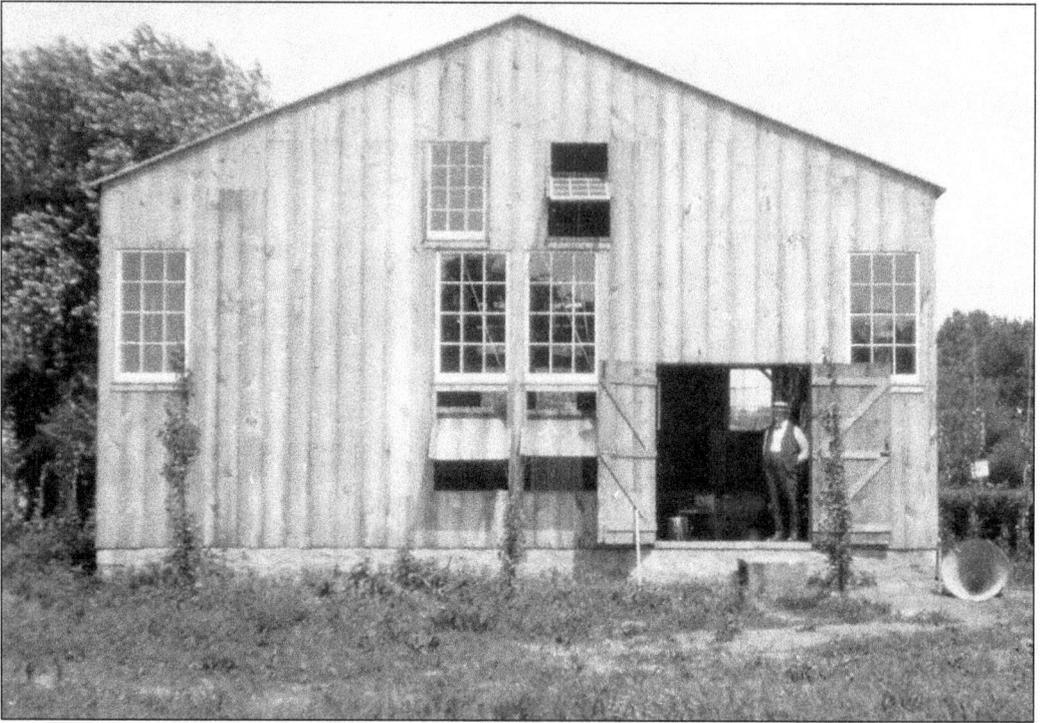

David Smith, glassblower, stands in the doorway of the Bryn Athyn glass factory. In 1916, Raymond Pitcairn met John A. Larson, a Swedish immigrant descended from a family of master glassblowers. Larson had set up his own glass factory in New York City, and Pitcairn employed him to conduct experiments in replicating medieval glassmaking techniques. In an effort to duplicate the original colors and textures, Larson studied medieval stained glass collections in New York City and later Pitcairn's own collection. Pitcairn built his own stained glass factory just across the road from Bryn Athyn Cathedral. The factory made its first batch of glass on July 5, 1922, and Larson stayed on to manage the operation until 1925. The factory was in continuous operation until April 1942. The building was torn down in the 1950s. (Above, courtesy of Carol Terry.)

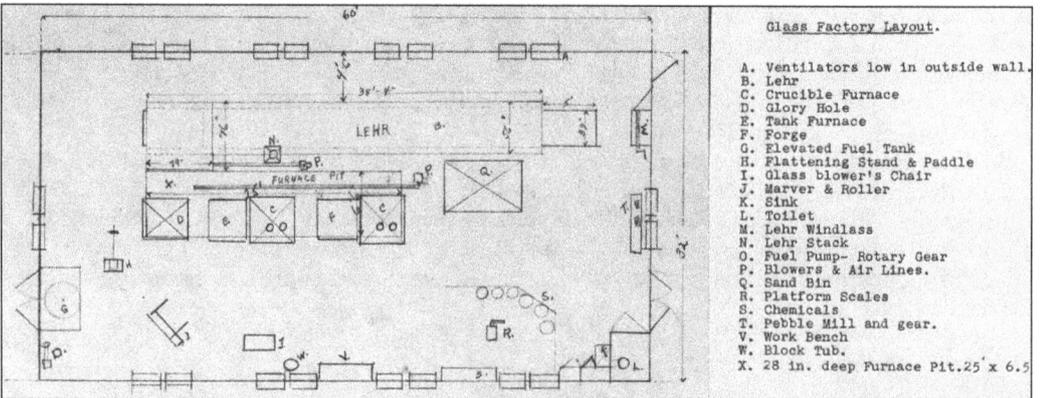

Glass Factory Layout.

A. Ventilators low in outside wall.
B. Lehr
C. Crucible Furnace
D. Glory Hole
E. Tank Furnace
F. Forge
G. Elevated Fuel Tank
H. Flattening Stand & Paddle
I. Glass blower's Chair
J. Marver & Roller
K. Sink
L. Toilet
M. Lehr Windlass
N. Lehr Stack
O. Fuel Pump- Rotary Gear
P. Blowers & Air Lines.
Q. Sand Bin
R. Platform Scales
S. Chemicals
T. Pebble Mill and gear.
V. Work Bench
W. Block Tub.
X. 28 in. deep Furnace Pit.25' x 6.5

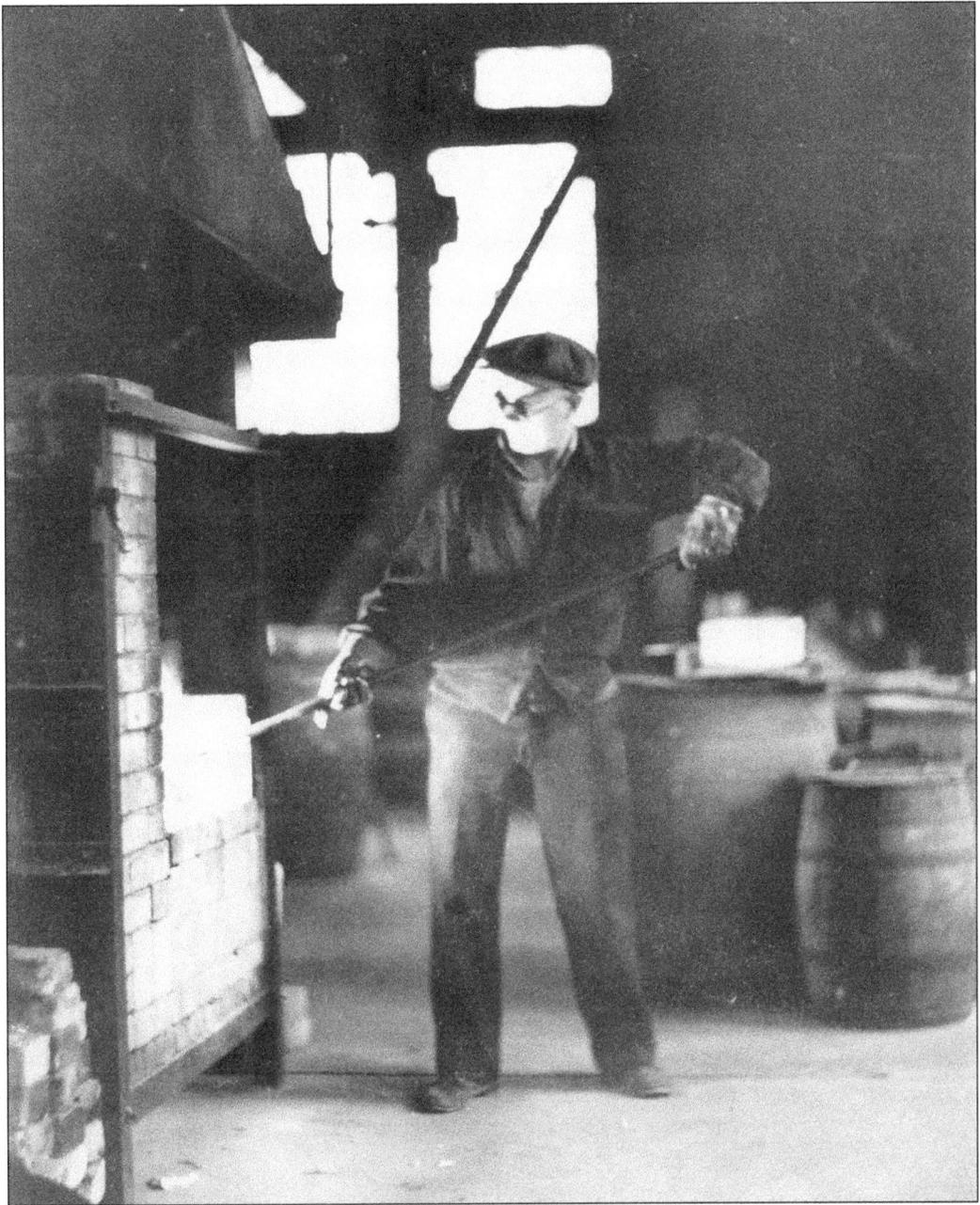

Assisting John Larson at the factory were David Smith, a Swedish glassblower whom Larson had brought from his New York factory, and Ariel C. Gunther (above), a member of the New Church congregation in Bryn Athyn who had been hired as an apprentice. Pitcairn offered Gunther a job in 1922, just after he graduated from the Academy of the New Church Boys School in Bryn Athyn. Only 19 years old when he began the work, Gunther was closely involved in the experiments that took place during Larson's tenure at the factory. When Larson left the project in 1925, Gunther took over management of the factory and continued to perfect the color formulas. Gunther was in charge of constructing furnaces, the chemical composition of the glass batches, and the overall supervision of the factory. He remained with the factory until it closed in 1942.

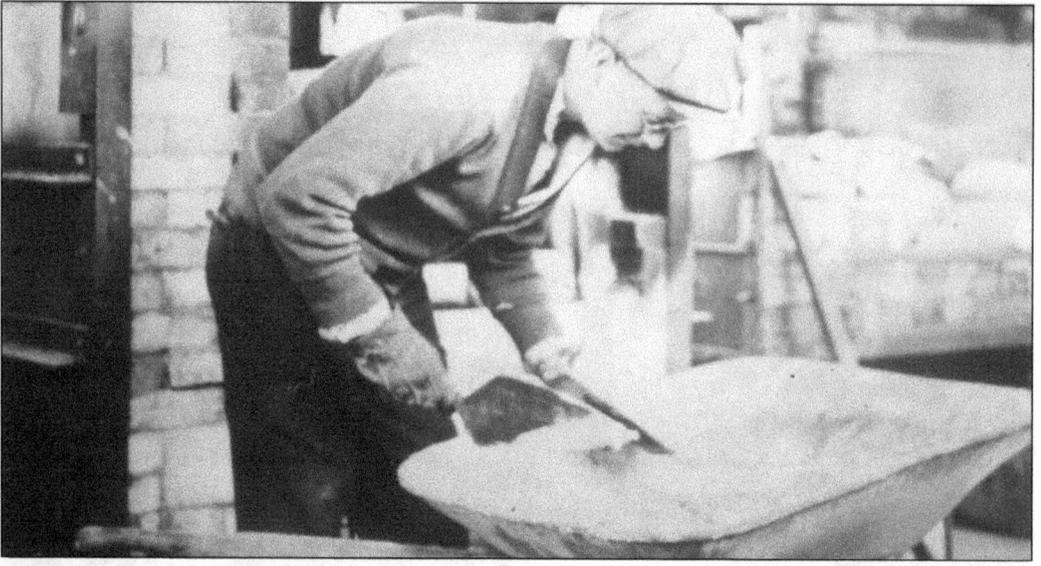

Ariel Gunther mixes together ingredients for glassblowing in the glass factory. Medieval stained glass and the variety of glass made in Bryn Athyn is known as "pot metal" glass. The three main ingredients—sand, sodium carbonate, and lime—produce a clear glass when melted at high temperatures. The colors are achieved by introducing metallic oxides such as iron, copper, gold, and silver in various ratios and quantities.

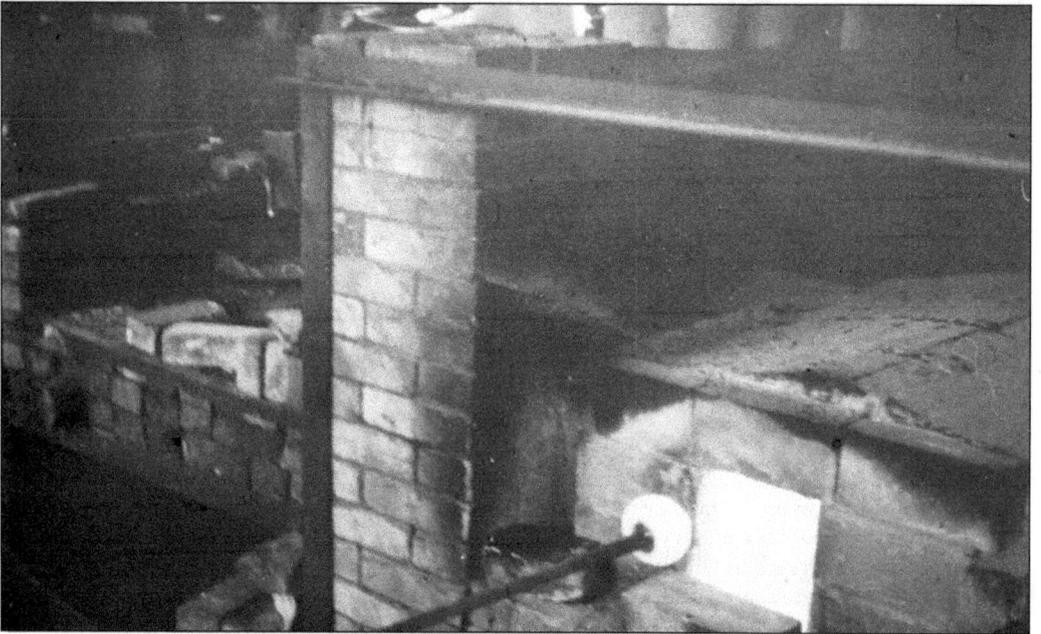

The temperature in the furnace and the length of firing time are extremely important. Certain colors require a hot, fast fire, while others are melted at lower temperatures for a longer period of time. The process of blowing glass begins when a large "gather" of molten glass is wound onto the end of a "blowpipe" (a hollow metal rod).

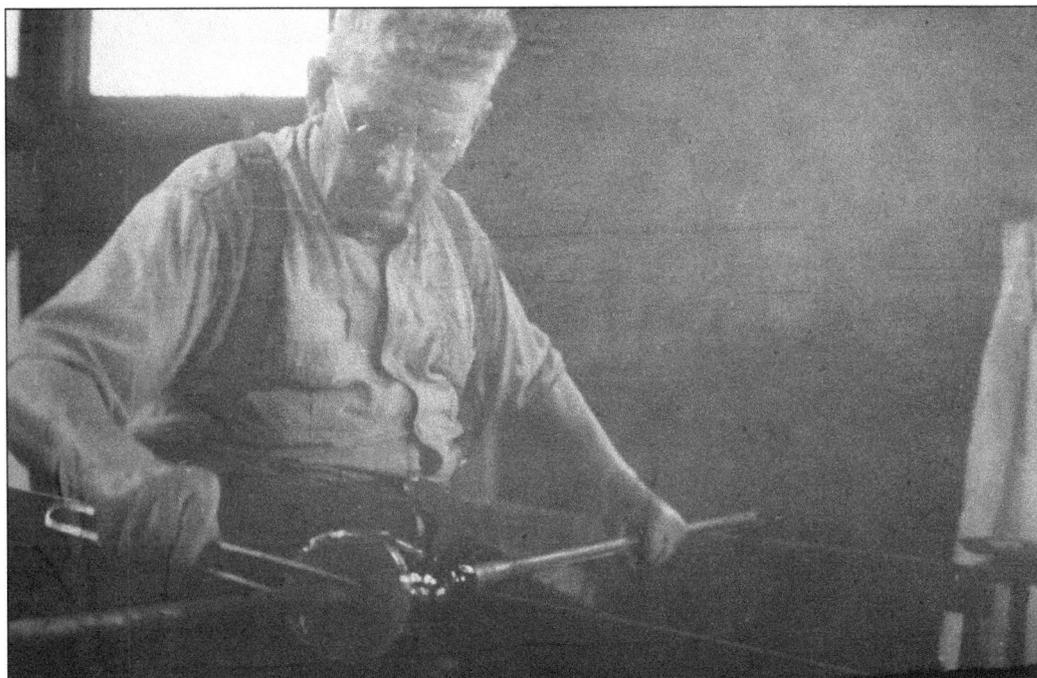

David Smith works at the glassblower's bench. Smith began work in Sweden in his grandfather's lamp chimney factory at the age of six. He immigrated to the United States as a young man and, after working for a time as a glassblower in New York, came to Bryn Athyn in July 1922. Smith stayed on at the factory until it closed 20 years later. He was 78 years old when he blew his last batch of Bryn Athyn glass on April 10, 1942.

Two principal methods of glassblowing were eventually perfected in the Bryn Athyn glass factory: the cylinder method and the rondel method. While the cylinder method provided more square inches of glass, the rondel method (above) was useful for its distinctive optical qualities.

The innumerable designs for stained glass windows produced by the Bryn Athyn glass studio were made in the former garden house at Cairnwood. This small building had large windows, providing natural light in which to view the stained glass. It also provided the artists with a striking view of the cathedral across a sweeping lawn. (Photograph by Diane Fehon.)

Early in the work of preparing for Bryn Athyn Cathedral's stained glass windows, Raymond Pitcairn enlisted the help of Winfred S. Hyatt (above), a young art student from a New Church family. Even as he pursued his studies, Hyatt was chosen to be a member of the cathedral's symbolism committee, which was charged with developing the subject matter for the cathedral's stained glass windows and sculptures. Hyatt, who was working on designs for windows as early as 1915, was also put in charge of the stained glass studio in Cairnwood's garden house (see photographs above and below). He produced hundreds of original cartoons and sketches and did most of the glass painting on the final windows. Hyatt continued in this capacity until his death in 1959. (Below, photograph by Diane Fehon.)

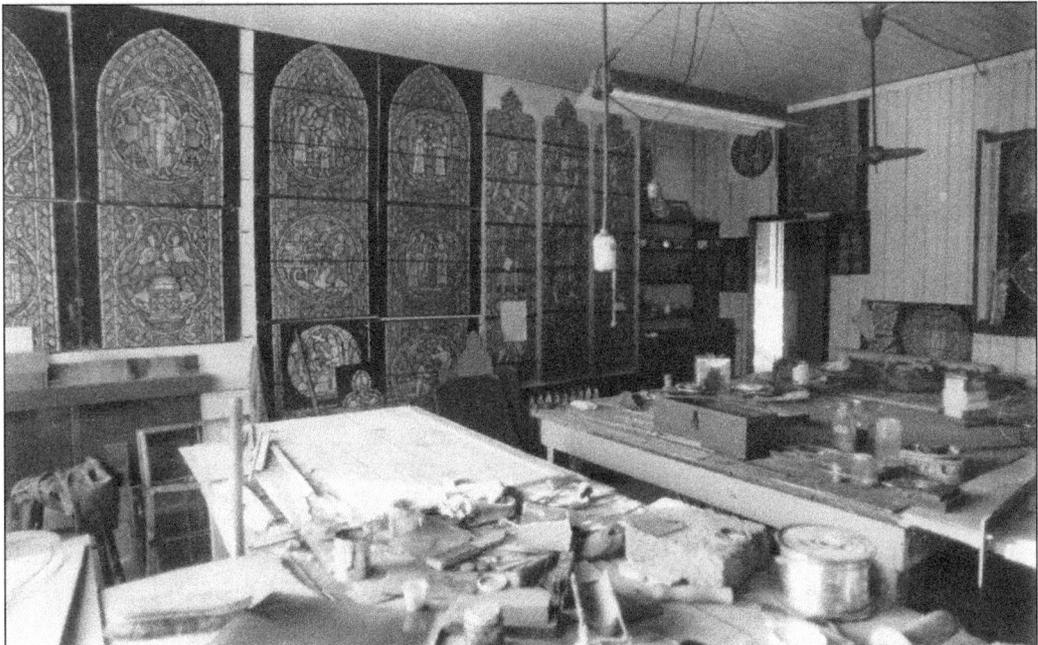

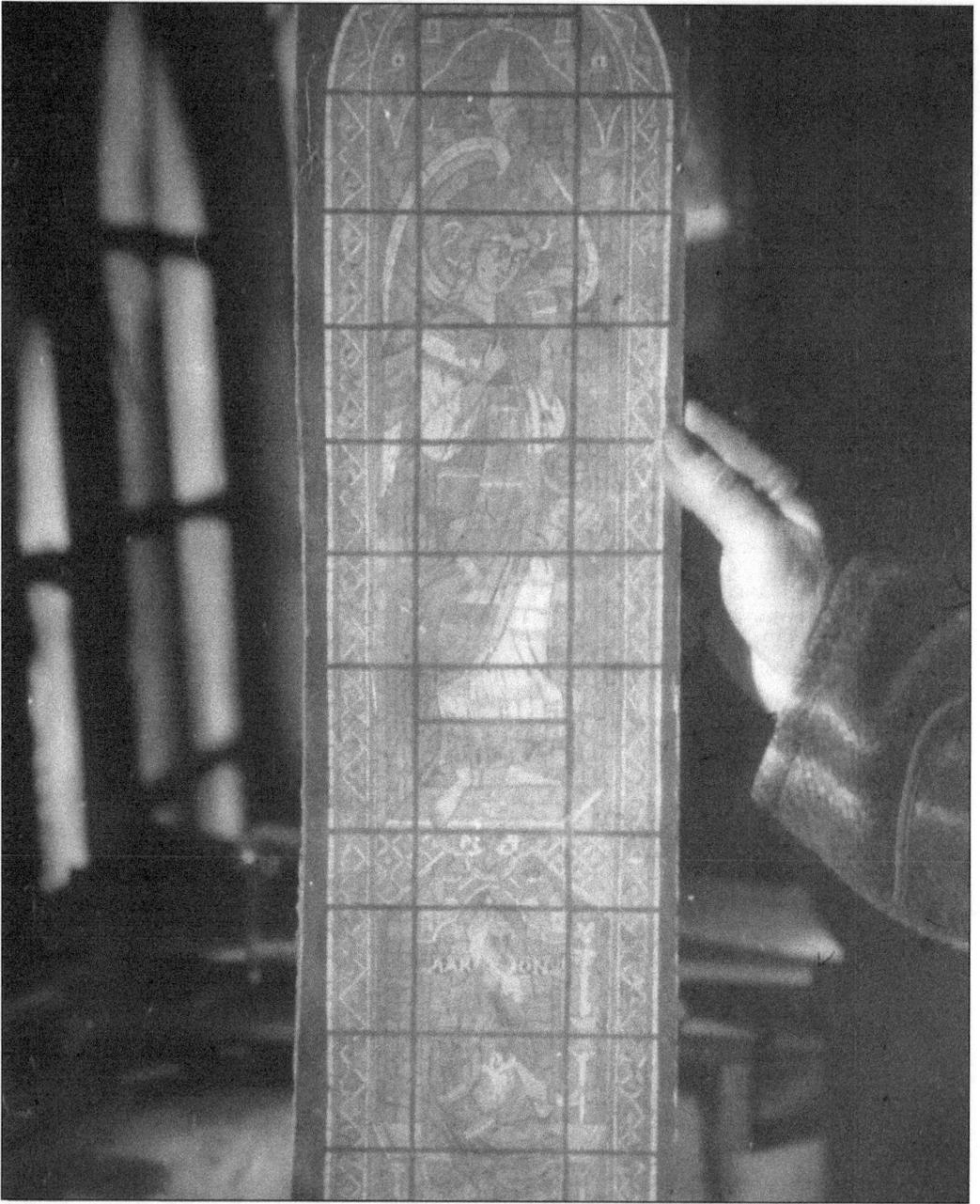

This scale watercolor design, adapted from a stained glass window in Chartres Cathedral in France, was used in the creation of the central lancet window in the north wall of Glencairn's great hall. Each stained glass window made for Bryn Athyn Cathedral and Glencairn went through a meticulous design process—from sketch, to scale version in watercolors, to full-sized cartoon—before the glass was cut and the window assembled. In the case of the cathedral, the subject matter of a window first had to be finalized by the symbolism committee, a process which in itself could take a great deal of time. Preliminary pencil sketches were submitted by the artists and evaluated by members of the committee until one was chosen.

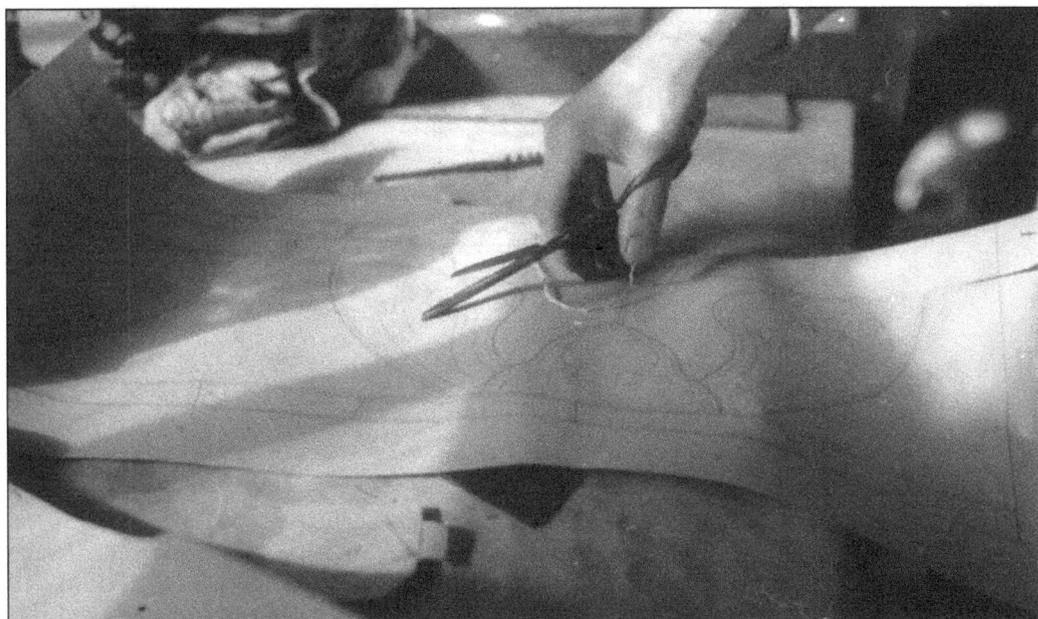

After the design of a window was finalized, the full-sized painted drawing, which included lead lines, was traced onto heavy brown paper (above). The tracing was then cut up into individual pieces with a special pair of shears that reduced the size of each piece to account for the width of the leads so the window would be the correct size when assembled. Each piece of paper was then matched to a panel of glass of the appropriate color (below). Each handblown panel produced in the Bryn Athyn factory was individual in tone and texture, making it possible for the artist to select the appropriate piece of glass as required by the design.

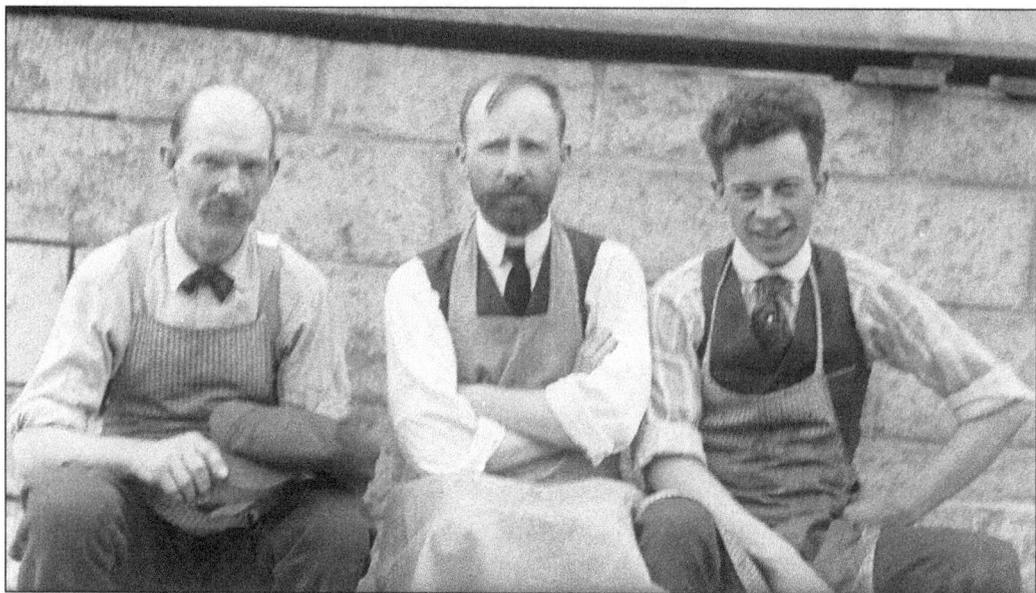

Lawrence B. Saint (center) was hired by Raymond Pitcairn to design and paint windows and also to conduct research and experimental work. Saint worked on the Bryn Athyn project from 1917 until 1928, when he left to begin work on the National Cathedral in Washington, DC, where he served as director of the stained glass department.

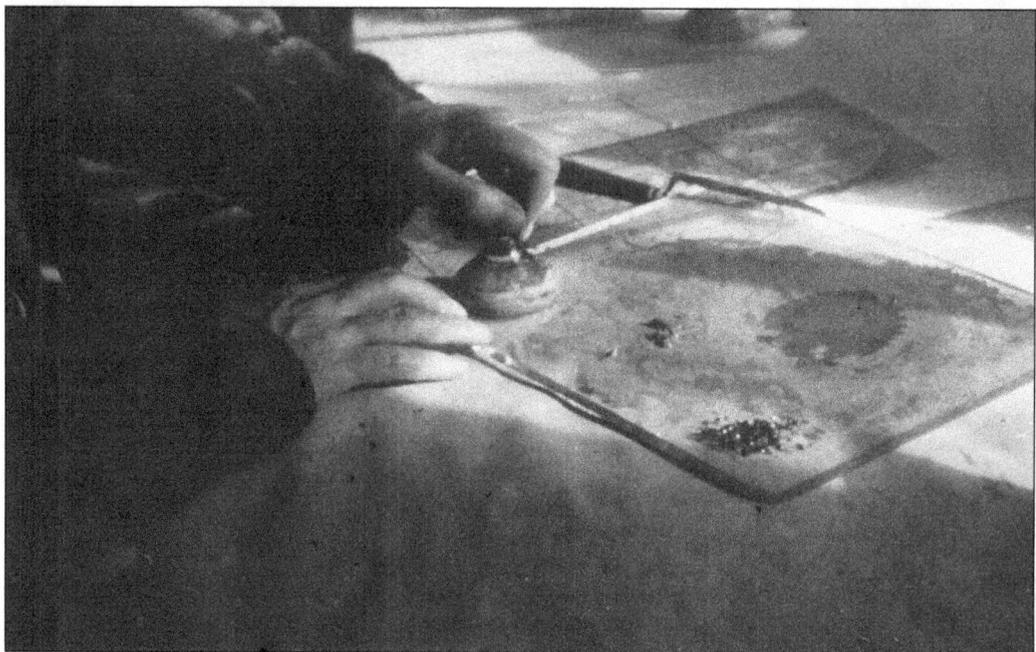

The glass paint used to create the faces and other details in medieval stained glass was something of a chemical mystery. After much experimentation, Lawrence Saint developed his own paint formula. Glass frit and metallic oxide were melted together in a tiny porcelain crucible using an electric furnace. The resulting mixture was crushed to produce a powdered glass paint. The glass grinder above, known as a "muller," was used to mix the glass paint with a liquid so it could be applied with a paintbrush.

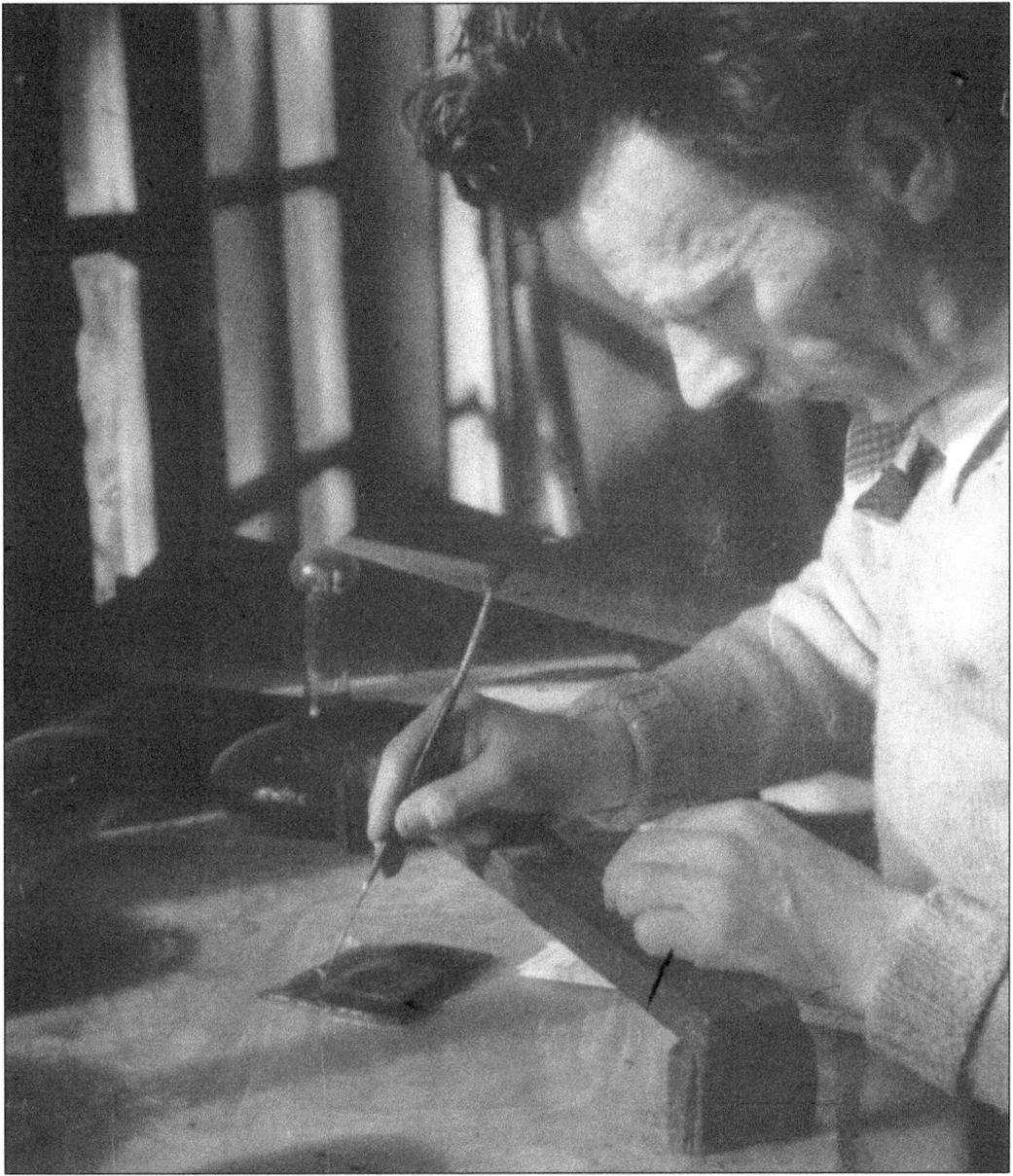

Once the pieces of glass were cut, the Bryn Athyn artists carefully painted on the faces, hands, feet, and other details. Next, the pieces were fired in a small electric kiln, bonding the paint to the glass. In the photograph above, Albert E. Cullen paints a piece of glass using a "bridge" to steady his hand. Cullen, born in England, was originally hired by the Bryn Athyn project to make tracings and paintings of windows at Canterbury, Chartres, and other cathedrals—a job that was not without its challenges. In one incident, Cullen was badly bruised after falling from a ladder, prompting the authorities to remove the scaffolding completely. Another time, as he recalled in a letter to Jennie Gaskill written on August 30, 1971, "I dropped a bottle of ink on top of a confessional box while [the] priest and confessor was inside." This created "quite a furore," but "Abbe de la Porte was pretty nice about it and seemed highly amused." In 1928, he came to America to work for the Bryn Athyn stained glass studio. (Glencairn Museum Archives.)

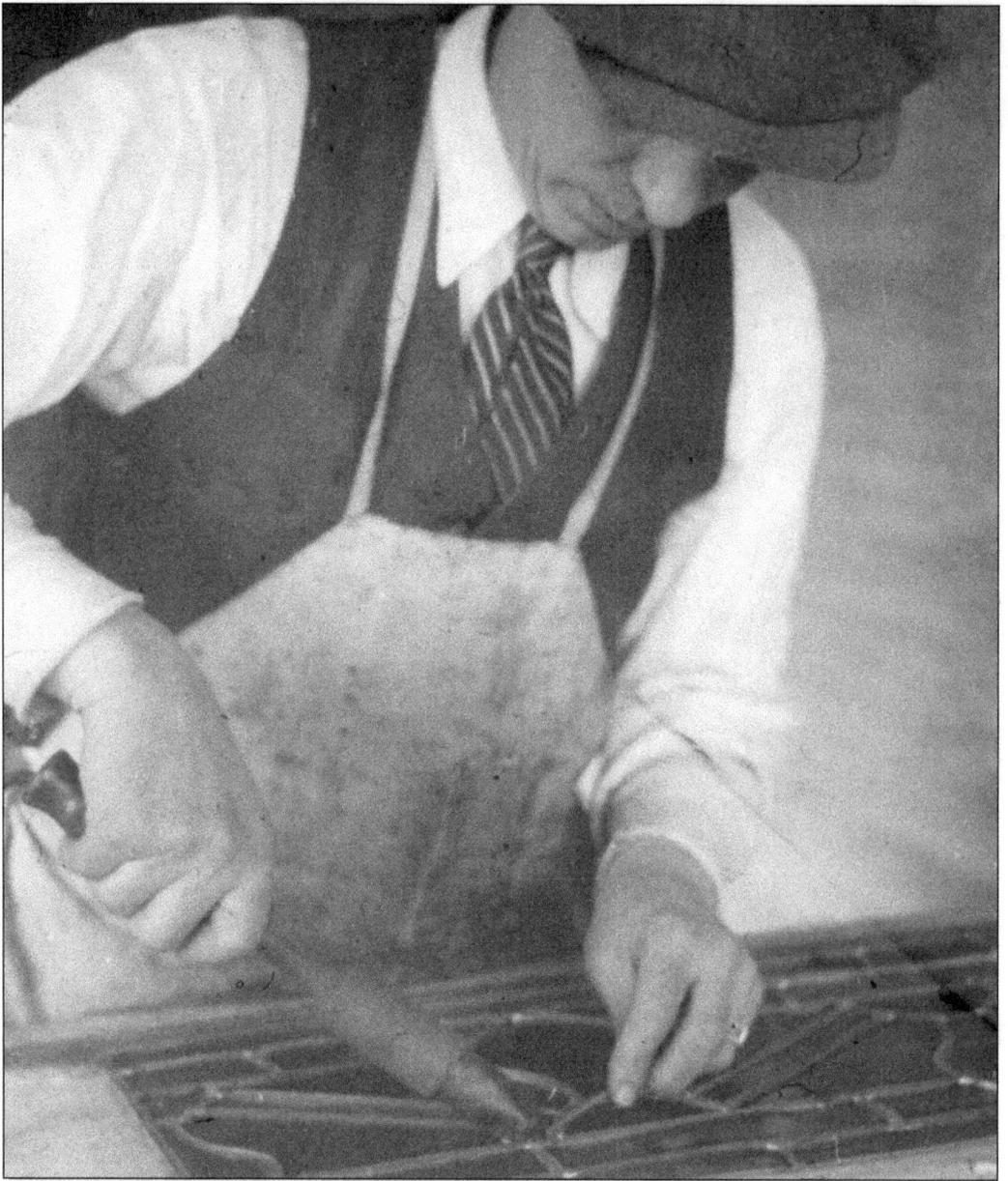

The glazier cut out individual pieces of glass using a glass cutter. He then assembled the various elements of the window with pieces of lead. Lead "came" was purchased in six-foot lengths. The came was shaped like a tiny I-beam with a channel on each side for the glass to fit into. Once assembled, the joints were soldered on both sides of the window (above). Next, in order to make the window weatherproof, the edges of the leading were lifted up and a special putty was poured onto the glass and scrubbed into the spaces. The leads were then pressed down and the putty was allowed to set before the window was mounted in its final space in Bryn Athyn Cathedral or Glencairn.

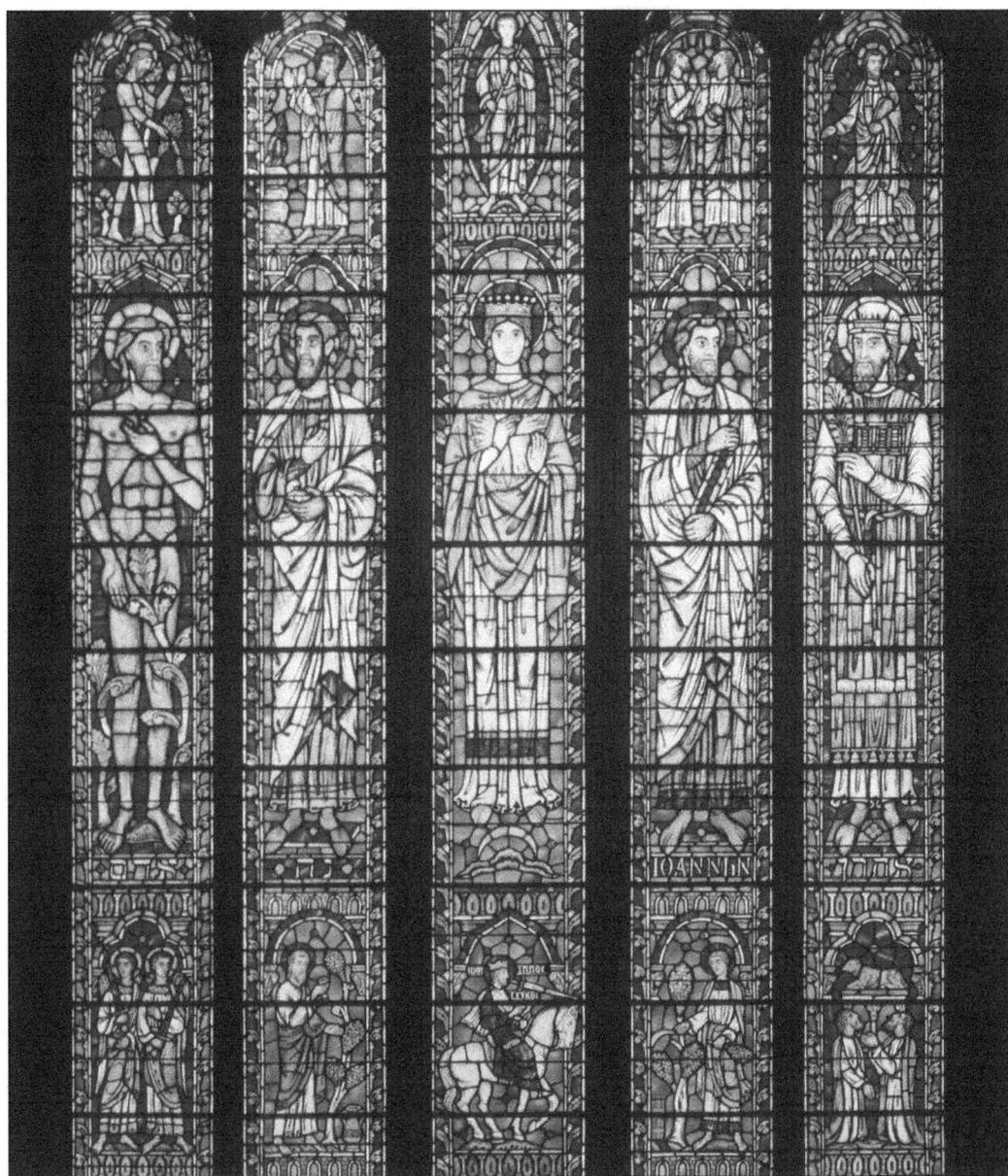

This window, located above Bryn Athyn Cathedral's west portal, was made in the Bryn Athyn stained glass studio and factory. From left to right, the biblical characters represented in the center panels are Adam, Noah, the woman clothed with the sun (Book of Revelation 12:1), John the Evangelist, and Aaron. Stained glass windows have been an essential part of medieval cathedrals since the beginning of the 12th century. Abbot Suger (d. 1151), of the Abbey Church of St. Denis in France, had expounded a theory of "divine light." Suger viewed the sunlight streaming through the walls of colored glass as symbolic of heavenly light and a means to union with God.

Many of the walls and ceilings in Glencairn are decorated with intricate glass mosaics, designed and produced in the Bryn Athyn glass studio and factory. A great deal of experimentation was needed to recreate the visual effect of 5th-century Byzantine mosaics, which Raymond Pitcairn regarded as the highest form of the art. Above, gold mosaic is made by encasing a sheet of gold leaf between two layers of glass. Below, individual pieces of mosaic tesserae are cut using a scutch hammer.

To support the weight of Glencairn's roof, which is made of poured concrete, the ceiling was spanned with large steel trusses, which were then covered with mosaic. Designs for the Glencairn mosaics were produced by Robert Glenn and Winfred S. Hyatt. Once a design was completed, it was transferred to a sheet of heavy paper and the individual pieces of mosaic tesserae were glued to it. The mosaic sheets were then pressed into wet cement, the paper and glue washed away, and the tesserae were grouted. In the photograph above, Samuel Croft II is preparing yellow mosaic stars for the blue ceiling of the great hall. According to Pitcairn, "The effect of this rich blue ground with the gold stars set off, or framed, by mosaic covered beams done in rich color is really thrilling." (Quoted in E. Bruce Glenn, *Glencairn: The Story of a Home*. Bryn Athyn, 1990: 68.)

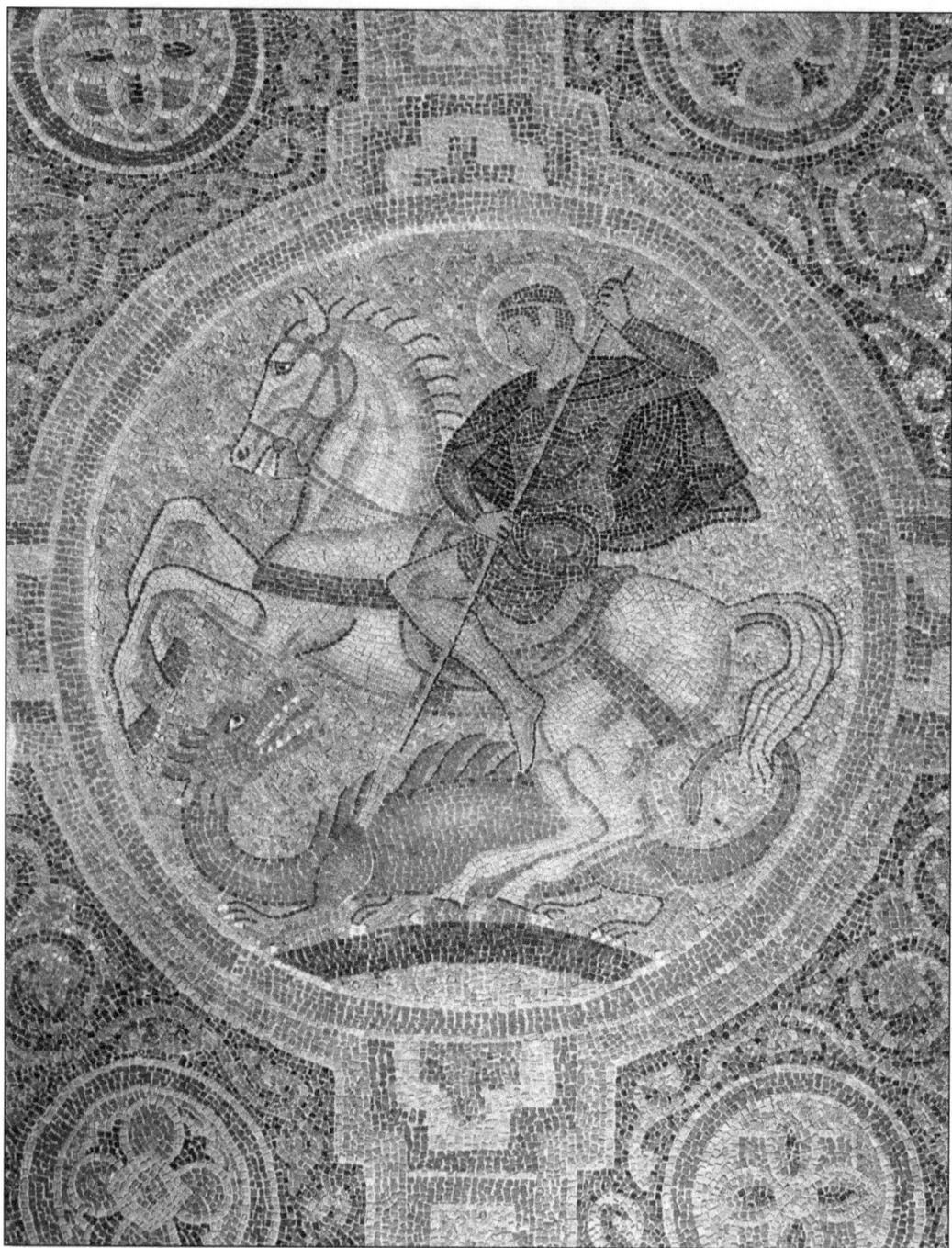

This mosaic of Michael slaying the dragon illustrates a passage from the Book of Revelation (12:7), "And war broke out in heaven: Michael and his angels fought with the dragon; and the dragon and his angels fought." Measuring more than three feet in diameter, this is one of four medallions in a monumental mosaic depicting the seal of the Academy of the New Church. The mosaic surrounds the large arch in Glencairn's great hall. (Photograph by Barry Halkin.)

Four

CAIRNCREST

Harold F. Pitcairn, the youngest child of John and Gertrude, was born at Cairnwood in 1897. From an early age, Harold exhibited a strong interest in aviation, inspired by the successes of the Wright brothers. As a young teenager he designed, built, and attempted to fly a full-sized glider from the highest hill in Bryn Athyn; the glider was pulled down the hill on a sledge by ponies. Pitcairn was attending the Curtiss Flying School in Virginia in 1916 when his father died and he was called home to Bryn Athyn. The next year he volunteered his services to the War Department and was posted to the School of Military Aeronautics in Texas in 1918. Pitcairn was still in training when World War I ended.

In June 1919, Harold Pitcairn married Clara Davis and together they began a family that eventually included nine children. For the design of Cairncrest, their Bryn Athyn estate, Harold's brother Raymond offered the services of his architectural studio. The initial plans drawn up in Bryn Athyn were passed on to architects Llewellyn R. Price and Wetherill P. Trout for further development, but Raymond remained closely involved in the project. The construction of Cairncrest was carried out by Synnestvedt and Leonard, a local building firm, between 1926 and 1928.

In the early 1920s, Harold Pitcairn decided to pursue aviation as a career. He formed two different companies and built a flying field in Bryn Athyn. One company successfully developed the Pitcairn Mailwing, a rugged biplane designed to carry mail on the newly opened airmail routes. Pitcairn then turned his attention to the emerging field of rotary wing flight. He obtained the American rights to the Autogiro, invented by the Spanish aeronautical engineer Juan de la Cierva, and spent years developing, manufacturing, and refining the design. Pitcairn's company patented many concepts in rotor blade design that were later utilized in the development of the helicopter. Examples of the Pitcairn Mailwing and the Pitcairn-Cierva Autogiro are now in the collection of the Smithsonian Institution.

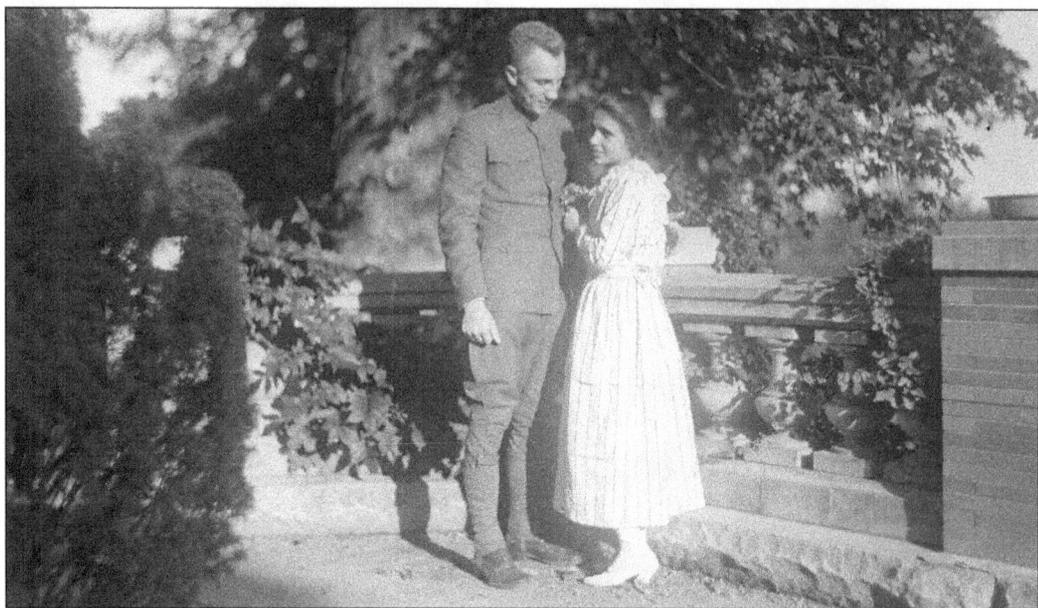

Harold F. Pitcairn and his fiancée, Clara Davis, were photographed by Raymond Pitcairn on Cairnwood's south terrace in the fall of 1918. Harold, a cadet at the time, was home on leave from the School of Military Aeronautics in Texas. Clara served as a member of the Academy of the New Church War Service Committee.

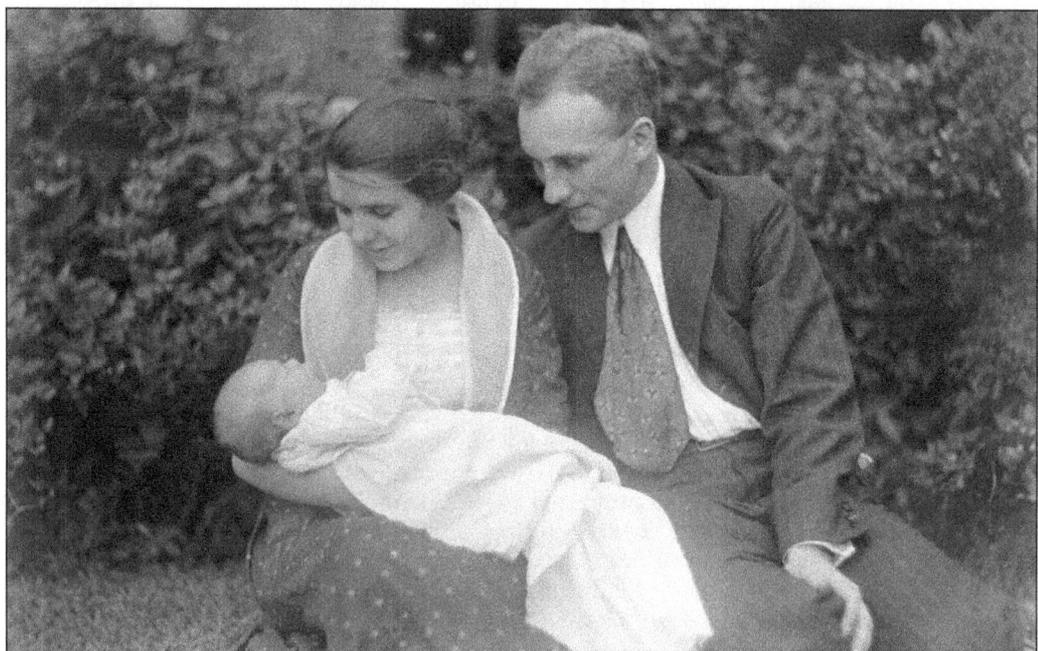

Harold Pitcairn and Clara Davis were married in Bryn Athyn on June 21, 1919, and spent their honeymoon at Onteora Park in the Catskill Mountains of New York. In the summer of 1920, their first child, Joel, was born and the young family was photographed on the grounds of Cairnwood. Their formal dress and the baby's long gown suggest that this photograph was taken at the time of Joel's baptism.

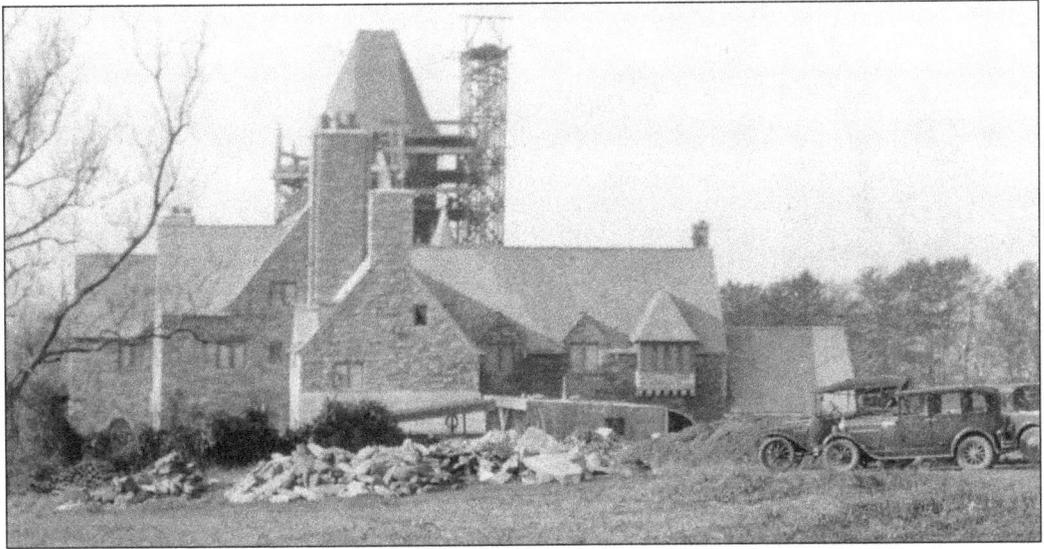

The construction of Harold and Clara Pitcairn's home, Cairncrest, is well underway in this photograph. The Bryn Athyn contracting firm of Synnestvedt and Leonard built the home between 1926 and 1928. The architectural plans for the residence had been undertaken in 1924 and were the result of a collaboration between the Bryn Athyn architectural studio, under the auspices of Raymond Pitcairn, and architects Llewellyn R. Price and Wetherill P. Trout. (Courtesy of the Harold and Clara Pitcairn family.)

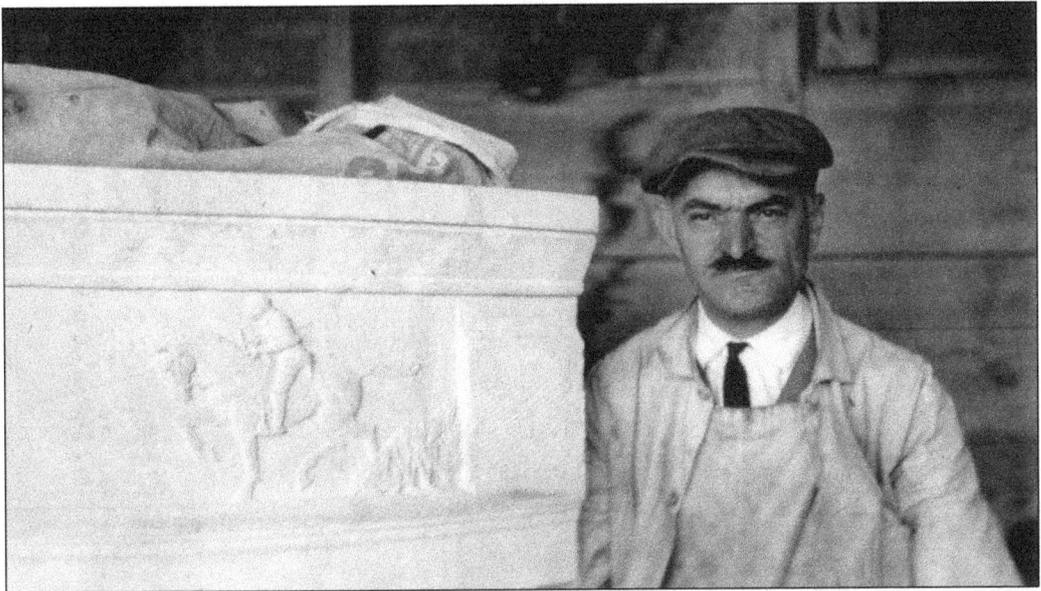

The first floor of Cairncrest was designed with a playroom at one end for the Pitcairn children. Murals depicting scenes from fairy tales decorate the walls from floor to ceiling. A fireplace with a hooded mantle, carved with a knight on horseback charging toward a dragon, occupies one corner of the room. In this photograph, an unidentified craftsman, perhaps the sculptor, poses with the mantle during construction. (Courtesy of the Harold and Clara Pitcairn family.)

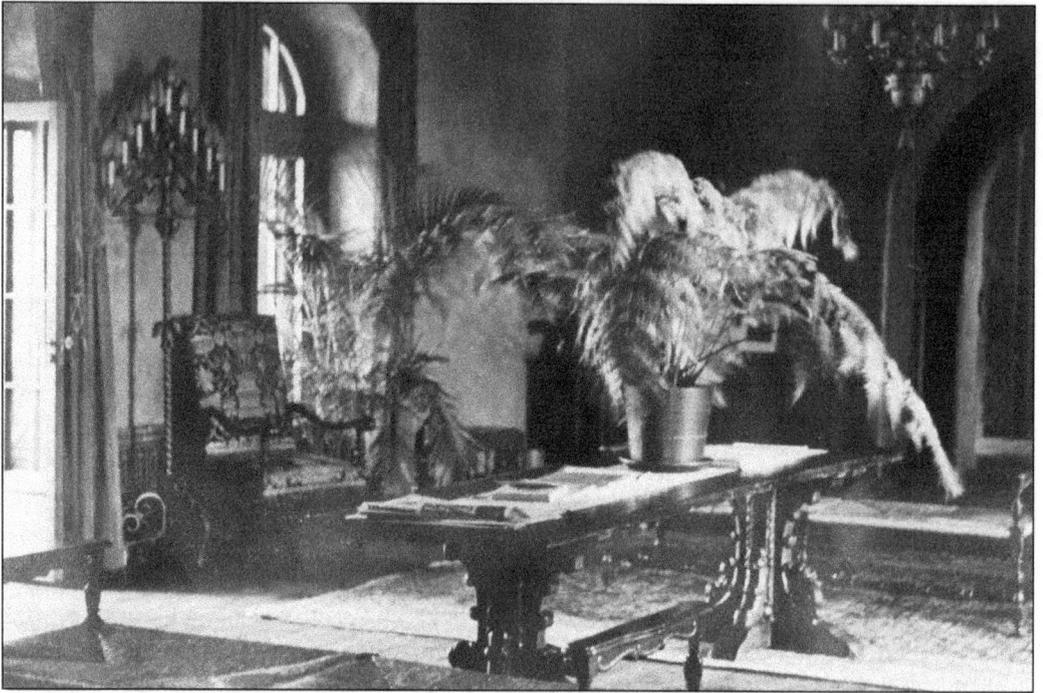

The New York firm of Anne Renner was responsible for the furnishing and decoration of Cairncrest. Renner had a number of other notable clients, including Thomas Edison's wife, Mina, and Alfred P. Sloan Jr., the president of General Motors. The main hall (above) was lit with a hanging chandelier and electric candelabra and was floored with Mercer Moravian tiles. (Courtesy of the Harold and Clara Pitcairn family.)

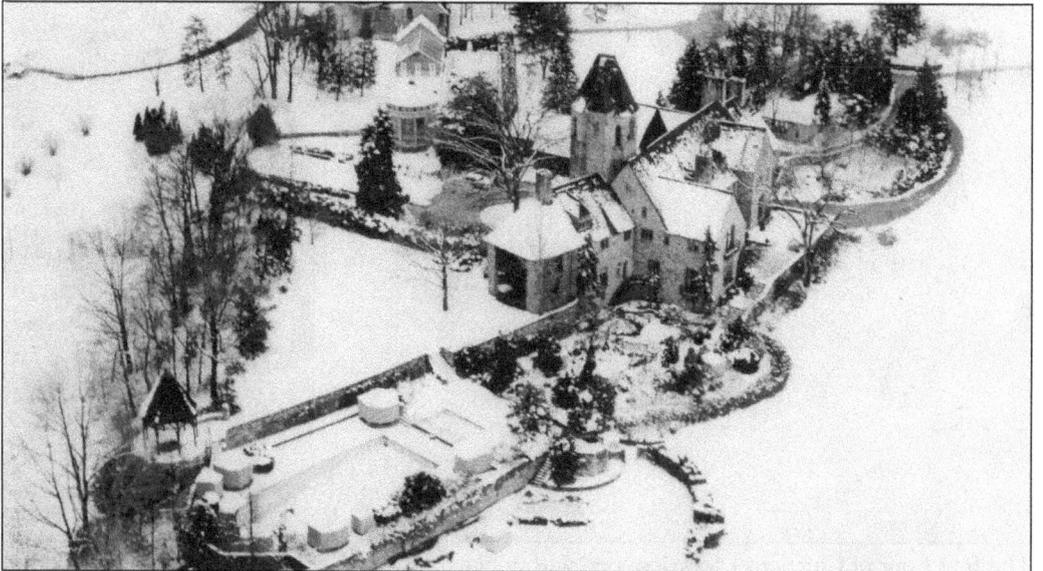

This aerial view of the Cairncrest estate, photographed in winter, reveals the outlines of the grounds and buildings. The estate included the main house and terrace, a swimming pool with a gazebo, a garage, a greenhouse, a palm house, a parterre, and a rose garden outlined with boxwood hedges. (Courtesy of the Harold and Clara Pitcairn family.)

The Cairncrest grounds, as originally designed, were the work of Arthur Westcott Cowell, a landscape architect from State College, Pennsylvania. Cowell is known for his design work at a number of sites in Pennsylvania, including the state park at Washington's Crossing and Bowman's Hill Tower. By June 1931, when these two photographs were taken, the Cairncrest garden plantings were well established. On the south side of the house (below) a well-maintained parterre included a planting bed with an elaborate geometric design created out of boxwood. This bed and another like it were positioned at opposite ends of a reflecting pool. The roof of the gazebo, located beside the swimming pool, can be seen on the upper level. (Both courtesy of the Pennsylvania State Archives; photographs by Mattie Edwards Hewitt.)

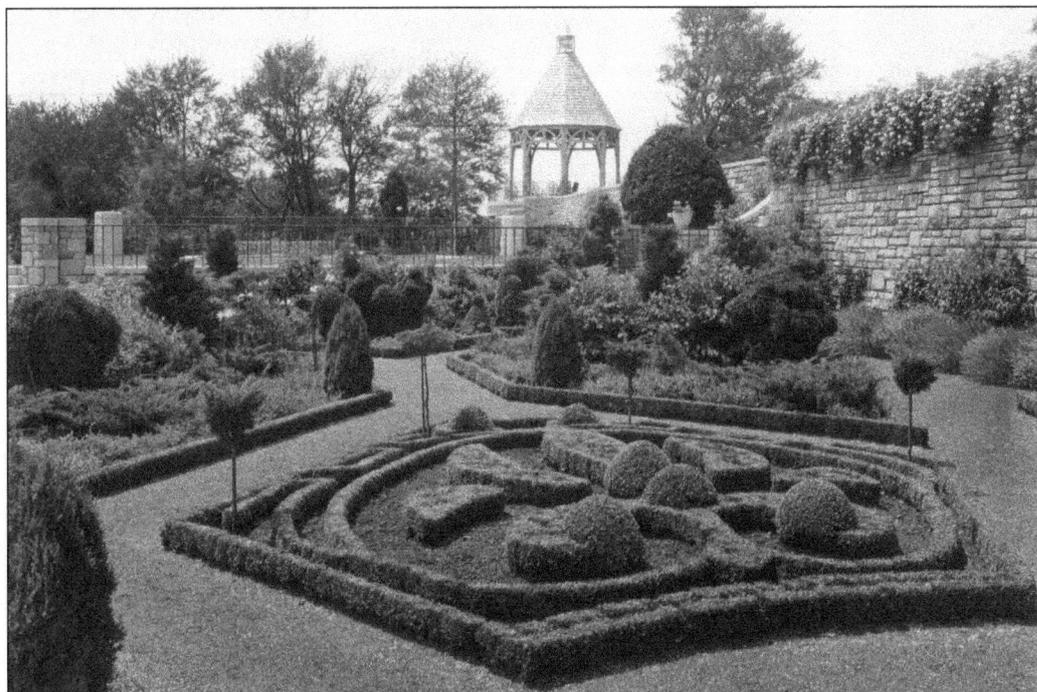

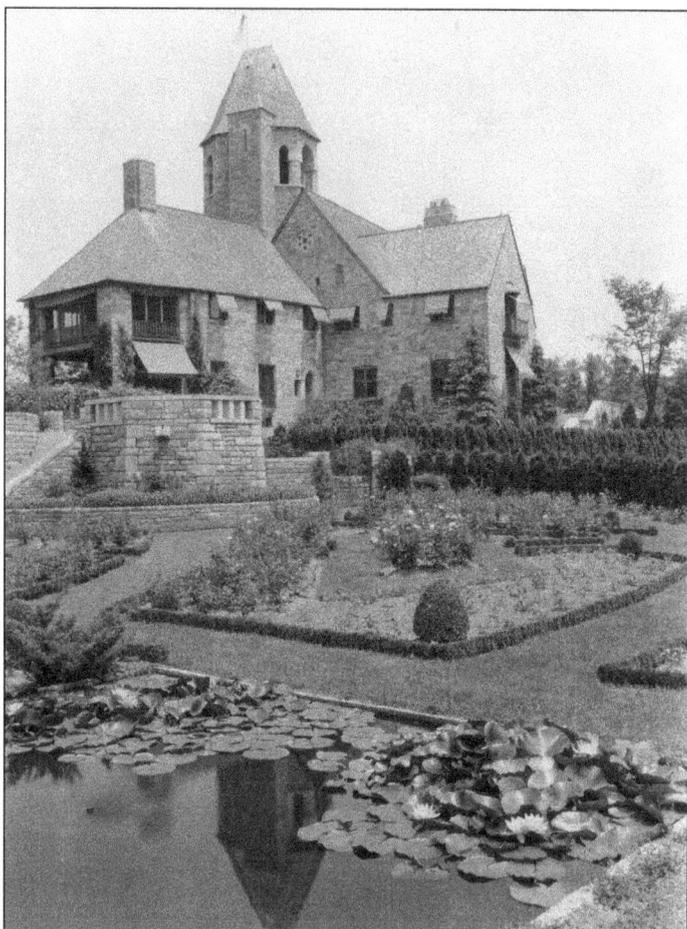

A lily pond was situated in the rose garden on the south side of the house. A walled overlook, visible in the background, afforded a view of the lower gardens and surrounding fields. Clara Pitcairn enjoyed flower arranging, and the rose garden provided her with a steady supply of cut flowers in season. (Courtesy of the Pennsylvania State Archives; photograph by Mattie Edwards Hewitt.)

Robert R. Pitcairn, son of Harold and Clara, sits on a stone block beside the lily pond in the summer of 1931. Like Cairnwood and Glencairn, the grounds of Cairncrest offered an excellent view of Bryn Athyn Cathedral. (Courtesy of the Harold and Clara Pitcairn family.)

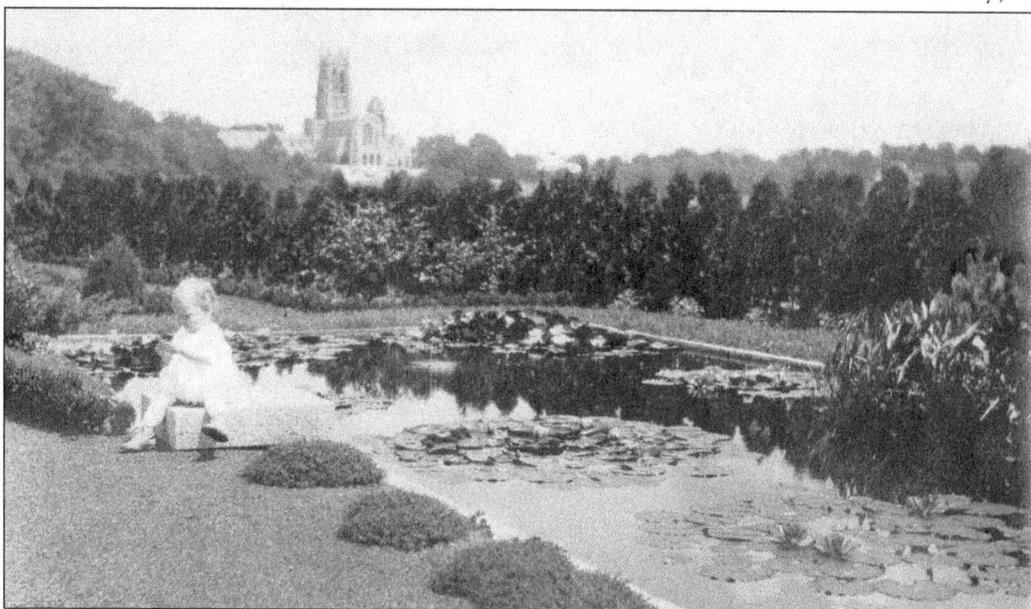

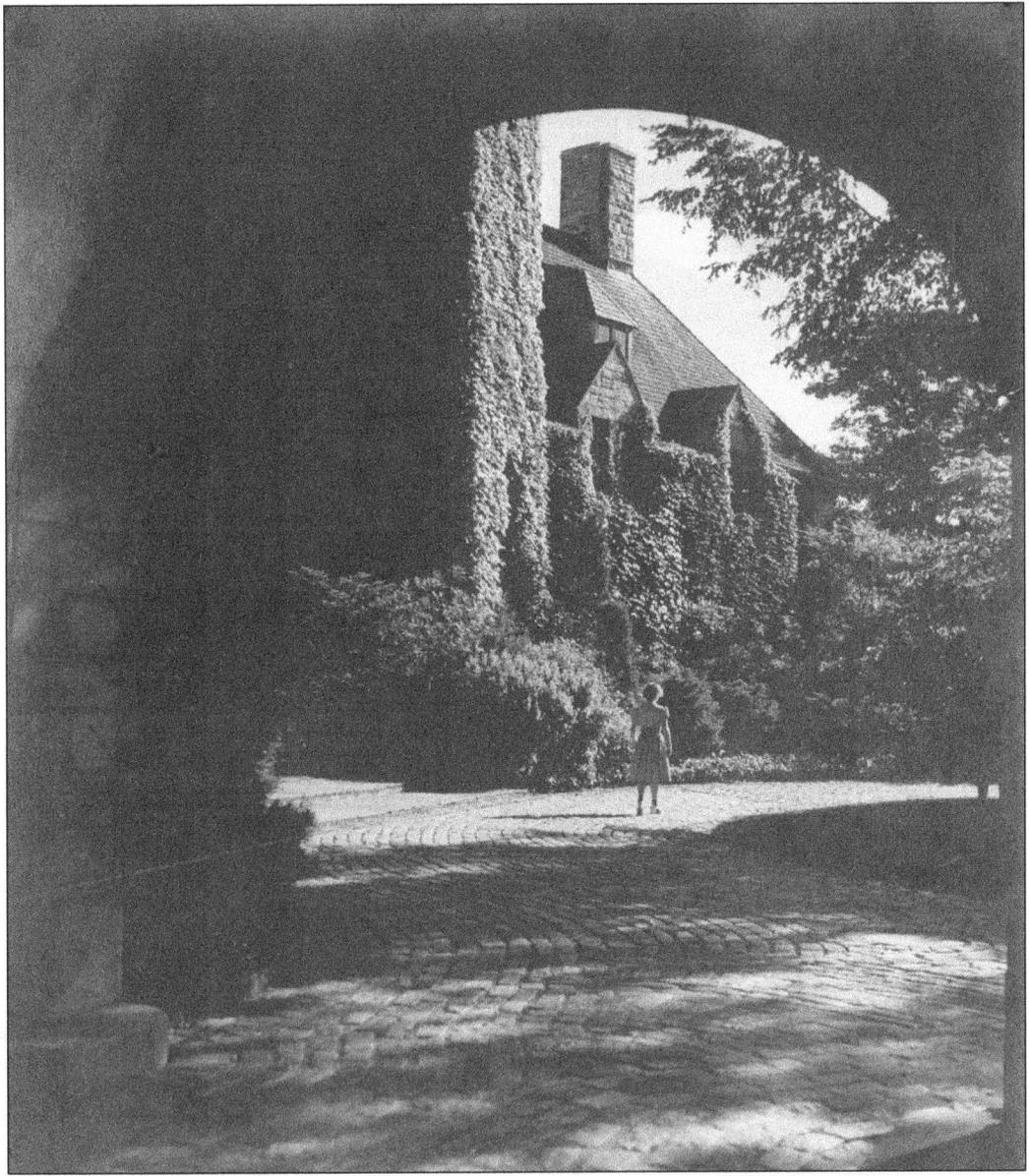

This photograph was taken from the porte cochère, which protected visitors from the weather who arrived by car at the main entrance (just out of view on the left). The Belgian block driveway included a circular turnaround. A lush covering of ivy blankets the north side of the house, which includes the walls of the tower. (Courtesy of the Harold and Clara Pitcairn family.)

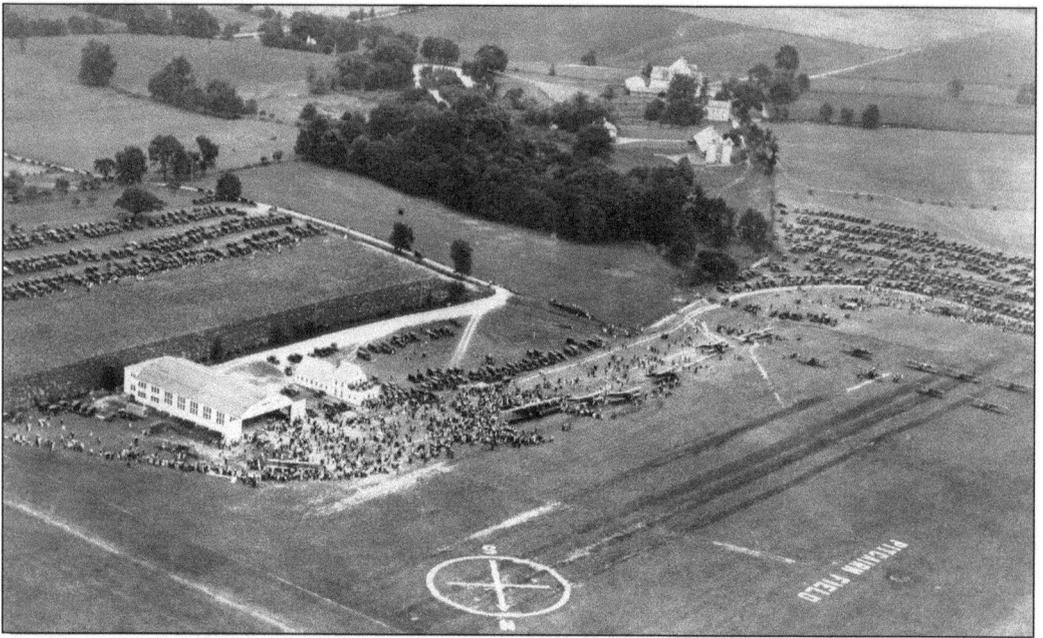

Harold Pitcairn's lifelong interest in aviation began to take shape as a career in the 1920s with the formation of two companies, Pitcairn Aircraft and Pitcairn Aviation. In empty fields in Bryn Athyn, bordered by Buck and Byberry Roads, he built a runway, hangar, and clubhouse for the Aero Club of Pennsylvania. Pitcairn Field was formally dedicated in the fall of 1924, with an estimated 20,000 people attending the event (above). The dairy and hay barn for Cairnwood Farms can be seen in the upper portion of the photograph. In 1926, a second Pitcairn Field, which accommodated more air traffic, was built in Willow Grove. Pitcairn's interest in aviation found its way into the decoration of his home at Cairncrest. Below, a biplane forms the central carving of a stone capital crowning one of the columns on the south terrace. (Above, courtesy of the Harold and Clara Pitcairn family.)

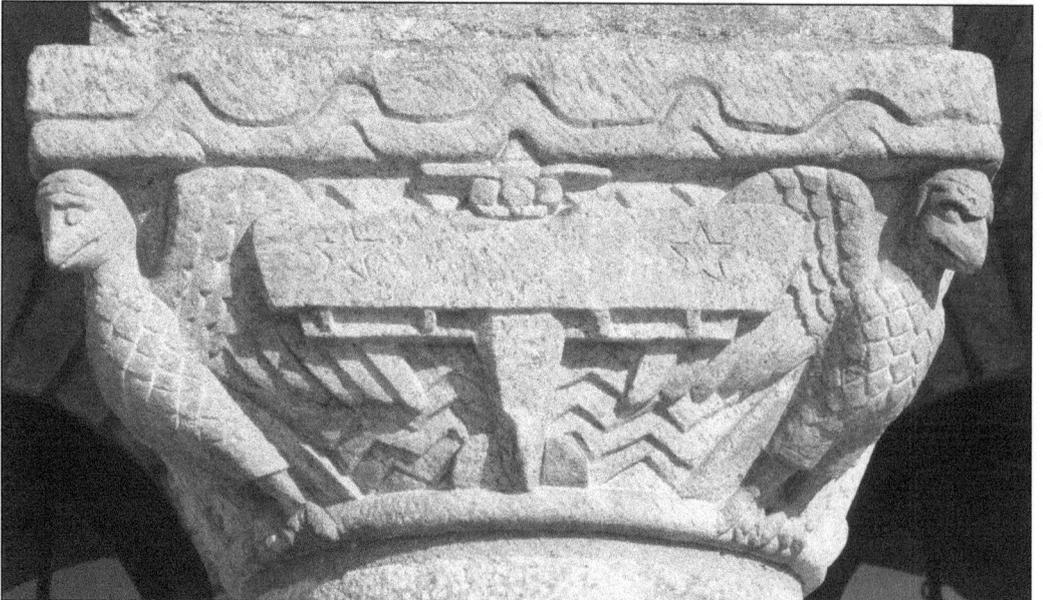

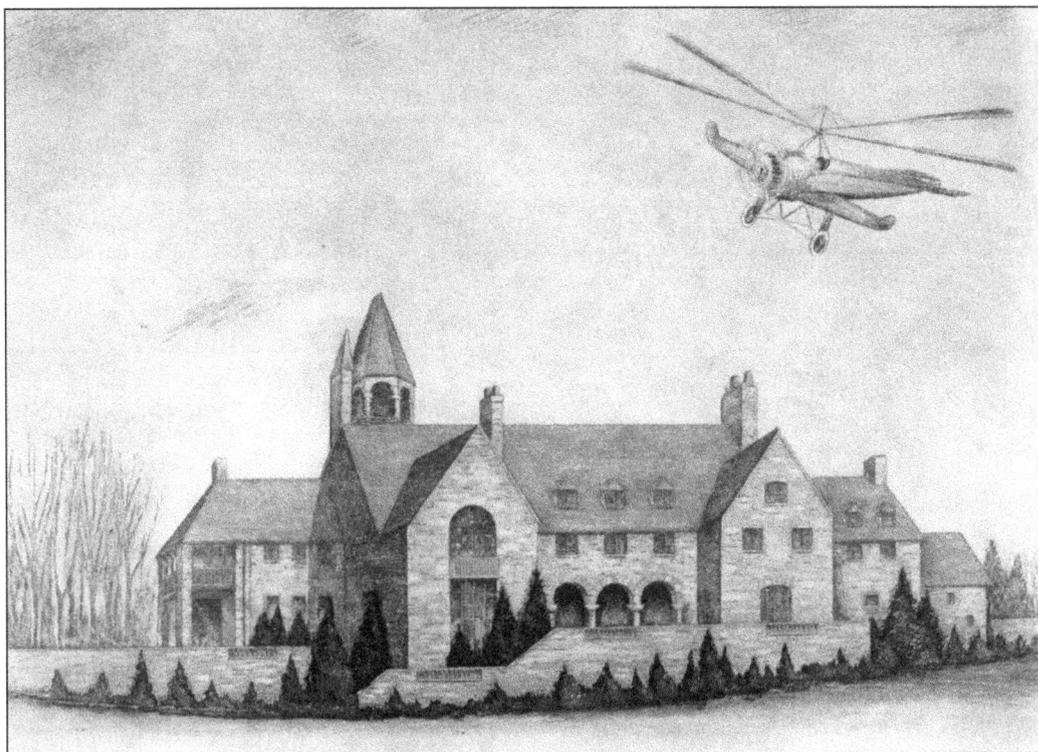

Following the successful development of the Pitcairn Mailwing, a fixed wing plane designed to carry mail, Pitcairn took on the challenge of rotary wing flight. In 1928, he became the first person to fly an Autogiro in the United States, having ordered one from the aircraft's Spanish inventor Juan de la Cierva. Pitcairn obtained exclusive rights to manufacture and develop the Autogiro in the United States, believing it had the features necessary to become a safe form of personal flight. He regularly flew his own model between Cairncrest and his factory. Above, a pencil drawing shows an Autogiro in flight on the south side of the house, while the photograph below shows a stationary Autogiro on the east lawn. The pilot, most likely Pitcairn himself, stands on the wing. (Below, courtesy of the Harold and Clara Pitcairn family.)

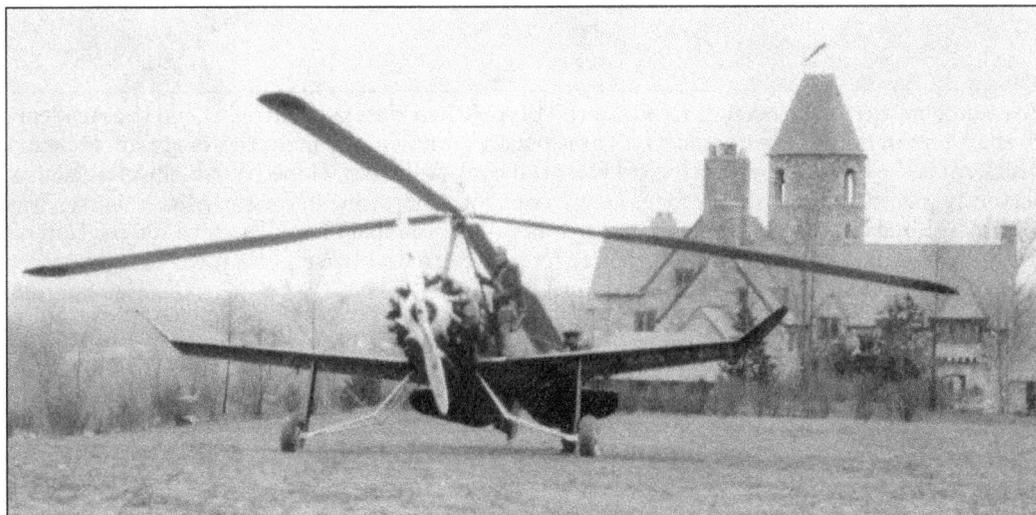

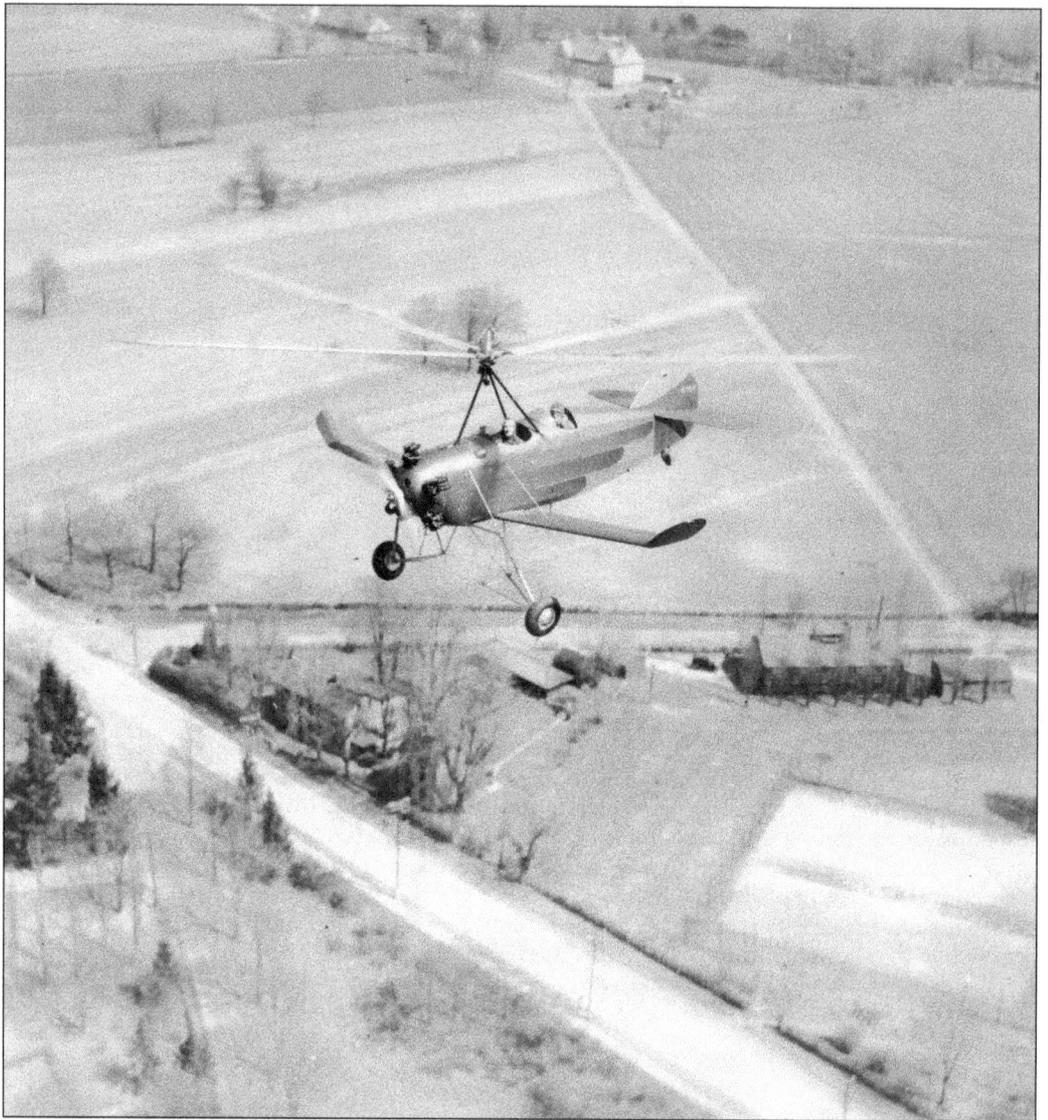

An Autogiro with one passenger flies over the Bryn Athyn glass factory (right) and the Academy of the New Church tennis courts. The Huntingdon Turnpike, the main thoroughfare, is clearly visible, as is the hay barn for Cairnwood Farms (above). A small steel shed beside the glass factory served as an aircraft design space for Agnew Larsen for a short time in the early 1920s. Larsen was originally hired to work on a design for a sugar beet machine that Harold Pitcairn was developing for the Owosso Sugar Company, but before long Pitcairn and Larsen began working on rotary wing designs. (Courtesy of Aerial Viewpoint.)

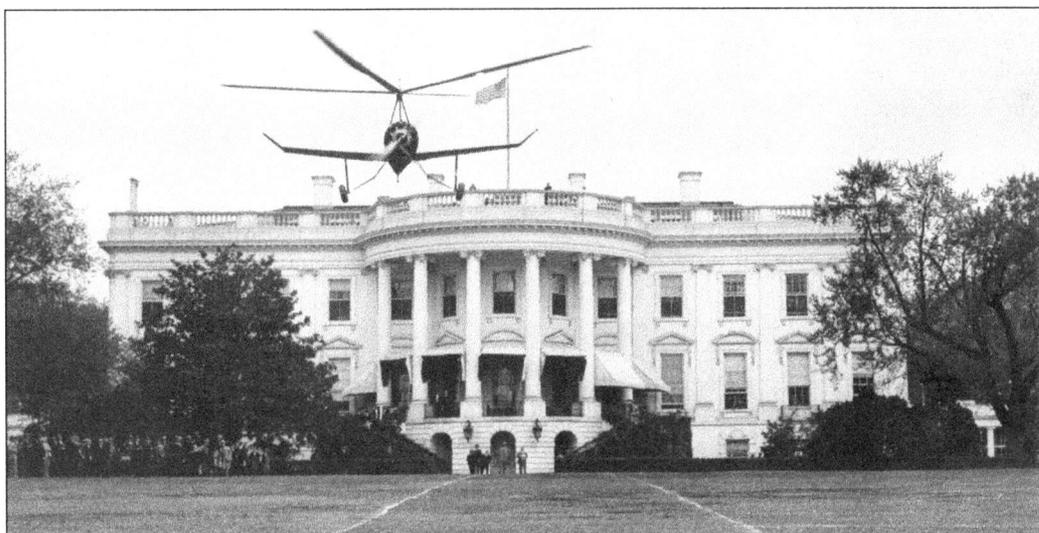

The National Aeronautic Association awarded the 1930 Collier Trophy to Harold Pitcairn and his associates "for their development and application of the Autogiro and the demonstration of its possibilities with a view to its use for safe aerial transport." Pres. Herbert Hoover presented the award at a White House ceremony at noon on April 22, 1931. Jim Ray, Pitcairn's company pilot and friend, landed a PCA-2 Autogiro on the White House lawn a few minutes before the presentation (above). Hoover shakes Pitcairn's hand (below). Orville Wright was present at the ceremony. The associates who were present with Pitcairn were Agnew Larsen, Jim Ray, Geoffrey Childs, and Edwin T. Asplundh. (Both courtesy of the Harold and Clara Pitcairn family.)

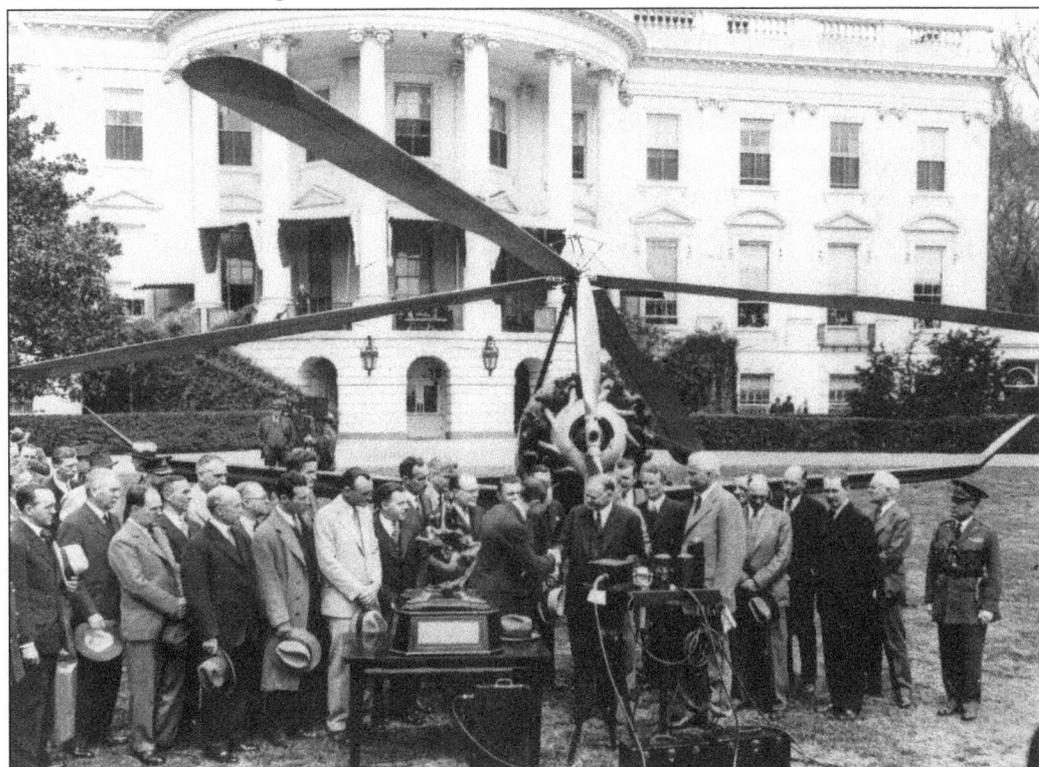

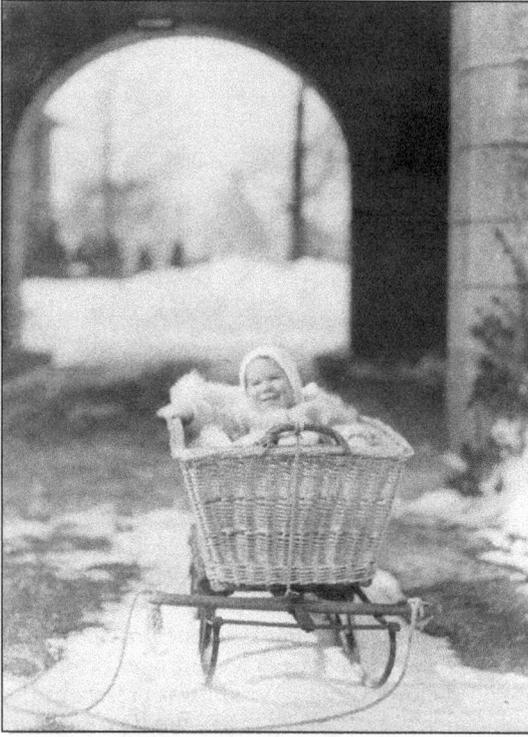

Harold and Clara Pitcairn had a large family of nine children. In the photograph at left, a wicker wash basket mounted on runners provides a sleigh ride for one of the babies. The shadowy outline of the gazebo can be glimpsed through the archway of the porte cochère. A formal portrait of the family was taken by the living room fireplace in 1930 (below). Pictured from left to right are (first row) Stephen, Judy, Clara, Harold with Robert, and Charis; (second row, standing) Joel and John. (Both courtesy of the Harold and Clara Pitcairn family.)

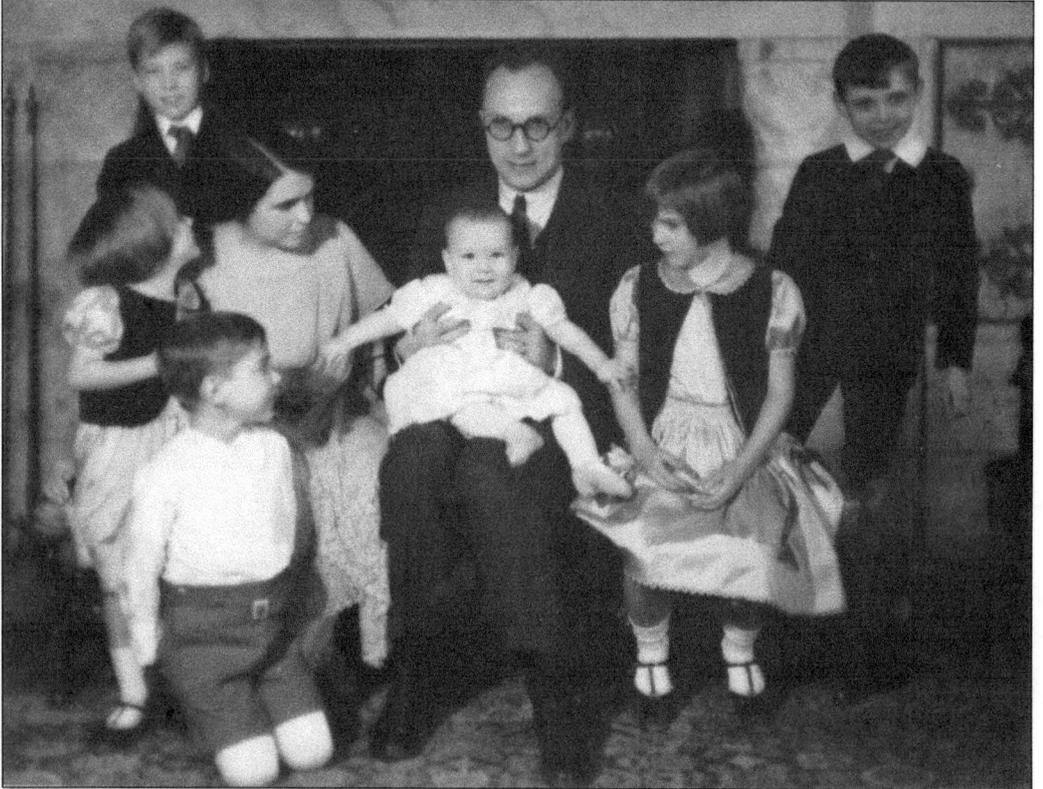

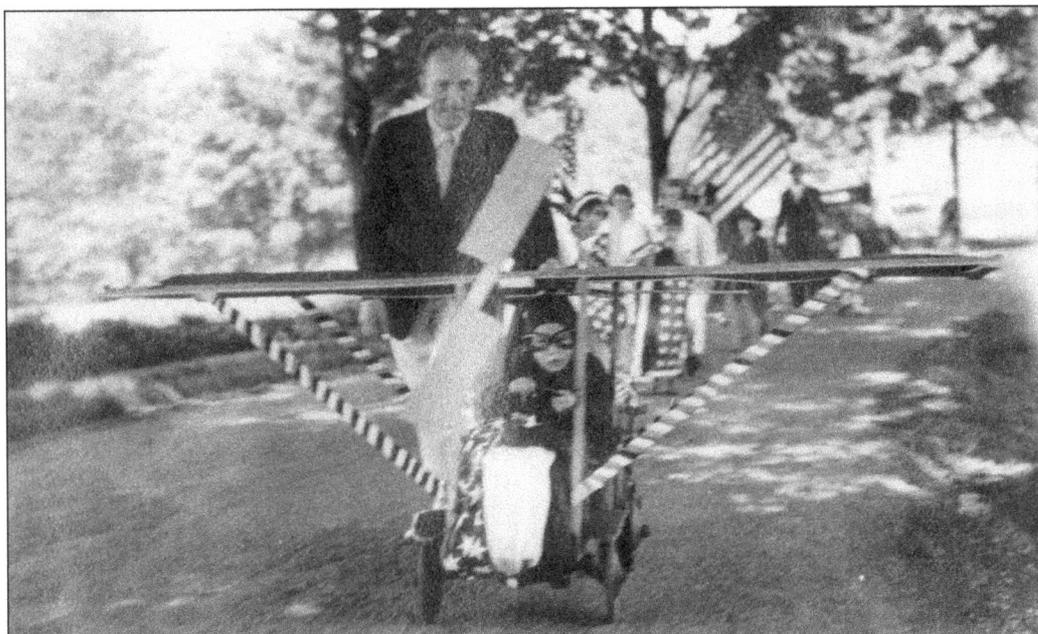

Harold Pitcairn helps one of his children "fly" a monoplane during a Fourth of July parade in Bryn Athyn. Below, Stephen Pitcairn sits at his desk in his bedroom at Cairncrest with his boyhood interests evident on the wall: aircraft, outboard motors, and dogs. As an adult, Stephen worked for the Pitcairn Company and spent much of his free time restoring and flying Pitcairn Mailwings and Autogiros. Three of his restored aircraft are now on exhibit at the AirVenture Museum in Oshkosh, Wisconsin. (Both courtesy of the Harold and Clara Pitcairn family.)

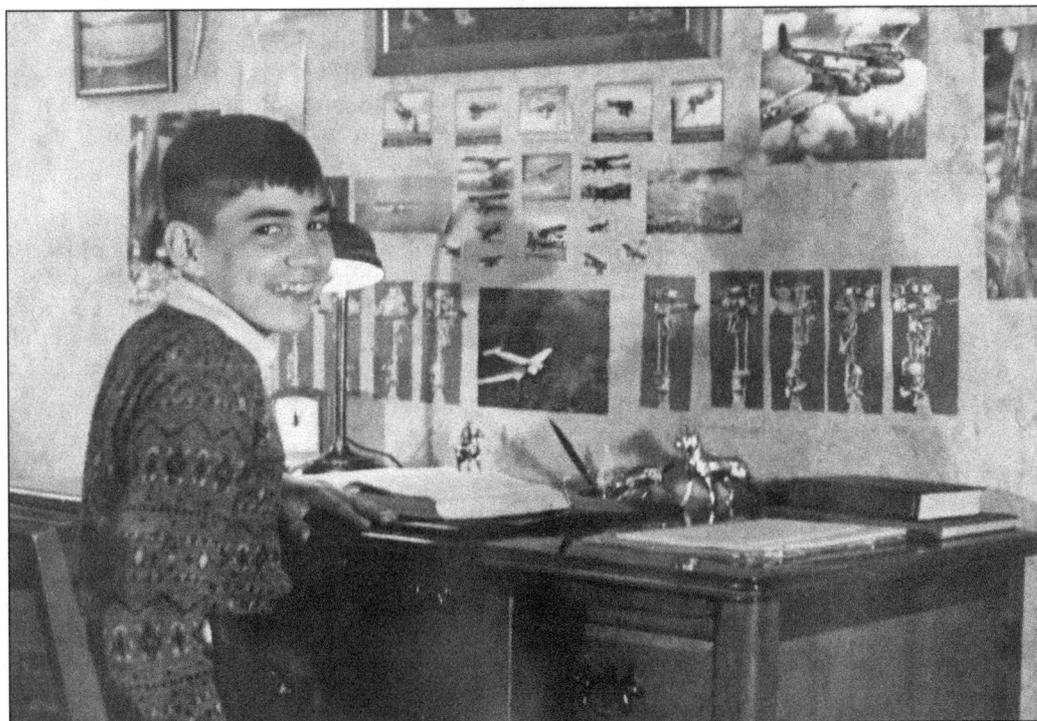

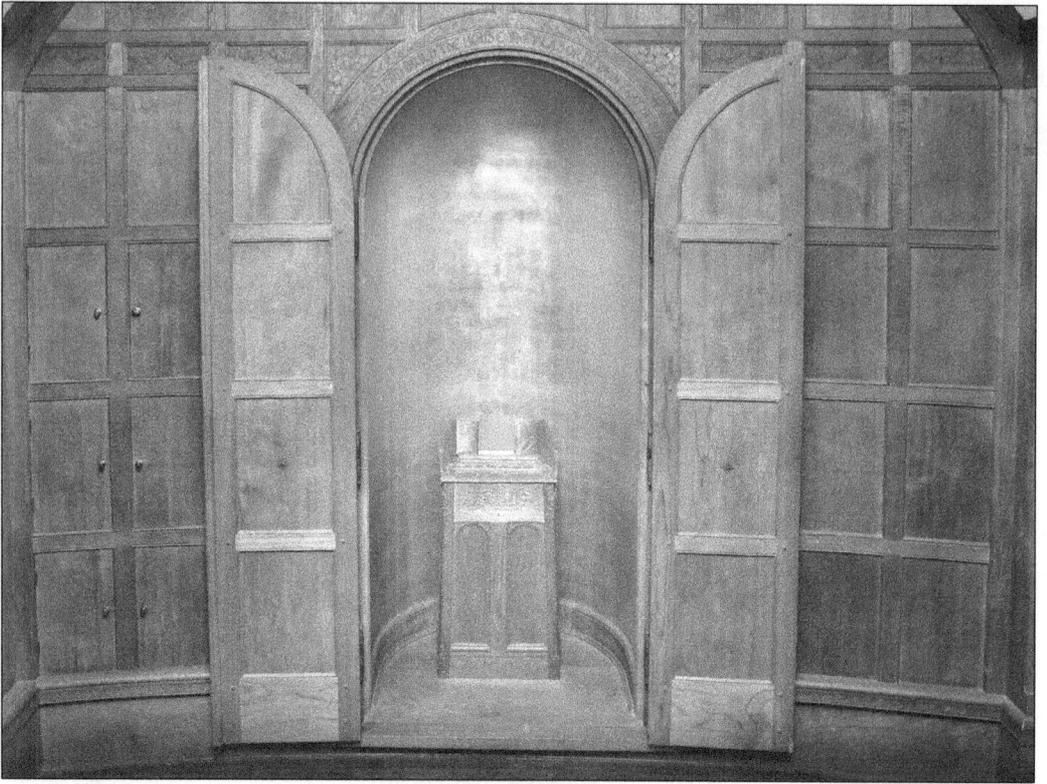

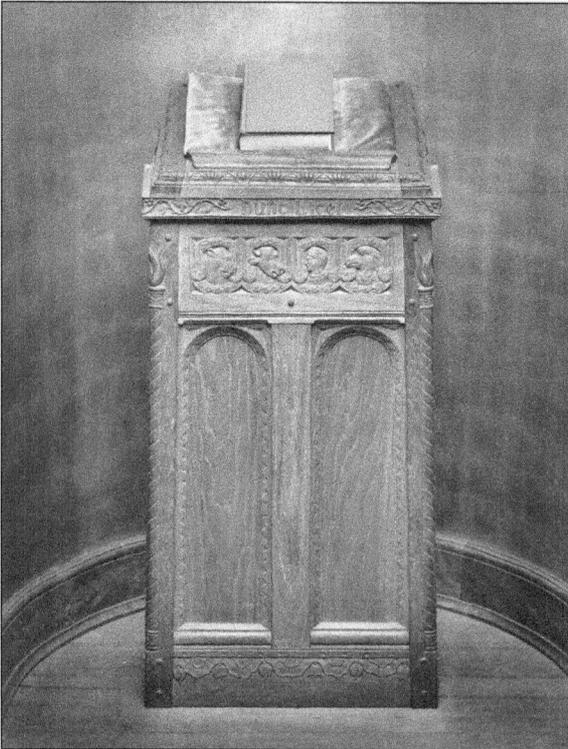

As a young man, Harold Pitcairn briefly studied to become a New Church minister, and at Cairncrest he led his family in a daily worship service. Family worship was common in Bryn Athyn in the first half of the 20th century and continues with many New Church families today. The library was designed with a built-in cabinet containing a special stand for the Bible. Carved into the arch above the cabinet doors is an inscription from Psalm 127:1, "Except the Lord build the house, they labor in vain that build it." (Photographs by Chara Odhner.)

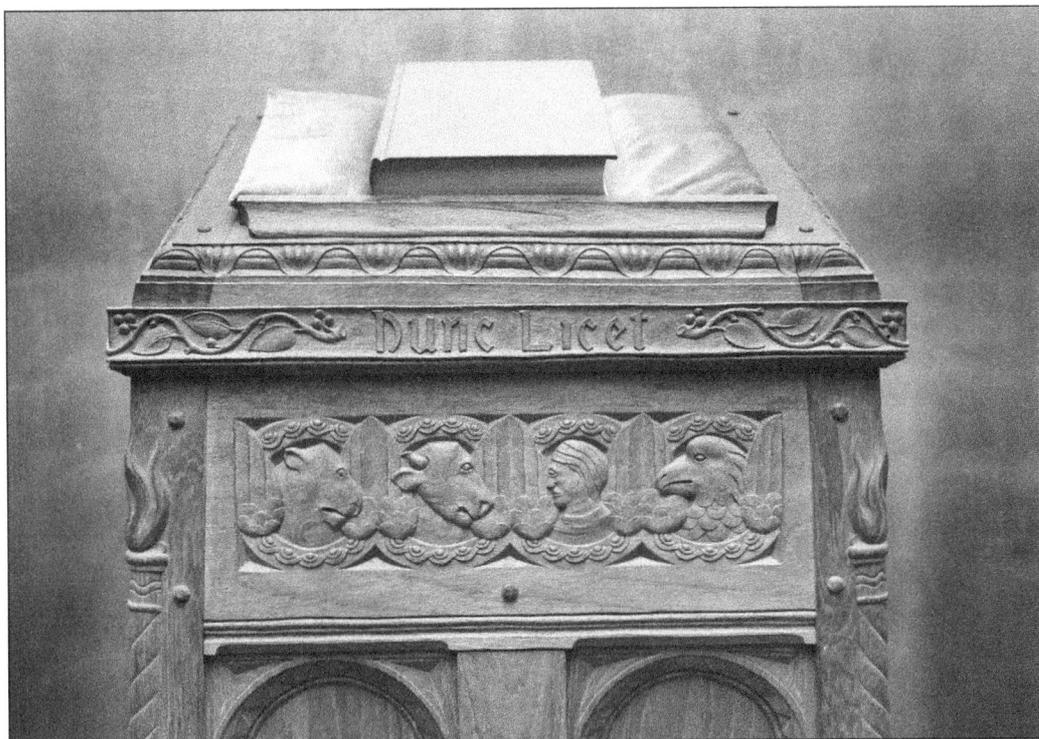

The imagery carved into the Bible stand is taken from the Book of Revelation (4:7), which describes the four living creatures around the throne of God in heaven, "The first living creature was like a lion, the second living creature like a calf, the third living creature had a face like a man, and the fourth living creature was like a flying eagle." The writings of Emanuel Swedenborg describe these creatures as representing four different aspects of the truth of the Word of God. (Photograph by Chara Odhner.)

The Cairncrest grounds were the setting for a garden party on June 16, 1935. The event was a social occasion for members of the General Church of the New Jerusalem, who were attending an international church assembly in Bryn Athyn.

This holiday photograph of Clara and Harold Pitcairn, taken in the living room at Cairncrest, was used as their Christmas card in 1957. The room is decorated for the season: poinsettias are beside the fireplace and a handmade figure of Mary and the Christ Child is in the center of the mantle. (Courtesy of the Harold and Clara Pitcairn family.)

Five

GLENCAIRN

Raymond Pitcairn, the first child of John and Gertrude, was born in Philadelphia in 1885. At the age of 10, he moved with his family to Cairnwood, their newly completed home in the New Church community later named Bryn Athyn. Pitcairn attended the Academy of the New Church schools, and later received a law degree from the University of Pennsylvania. He married Mildred Glenn in 1910, and the young couple set up their first home in Cairnwood, sharing it with Raymond's younger brothers and their widowed father.

By the time construction began on Bryn Athyn Cathedral in 1913, Raymond Pitcairn was already heavily involved in the project. When John died in 1916, Raymond inherited his father's positions in the family's business interests, taking on these responsibilities in addition to his work on the cathedral. As Jennie Gaskill noted in her *Biography of Raymond Pitcairn*, Raymond's sons, when asked what their father's occupation was, preferred this answer, "He is a lawyer by profession, an architect by choice, and a business man by force of circumstances."

Pitcairn's collection of medieval art, begun in 1916, was originally intended to provide inspirational models for the craftsmen at the cathedral, who were producing stained glass windows and sculptures. Although he was more interested in architecture than art collecting, by 1922 the size of the collection had outgrown Cairnwood, and Pitcairn began planning a new building. Over the next few years, his initial concept of a "cloister studio" developed into a plan for a Romanesque-style "castle," located on a flat piece of ground adjacent to Cairnwood. Intended primarily as a home for the Raymond and Mildred Pitcairn family, Glencairn also provided an ideal setting for his medieval collection, which today is regarded as one of the finest in the country.

Pitcairn and his design team carefully planned how to incorporate his favorite works of art into the fabric of the building. A scale model of Glencairn's great hall was made so that objects could be tested in a variety of locations until they seemed to be in harmony with their new surroundings. After many years of design and construction, the Pitcairns moved into their new home in 1939.

Glencairn was built by Raymond Pitcairn in a style based on medieval Romanesque architecture. Pitcairn, who had no formal architectural training, had previously supervised the construction of Bryn Athyn Cathedral, a Gothic- and Romanesque-style complex. The design of both buildings evolved gradually, using scale and full-sized models rather than relying exclusively on predetermined architectural plans. This clay model of Glencairn was one of the earliest produced.

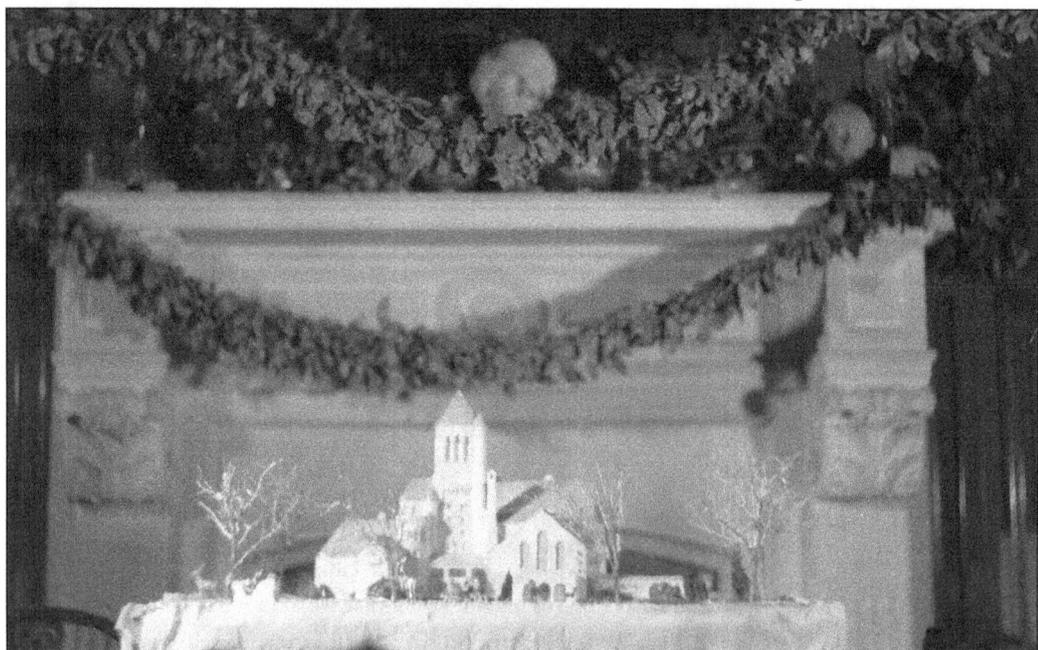

This scale model of Glencairn, complete with Santa Claus and reindeer, was photographed in the dining room at Cairnwood. Raymond and Mildred Pitcairn's son Lachlan remembers, "Every Christmas they had a model of Glencairn in the middle of the table at Cairnwood, and my mother would look at it and she'd say, 'Raymond, do you think we'll ever move in?' because it took 13 years to build Glencairn." (Interview with Lachlan Pitcairn, May 1, 2006. Glencairn Museum Archives.)

94

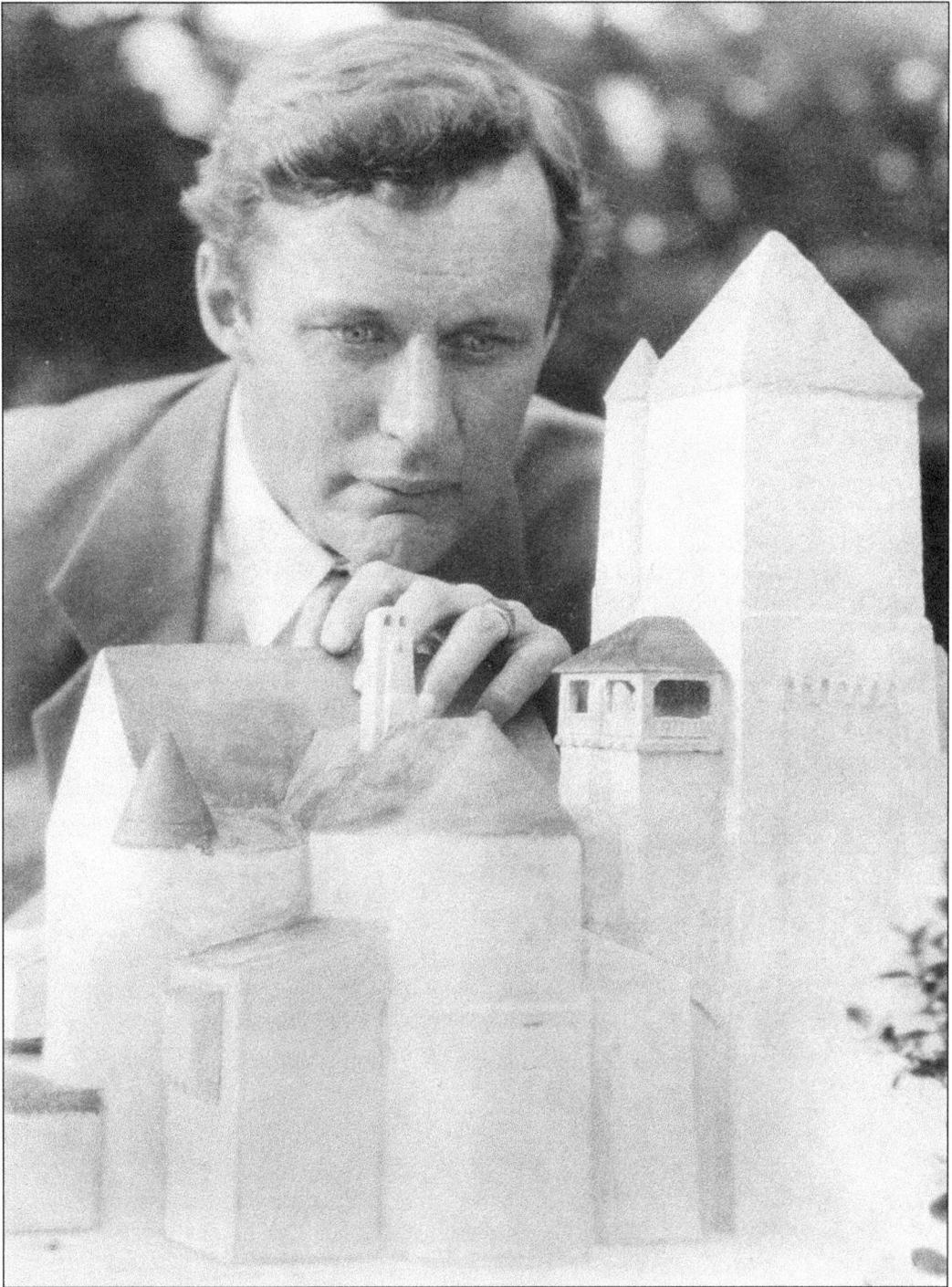

"The nature of the work is stimulating and full of joy. On the other hand it requires much thought and effort and is most assuredly work as distinguished from play. It also involves patience of a kind which has grown scarce in these days of rapid mechanical production." (Raymond Pitcairn, quoted in E. Bruce Glenn, *Glencairn: The Story of a Home*. Bryn Athyn, 1990: 71.)

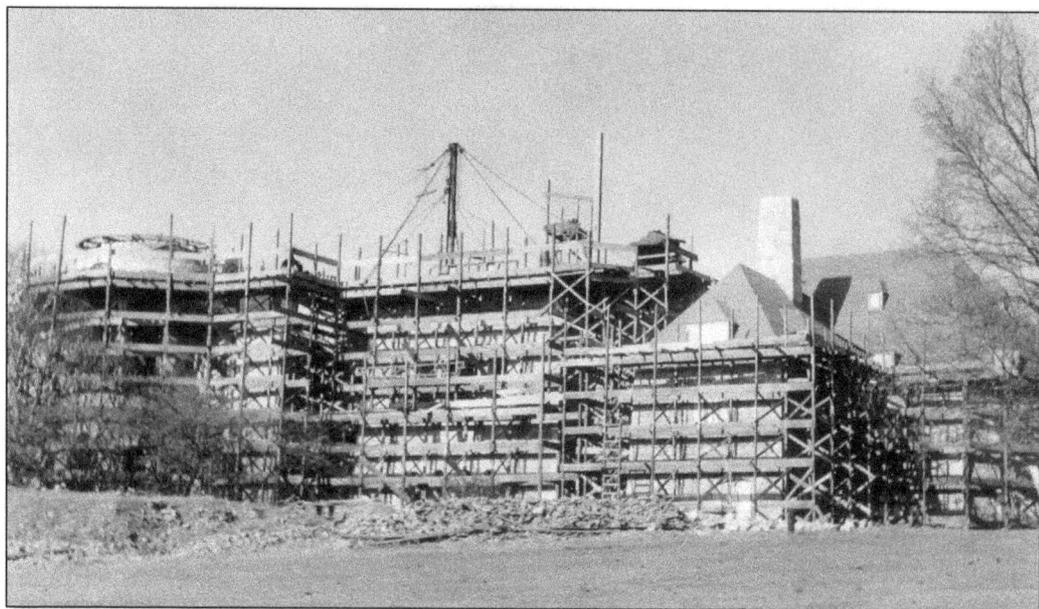

In 1929, after excavation for the foundation of Glencairn had already begun, America was struck by the Great Depression. Raymond Pitcairn ordered the digging stopped and the hole for the foundation was partially filled in while he decided what to do. On July 22, 1931, Pitcairn wrote to James Levey, "Our new building is progressing slowly due to the hard times. I have eight masons at work where I had hoped to have thirty." Construction on Glencairn was to continue throughout the 1930s, providing employment for more than 100 men. On December 25, 1939, eighty-two of the men wrote Raymond Pitcairn a letter of appreciation for continuing to employ them "during the recent years of adversity" and for "the opportunity of participating in an unusual and outstanding architectural achievement." (Glencairn Museum Archives; below, photograph by Arthur Westcott Cowell.)

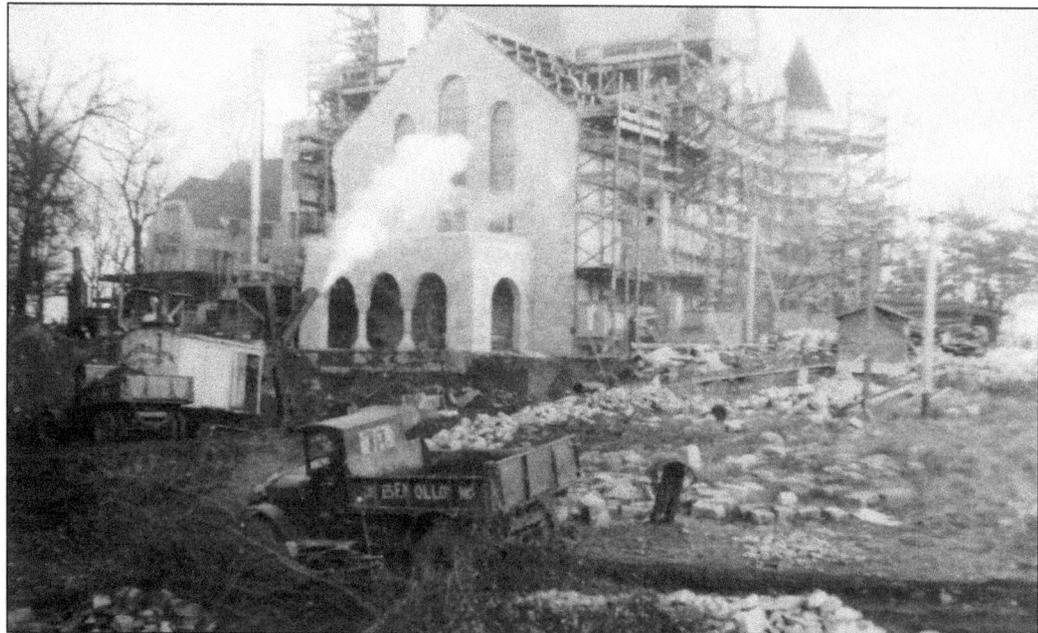

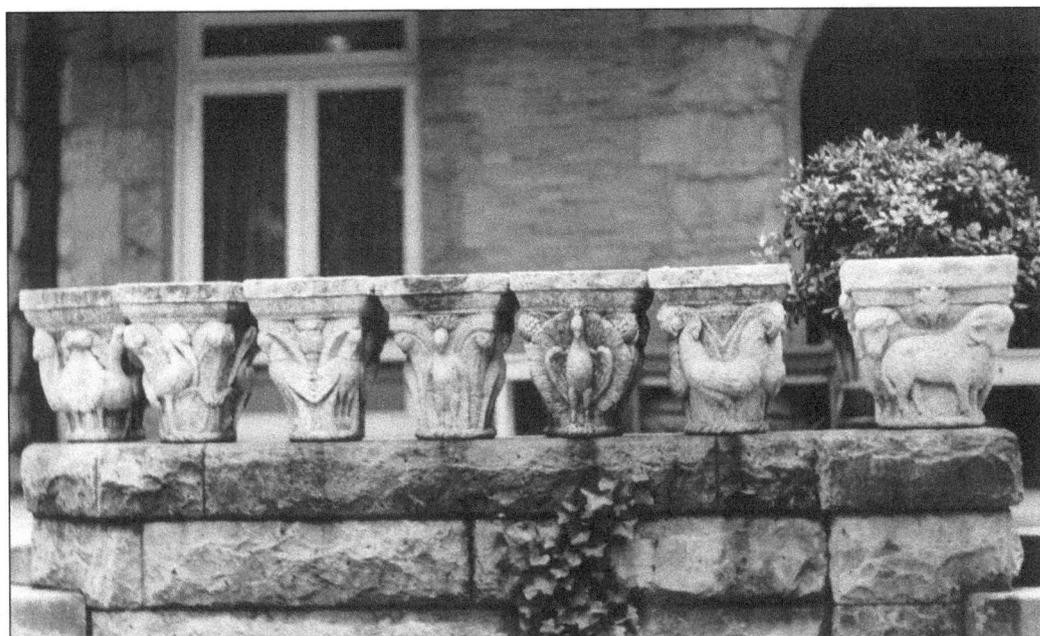

While Glencairn was being built, the Pitcairn family continued living next door at Cairnwood. Many of the same artists and craftsmen who had worked on Bryn Athyn Cathedral were now hired to produce works of art for Glencairn. Some of the most interesting examples of New Church symbolism in Glencairn can be found in the cloister. The photograph above shows seven capitals lined up on a balustrade with Cairnwood in the background. The photographs below show some of the capitals in place in the cloister. (Below left, courtesy of Anne Snyder; below right, photograph by Barry Halkin.)

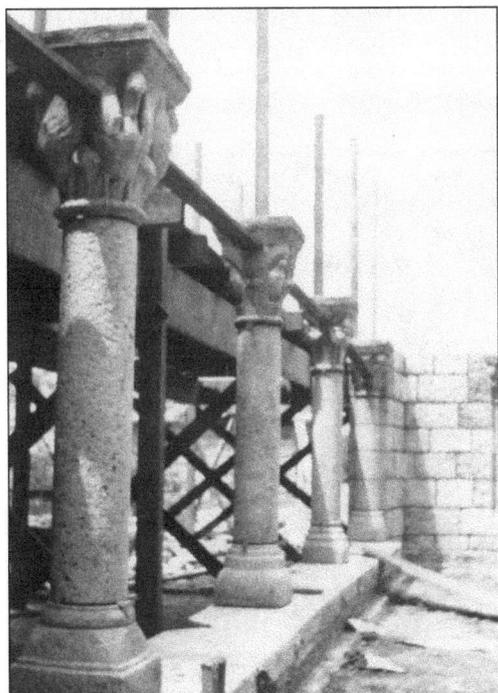

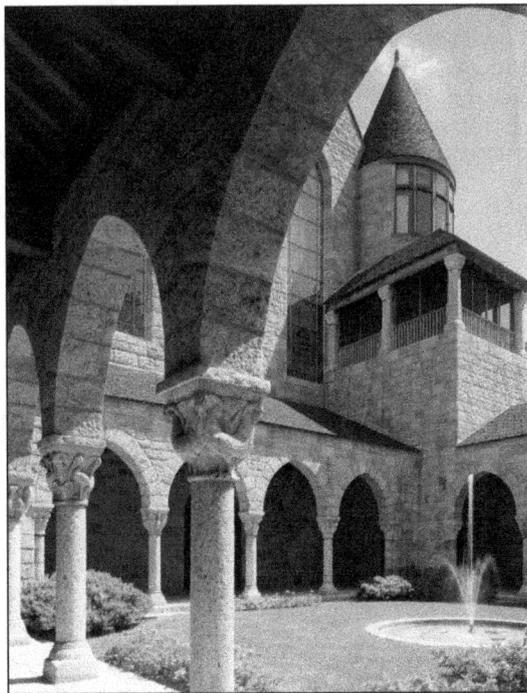

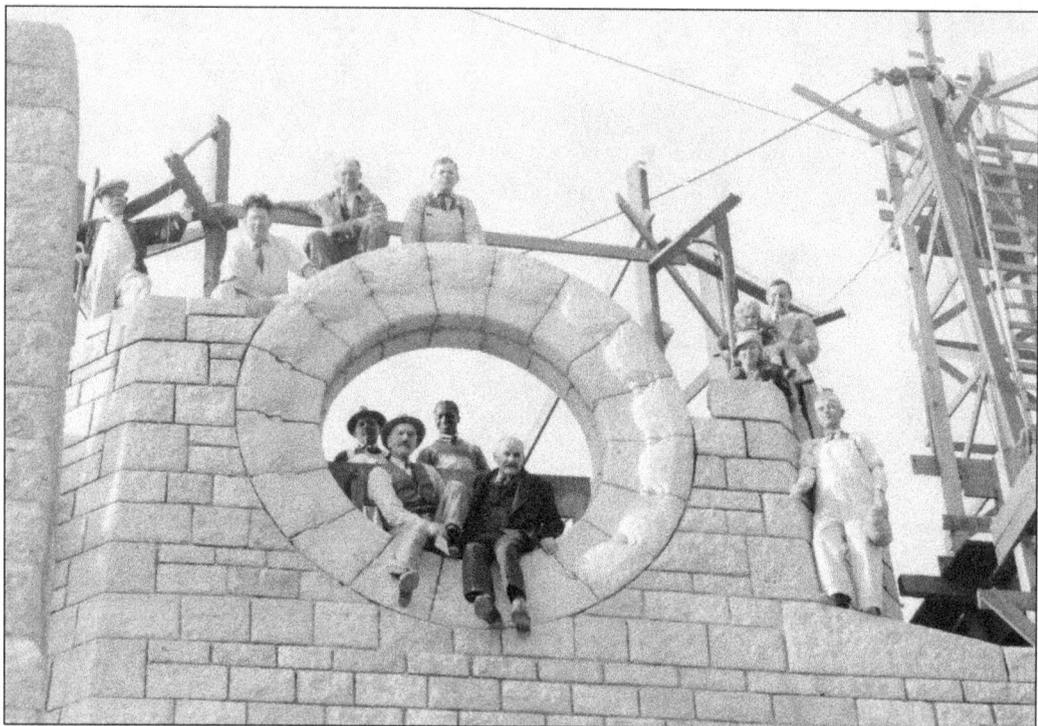

Raymond, Mildred, and Vera Pitcairn pose with workmen on the east wall of Glencairn's chapel. Below, Vincent Odhner ties a bow around the neck of a trial version of the sculpture on the roof of the upstairs living room. On March 21, 1938, Raymond Pitcairn wrote to E. Donald Robb, "In spite of taxes and other difficulties which, from a practical and economic standpoint, make my house-building project seem a colossal blunder and the creation of a burden for which my family may have scant reason to thank me in the future, the work has progressed and from a creative and architectural standpoint I get considerable satisfaction out of it. Besides this there is the fact that it has provided employment for many people." (Glencairn Museum Archives; above, photograph by Michael Pitcairn.)

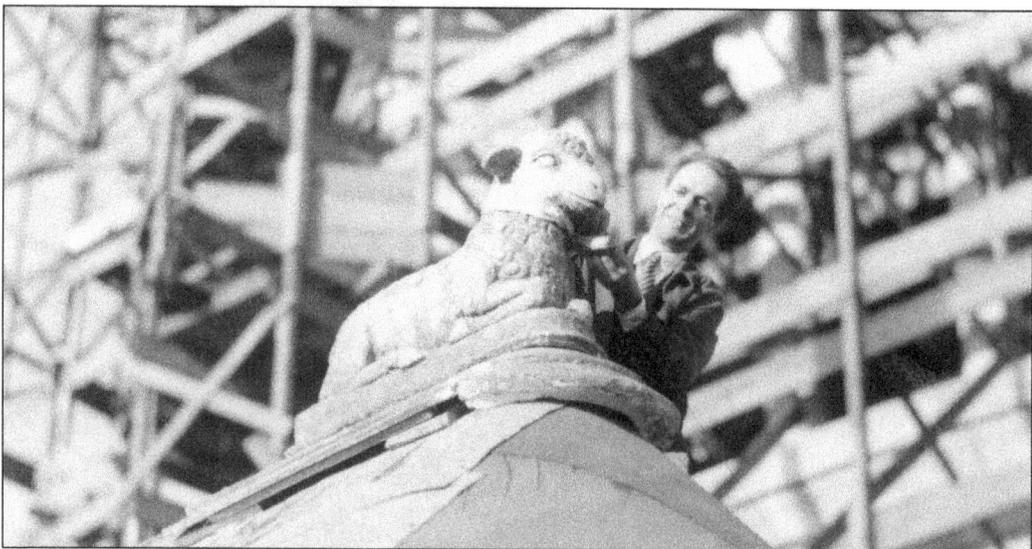

On November 10, 1931, Raymond Pitcairn wrote to A. Cimarosti, "The glass for the mosaic we are producing at our own studios. It breaks with a non-glossy surface and is, I believe, the finest material which has been produced for mosaic in modern times." This mosaic lion from the seal of the Academy of the New Church is located above Glencairn's third-floor balcony. The intricate mosaic designs in the photograph below, produced for the ceiling trusses in the great hall, were based on the Book of Kells, a medieval Celtic manuscript containing the four Gospels written around 800 AD. Several quotations from the theological works of Emanuel Swedenborg were incorporated into the design. (Glencairn Museum Archives; above, photograph by Barry Halkin.)

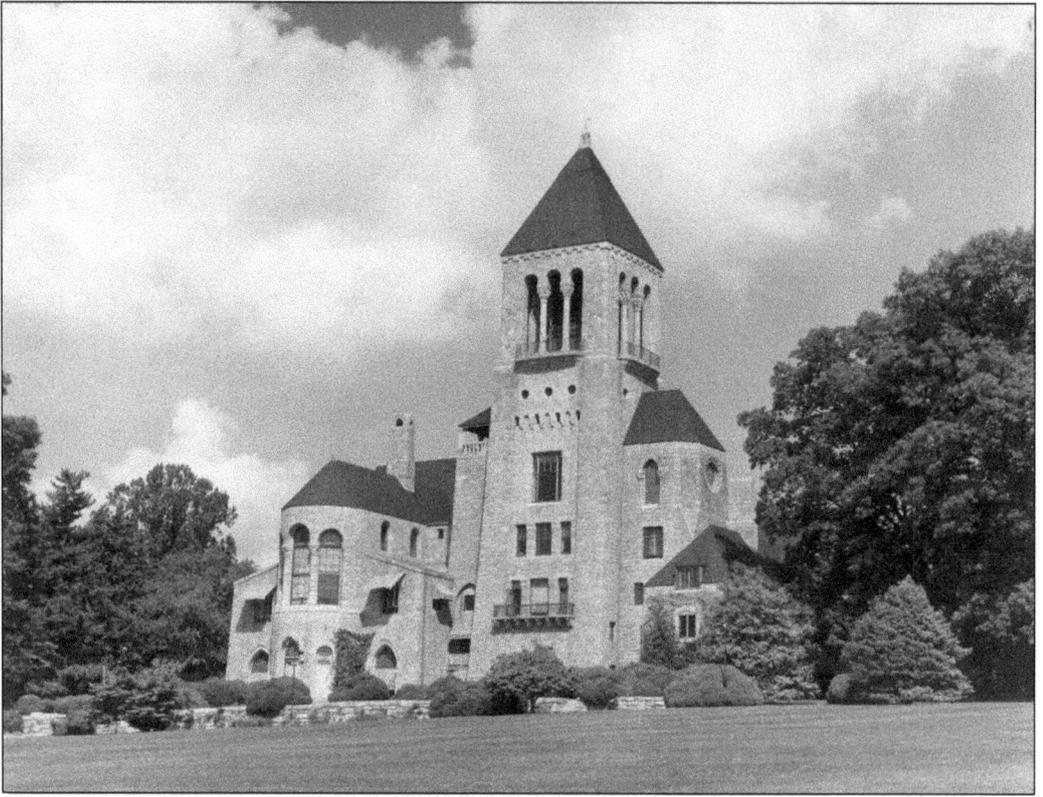

The Raymond and Mildred Pitcairn family moved from Cairnwood to Glencairn shortly after it was dedicated as a home on December 29, 1938. In the photograph below, the Huntingdon Turnpike is visible at the top, and a portion of Cairnwood can be seen to the left of Glencairn.

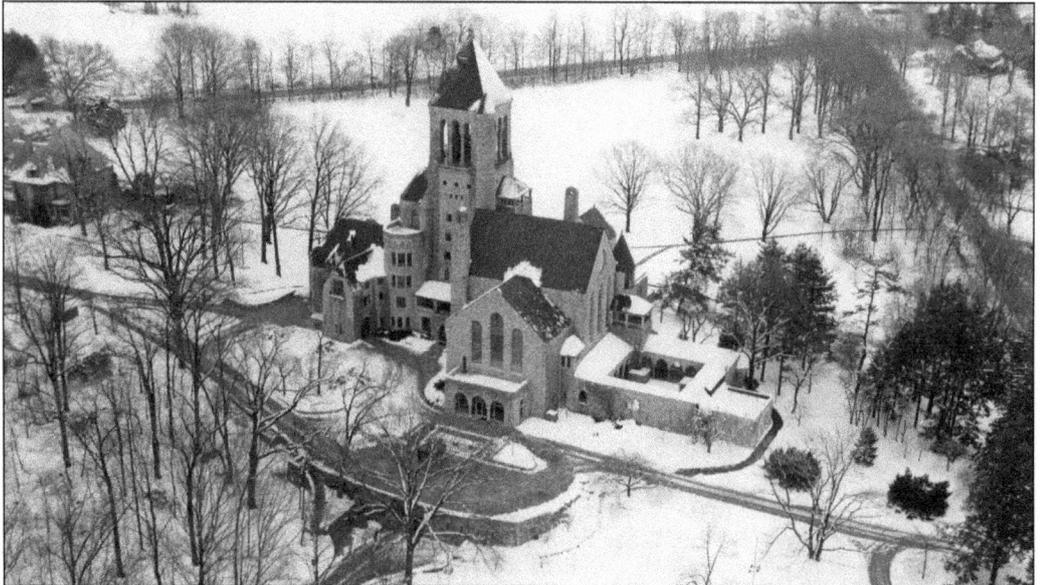

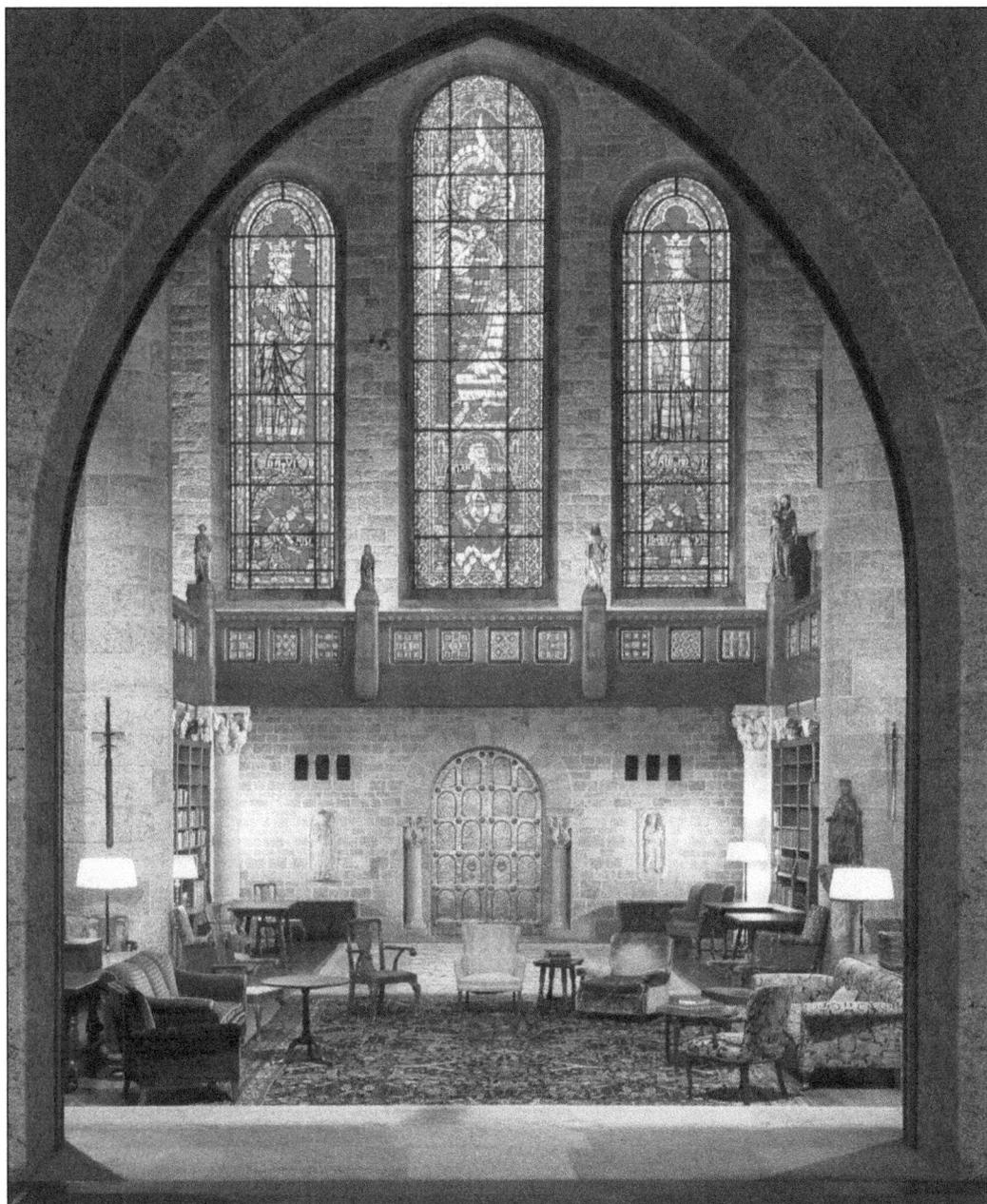

The name Glencairn is a blend of the family names of Raymond Pitcairn and his wife, Mildred Glenn. The Pitcairns had nine children. Although the great hall was designed to display an art collection, above all else Glencairn was intended as a home for the family. In addition to medieval art, Glencairn contains a wealth of original art in stone, wood, glass, and mosaic created by Bryn Athyn craftsmen and inspired by New Church beliefs. The major decorative themes are variations of one of the Bible's most repeated commands, "You shall love your neighbor as yourself." Symbols of the four communities the Pitcairns hoped to serve during their lifetimes can be found throughout the building: family, school, country, and church. (Photograph by Barry Halkin.)

The theme of family appears many times in the decoration of Glencairn, usually represented by sheep and lambs. Above, Raymond Pitcairn and his daughter Gabriele pose with a large granite relief of a ram and ewe, later installed above the main entrance to Glencairn. Nine lambs—one for each of the Pitcairn children—were carved below this relief around the doorway arch. Below, Vera and Garth Pitcairn stand beside a capital carved with a ram and ewe, made for one of the columns in Glencairn's north porch. (Above, photograph by Michael Pitcairn.)

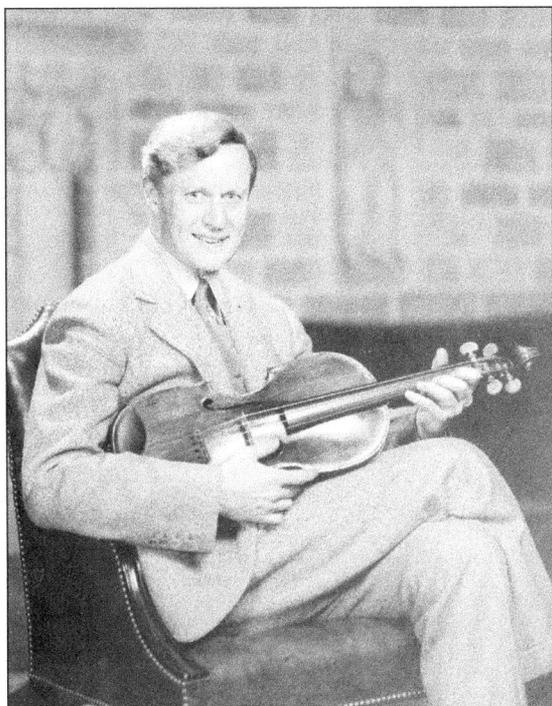

Music was an important part of the life of the Pitcairn family. Raymond played the violin and viola, Mildred played the piano, and all of the children played instruments. Michael made the cigar-box banjo (above right) for his younger brother Lachlan. Images of the Pitcairn children with their musical instruments are carved on large corbels supporting a balcony on the south wall of Glencairn's tower. Below are, from left to right, Michael with a violin, Bethel at a piano, Lachlan with a cigar-box banjo, and Garth with a snare drum. Lachlan later learned to play the cello, and Garth learned the French horn. (Above right, courtesy of Bachrach Photography; below, photograph by Barry Halkin.)

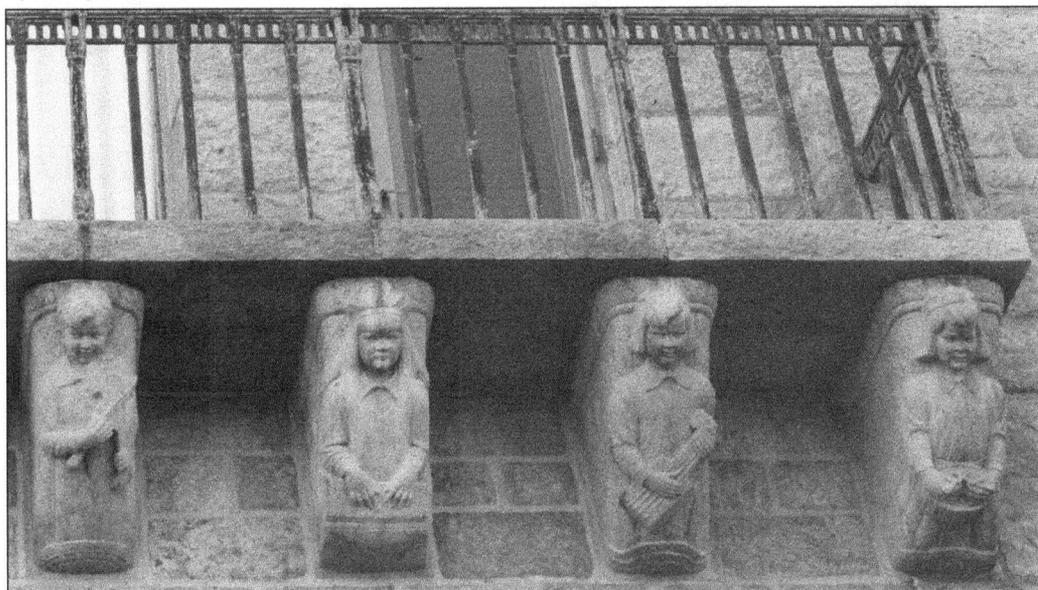

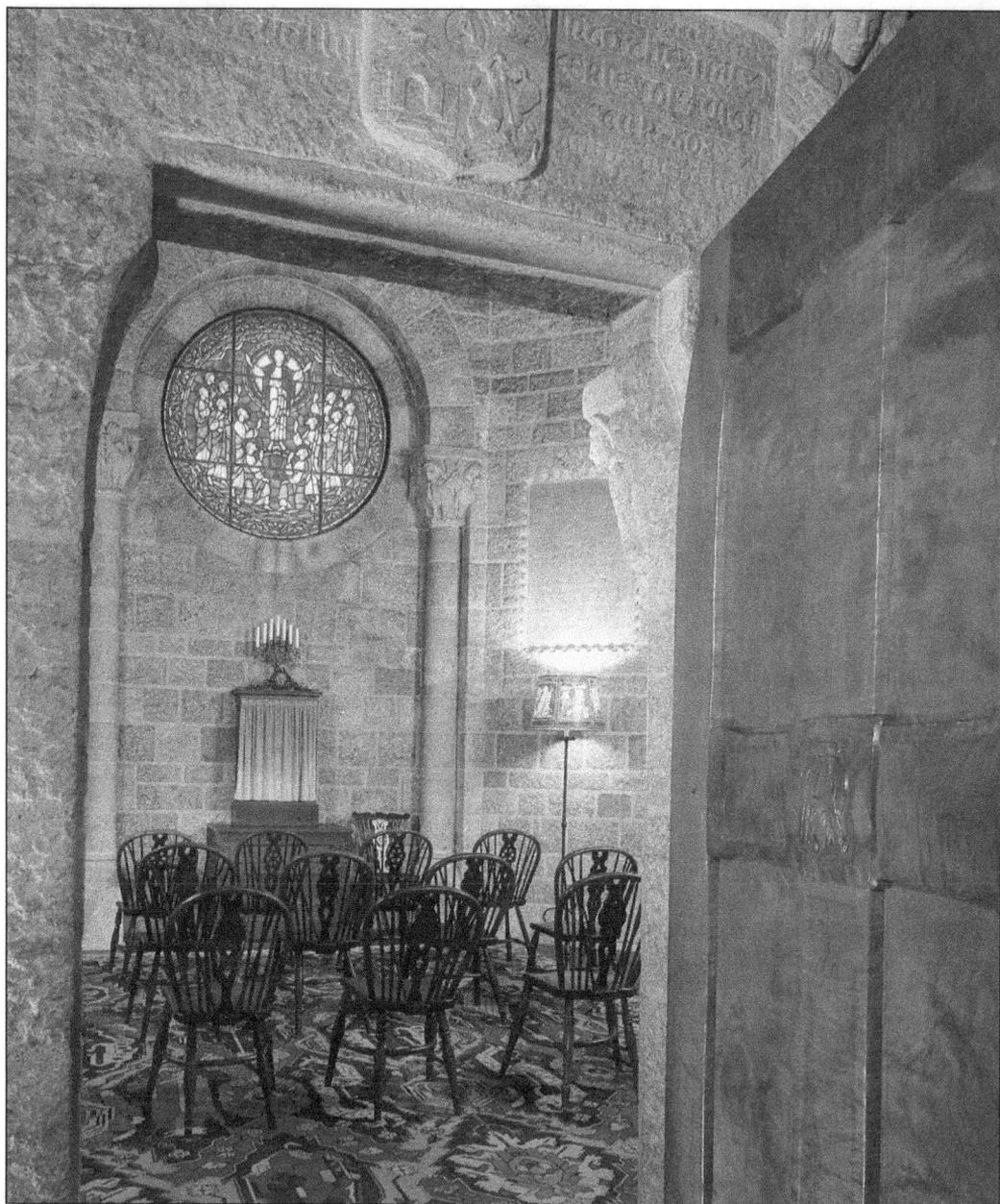

Every evening after dinner, Raymond Pitcairn led a short worship service for his family and household staff in the chapel, located on the fifth floor. The simple format consisted of singing, a reading from the Bible or a passage from the theological works of Emanuel Swedenborg, and a prayer. Carved in stone on the left wall of the chapel is a synopsis of the Ten Commandments in Hebrew. On the right wall is the Lord's Prayer in Greek, the language of the New Testament. (Photograph by Barry Halkin.)

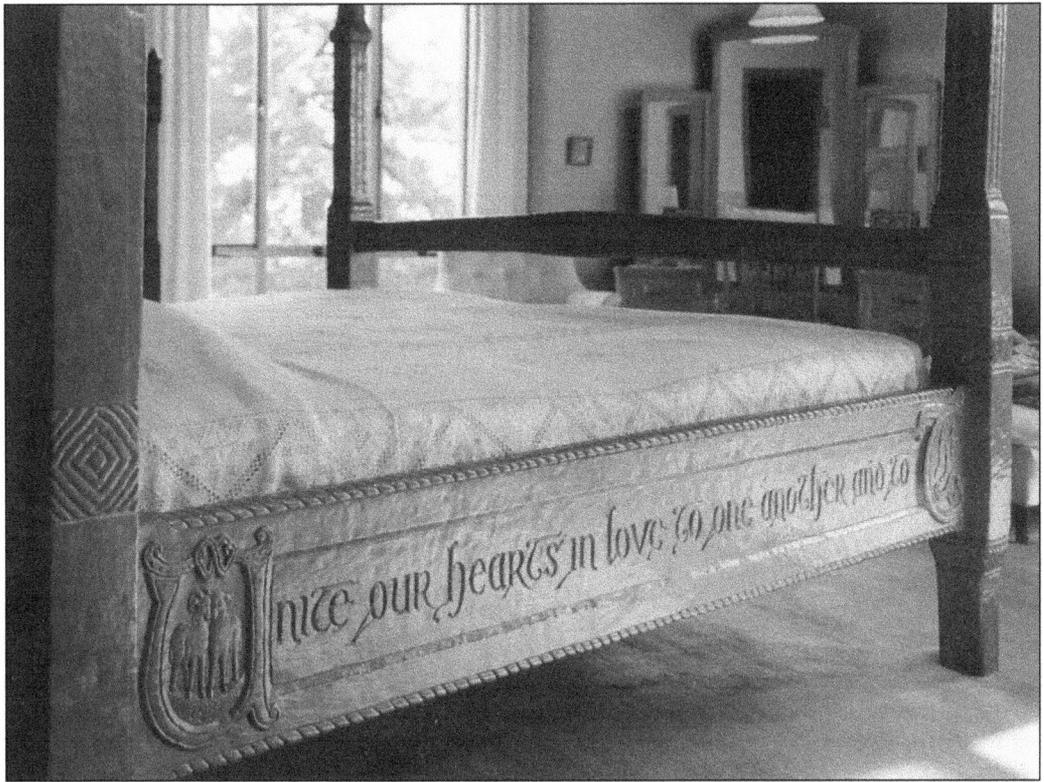

Glencairn's master bedroom (above) features a teakwood bed handcarved by Frank Jeck. The words inscribed around the bed are adapted from a New Church marriage service, "Unite our hearts in love to one another and to Thee. Give us one heart, one mind, one way. Grant us knowledge to see Thy way and power to do Thy will." Like the other family bedrooms, Lachlan and Garth's room (below) was designed with a special niche in the wall for the Bible. (Above, photograph by Barry Halkin; below, photograph by Michael Pitcairn.)

Raymond and Mildred Pitcairn pose for a family photograph with their children in the woods just below Glencairn around 1936. Absent from the picture is Gabriele, who was married in 1934.

Mildred Pitcairn celebrates her 81st birthday at Glencairn in 1967 with her children and grandchildren. The dog, a Harlequin Great Dane, was named Hoover.

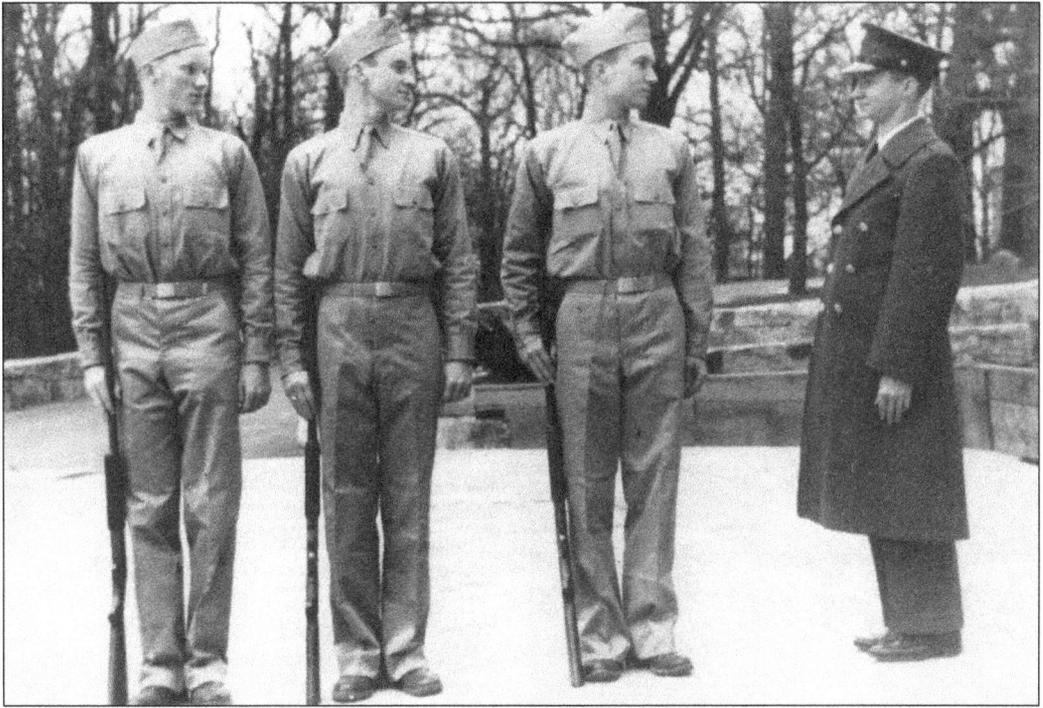

During the months leading up to America's entry into World War II, Bryn Athyn formed a volunteer Civil Defense Corps. Members purchased their own uniforms and participated in a wide variety of activities, including marching, bayonet drill, target practice, boxing, and wrestling. Three of the Pitcairn boys participated in the Civil Defense Corps prior to their actual military service. In the photograph above, from left to right, Garth, Lachlan, and Nathan "stand at attention" before Michael in the Glencairn driveway. Michael, who enlisted in the Army Signal Corps in August 1941, wears his Army uniform. Below, Nathan, in his Marine Corps dress uniform, and Carolyn (Harris) Pitcairn pose in Glencairn's cloister on their wedding day in 1944.

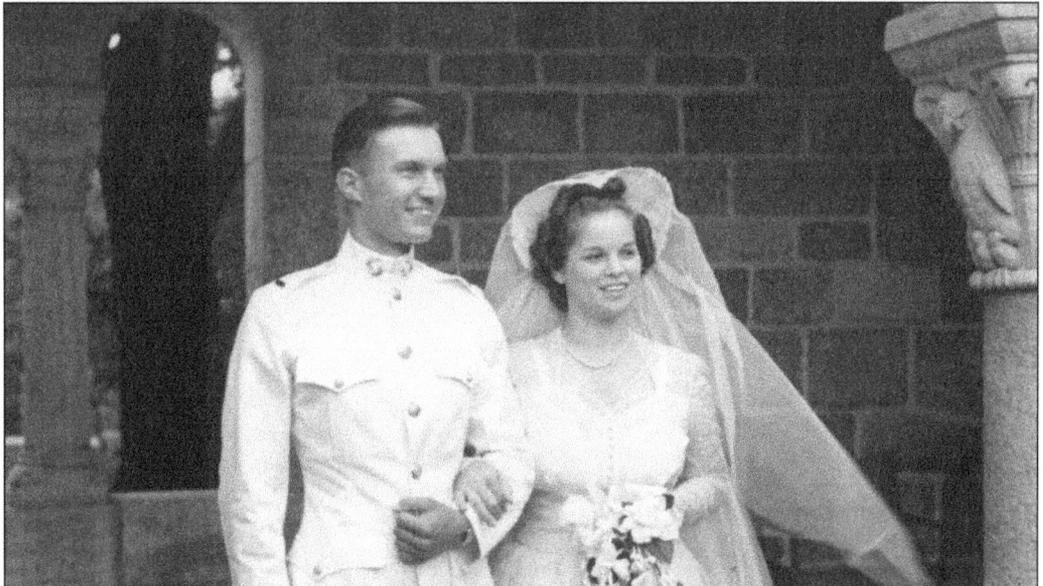

The "Glencairn Girls" were students from Bryn Athyn College, located across the street from Glencairn, who worked for the Pitcairns during the school year. Some of them also worked at Tonche, the Pitcairns' summer residence in the Catskills. Eleanor Stroh and Jorgen Hansen (left and center, pictured in Glencairn's pantry) courted at Tonche and became engaged in 1949. They were married two years later. Musical ability was appreciated and encouraged by the Pitcairns and both Eleanor and her younger sister Marilyn (right) played violin. The Pitcairns paid for Marilyn's music lessons and bought her an instrument. In 1956, she was accepted at Julliard and became the first woman with a permanent position in the Metropolitan Opera Orchestra. Below, Glencairn Girls and other young employees relax at Tonche in the summer around 1954.

Joyce Bellinger, originally from a New Church family in Canada, became one of the "Glencairn Girls" in 1947, living and working at Glencairn while attending Bryn Athyn College. Within a few years she became Glencairn's full-time housekeeper and Mildred Pitcairn's personal assistant. Bellinger also coordinated the details of many events, such as the annual Glencairn Christmas Sing and visits by the Pitcairns' many grandchildren. When Mildred Pitcairn died in 1979, Bellinger continued on as housekeeper, assisting with the building's transition from family home to Glencairn Museum. She also became a tour guide and took on the role of tour coordinator. When she retired in 1992 after 45 years of service at Glencairn, Bellinger became a part-time archivist at the Glencairn Museum Archives, helping to organize and make accessible a vast collection of letters, photographs, speeches, and other material.

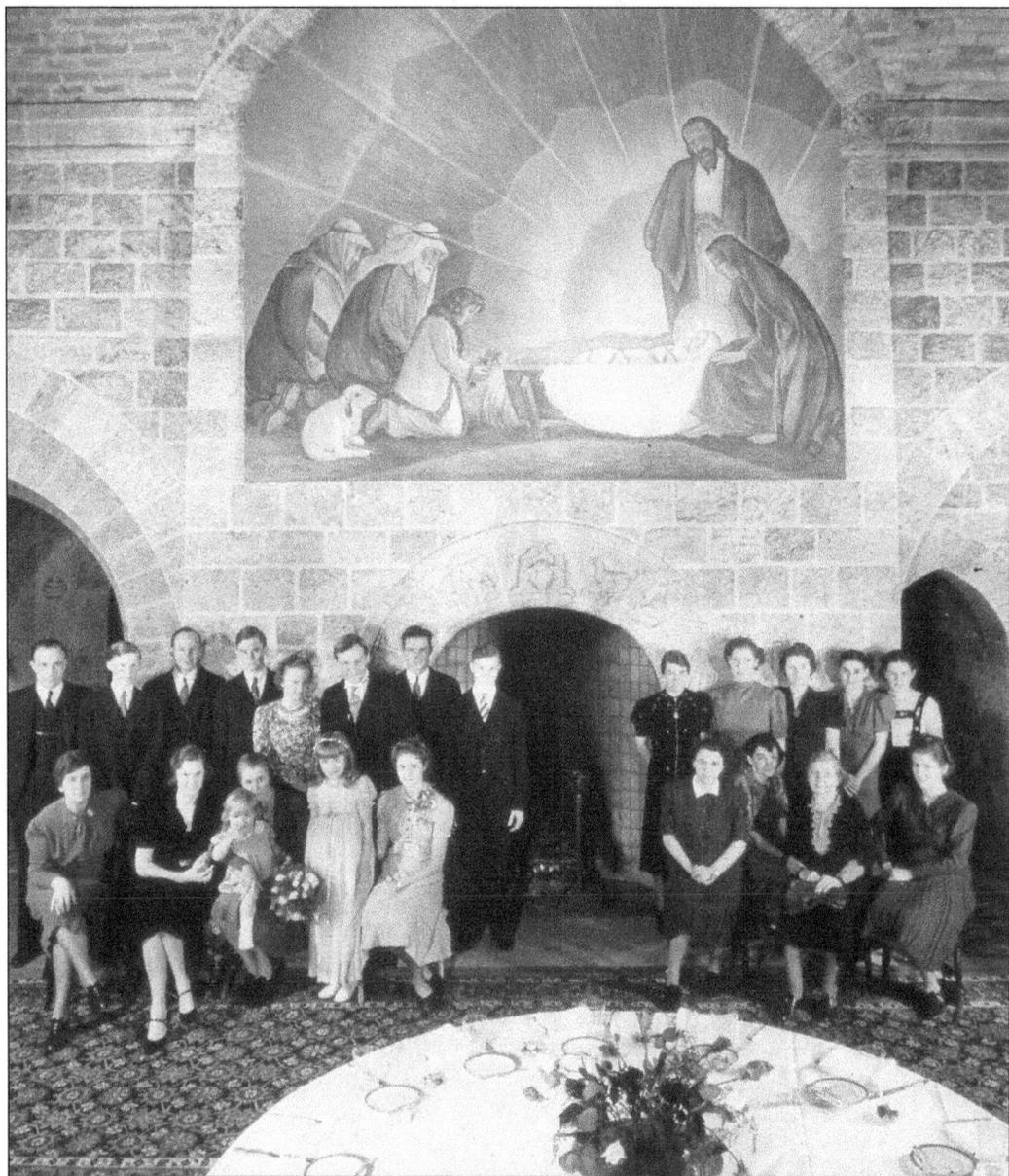

Pitcairn family, friends, and Glencairn staff pose for a group photograph in the early 1940s in the upper hall of Glencairn, decorated for Christmas. The upper hall was used as a dining room, and at holiday meals, several tables were placed end to end to accommodate dozens of guests. Christmas has been a major celebration at Glencairn ever since December 19, 1937, when the Pitcairns opened their nearly completed home to the Bryn Athyn community for the first annual Glencairn Christmas Sing. That first year, the orchestra was made up mostly of young people and children, although Raymond Pitcairn himself played two viola solos. Beginning in 1939, the Christmas sing was enhanced with the addition of the Glencairn Horns, a brass quintet drawn mainly from members of the Philadelphia Orchestra. This annual tradition, which has continued to the present day, has been open to the general public since the early 1990s.

Mildred Pitcairn, shown here with Raymond in a garden on the south side of the building, had a special interest in Glencairn's flower gardens. A longtime member of the Pennsylvania Horticultural Society, Mildred made detailed lists of the plants she ordered from suppliers as far away as England and then kept careful track of each season's plantings. The Pitcairns maintained an operating greenhouse next door at Cairnwood, and Mildred often sent flowers from the property to family and friends, including First Lady Mamie Eisenhower. Dogwoods were a favorite tree at Glencairn, and in 1956 the Pitcairns arranged for several pink dogwoods to be planted at the Eisenhower farm in Gettysburg.

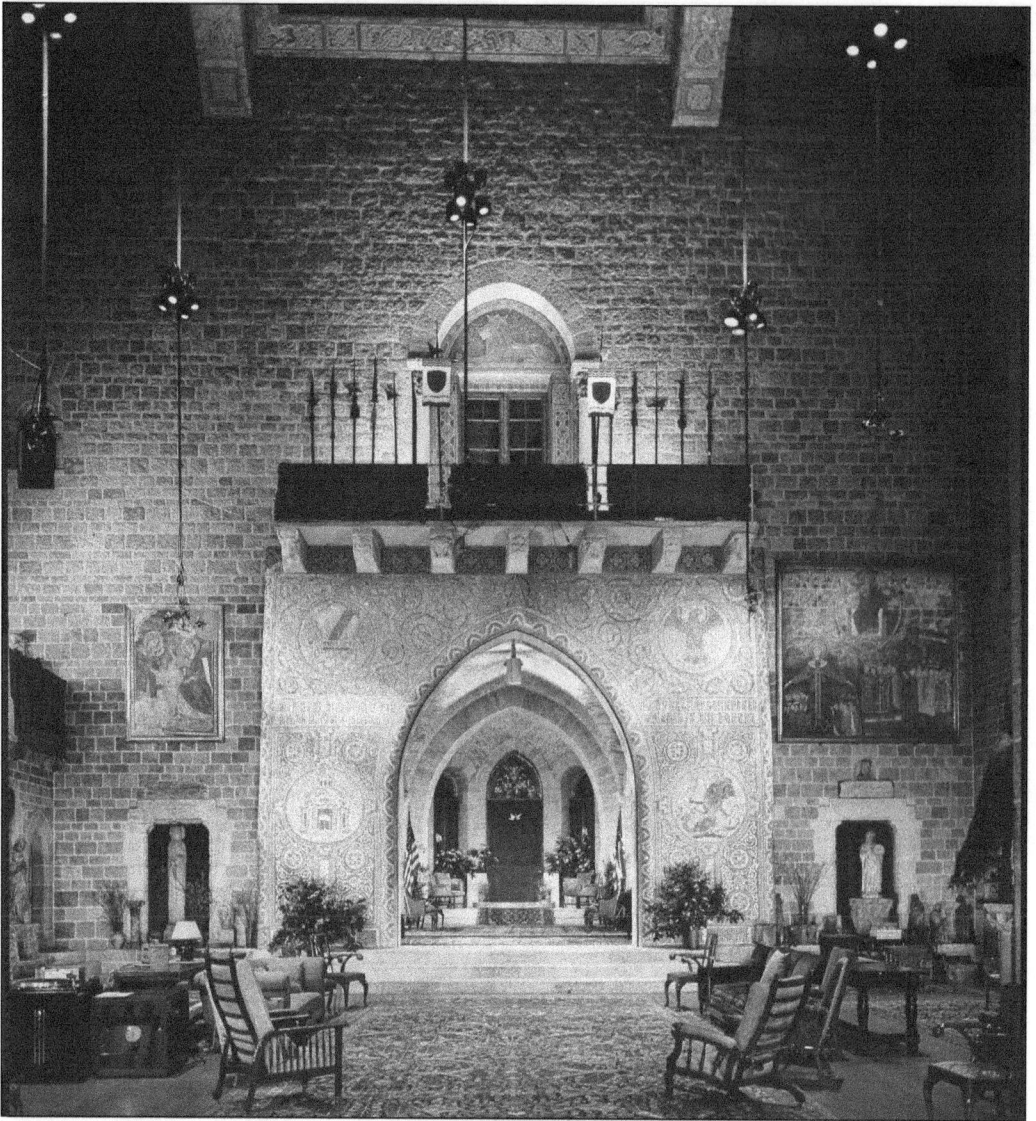

Raymond and Mildred Pitcairn both attended the Academy of the New Church schools in Bryn Athyn, and they strongly believed in the benefits of a religious education for their children. A monumental glass mosaic in Glencairn, extending three stories to the third-floor balcony, decorates the large arch between the great hall and upper hall. The subject of the mosaic is the school seal, which consists of four medallions surmounted by a crowned seated lion (above the balcony doors). Each medallion represents one of the four schools: the Boys School, the Girls School, Bryn Athyn College, and the Theological School. Beginning in 1948, Raymond was asked to teach a music appreciation course for Bryn Athyn College, a subject for which the great hall was eminently suited. The room was equipped with acoustic ceiling tiles, and Pitcairn had a state-of-the-art radio-phonograph system designed for the space (lower left). Several conductors who visited Glencairn were entertained with recordings of their own orchestras, including Leopold Stokowski and Arturo Toscanini.

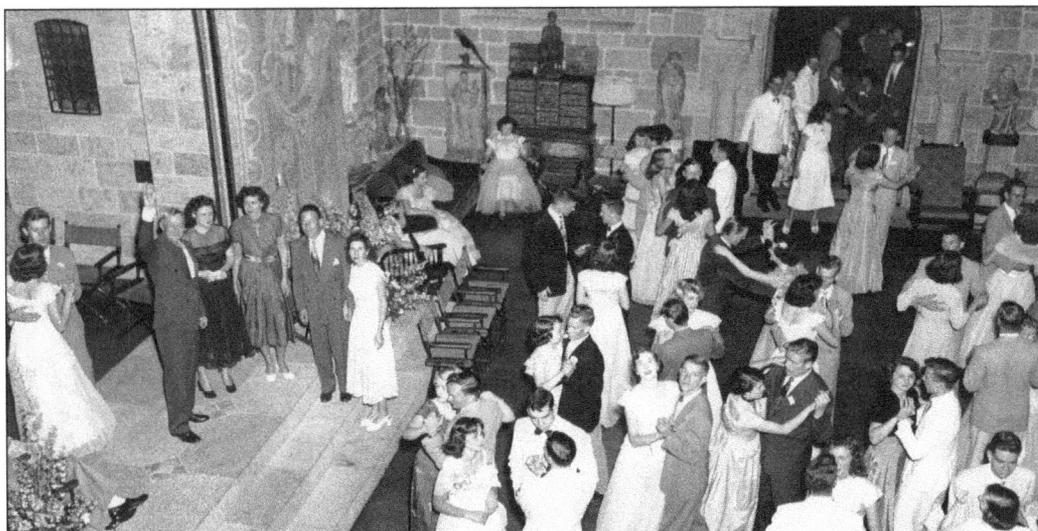

Raymond Pitcairn waves to the photographer during the annual spring dance at Glencairn. The tradition of a formal dance for students and friends of the Academy of the New Church began the first year the Pitcairns moved into Glencairn and continued throughout the life of the home. Many young people in Bryn Athyn also enjoyed the benefits of dance classes held in the great hall. (Photograph by Michael Pitcairn.)

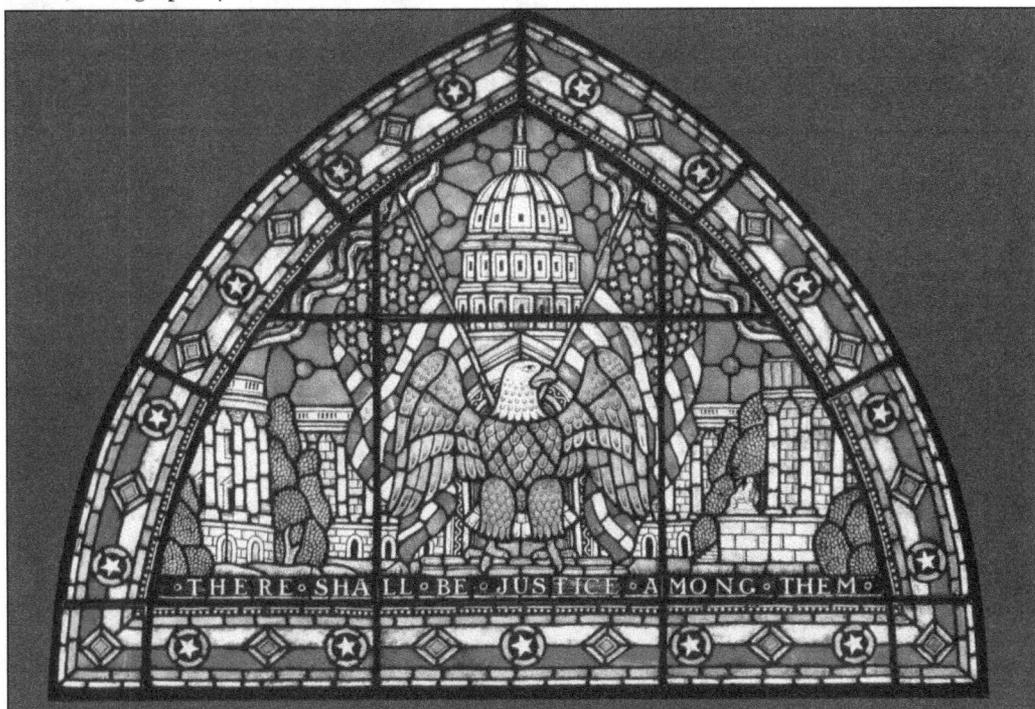

THERE · SHALL · BE · JUSTICE · AMONG · THEM

Glencairn's upper hall contains a patriotic stained glass window designed by Winfred S. Hyatt and made in the Bryn Athyn glass studio and factory. Raymond and Mildred Pitcairn were politically active throughout their adult lives, believing that the biblical admonition to "love your neighbor" included not only individuals but larger units of society as well, such as one's country. (Photograph by Barry Halkin.)

From left to right, Raymond Pitcairn, Mamie Eisenhower, Mildred Pitcairn, and Dwight D. Eisenhower pose in front of a mosaic of a white peacock in Glencairn's "bird room." In 1951, Raymond led the "Americans for Eisenhower" committee in Bryn Athyn, which sent petitions to the general, in Paris, encouraging him to run for office. In 1961, shortly after leaving the White House, the Eisenhowers visited Glencairn for two days to thank the Pitcairns and the Bryn Athyn community for their support. During their stay, Eisenhower addressed a large gathering in Glencairn's great hall (below).

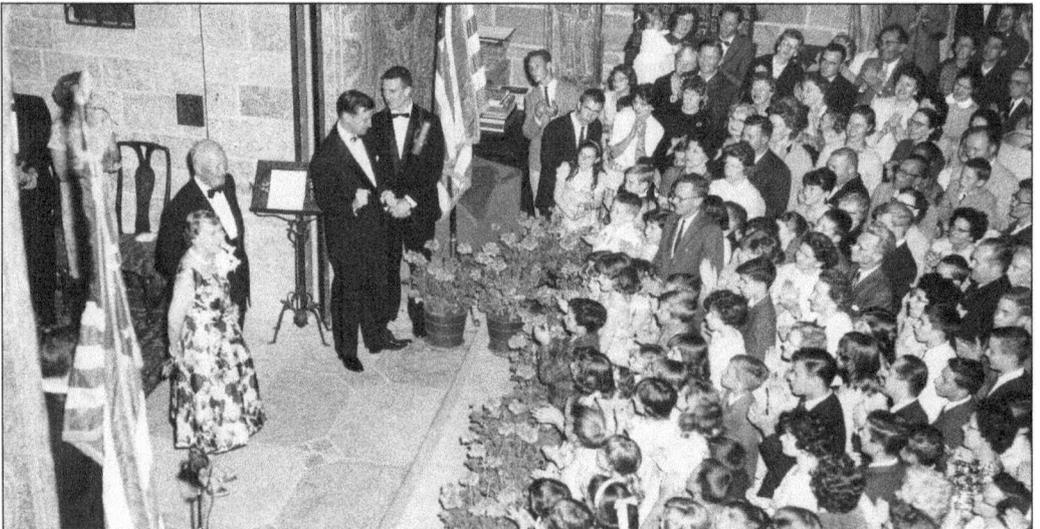

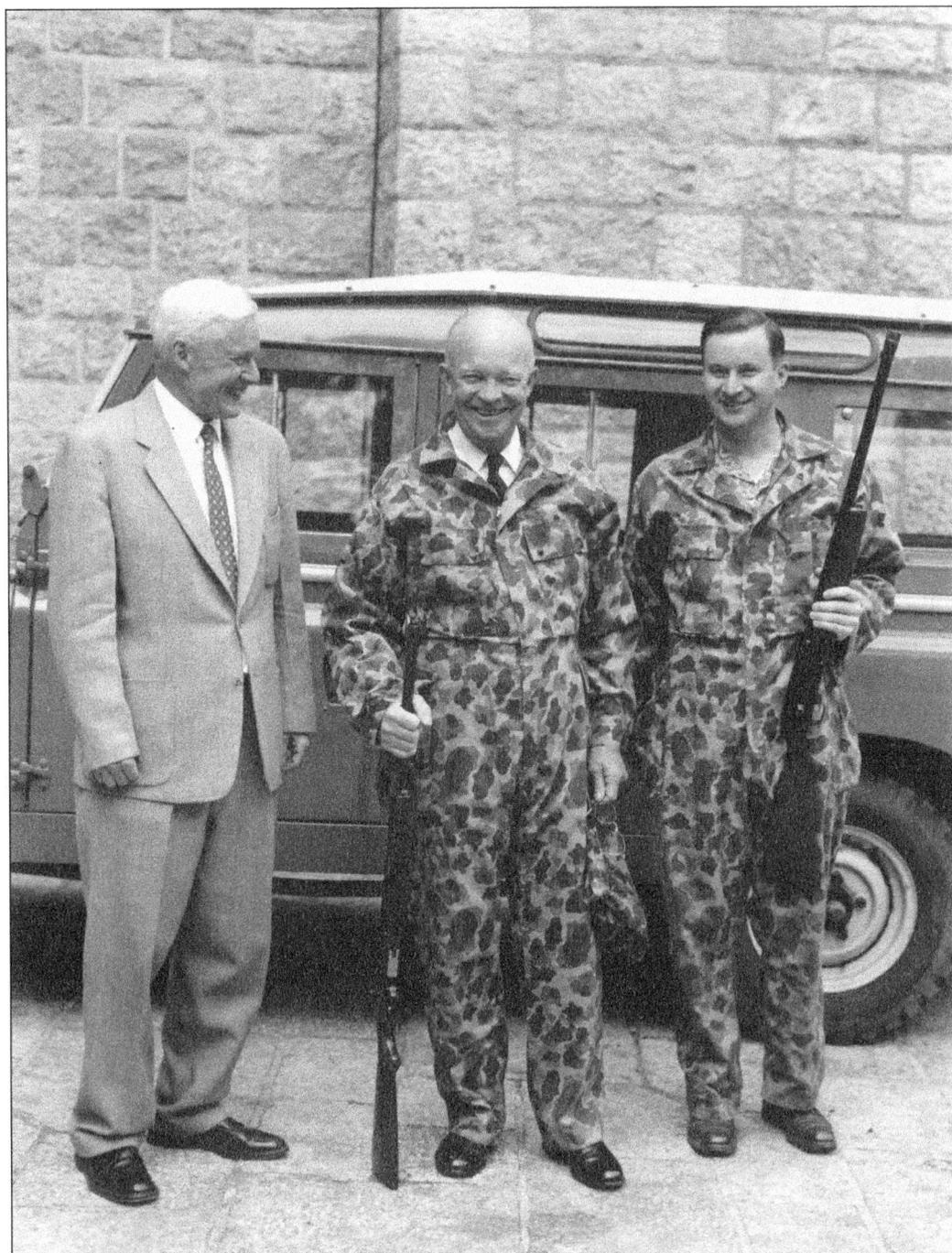

Raymond Pitcairn looks on as Dwight D. Eisenhower and Lachlan Pitcairn prepare for a crow hunting excursion in Bryn Athyn. The photograph was taken in the courtyard of Glencairn, just outside the front door. The Eisenhowers spent their retirement years at their farm in Gettysburg, Pennsylvania, where the Pitcairns visited them on several occasions. Lachlan remembers asking Eisenhower for his assessment of Gen. George S. Patton. Eisenhower replied, "Hell of a general, but awful hard to handle." (Interview with Lachlan Pitcairn, May 1, 2006. Glencairn Museum Archives.)

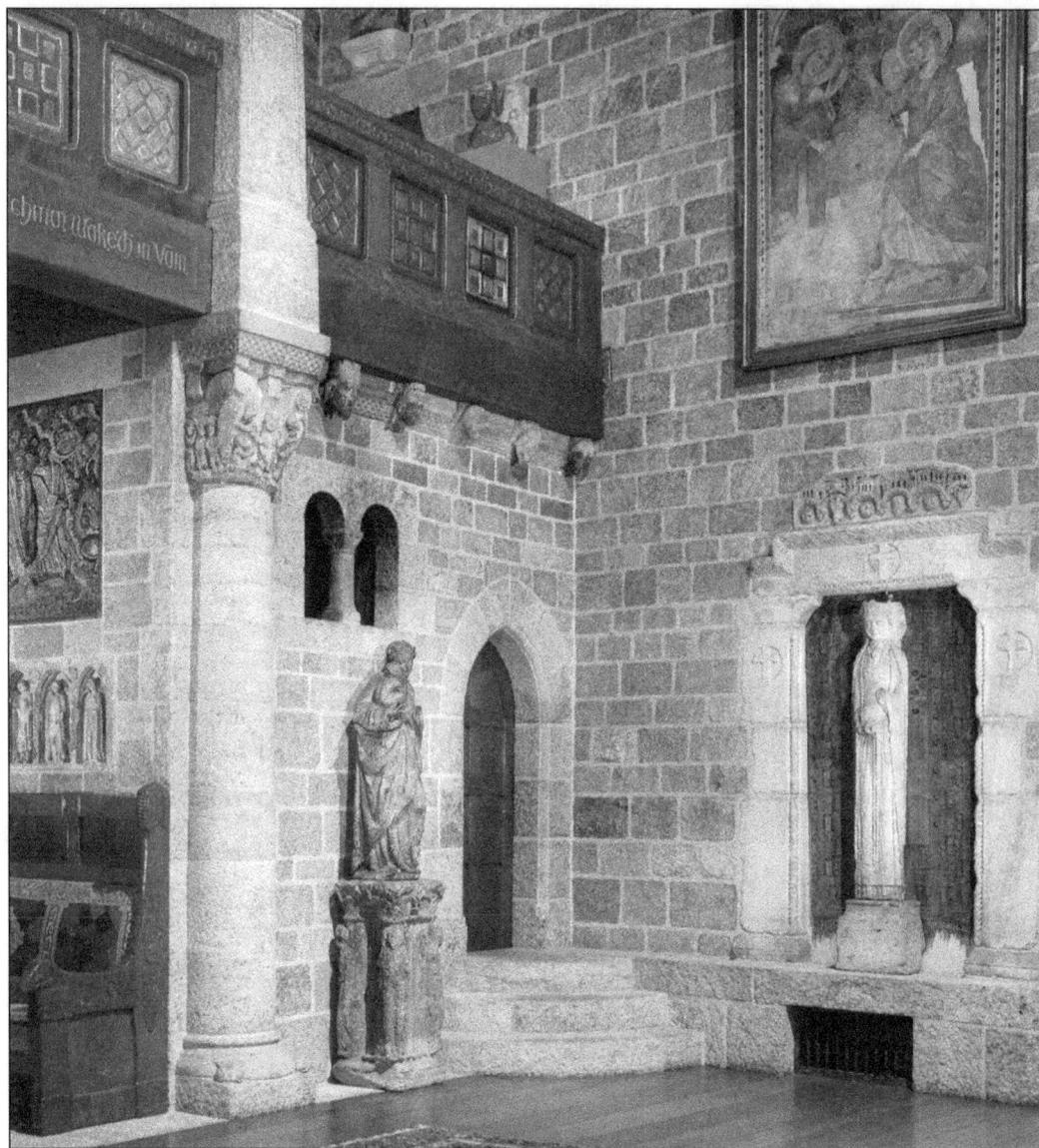

Glencairn was designed to house Raymond Pitcairn's collection of medieval objects, many of which were purchased as inspirational models for the artists who worked on Bryn Athyn Cathedral. The concept for Glencairn was influenced by the work of George Grey Barnard, the American sculptor and medieval art collector who in 1914 opened his Cloisters museum in Manhattan. The interior of Barnard's museum resembled a small medieval church, and the objects were incorporated into the fabric of the architecture in an aesthetically pleasing way. On January 12, 1922, while still in the early stages of planning Glencairn, Raymond Pitcairn wrote to his brother Theodore, "Barnard's cloister stands head and shoulders above the private and museum collections because his objects were made part of the building which he built them into. I should like, one day, to incorporate my little collection into a studio which would be a Romanesque or early Gothic room or small building." (Glencairn Museum Archives; photograph by Barry Halkin.)

This ancient Egyptian libation bowl, carved from black granite in the late 18th or early 19th Dynasty, was purchased in 1923. Originally displayed in the entrance hall of Cairnwood, the bowl was later moved to Glencairn and installed in a special niche with a large glass mosaic of a white peacock decorating the wall behind it. In addition to Christian art, Raymond Pitcairn acquired art from ancient Egypt, the Ancient Near East, ancient Greece and Rome, and a few objects from Asian and Islamic cultures. The jewel of the Pitcairn collection of medieval stained glass is a colorful 13th-century panel depicting a king from the Tree of Jesse Window at Soissons Cathedral in France (below). The subject is the royal genealogy of Jesus Christ. (Right, photograph by Fred Schoch.)

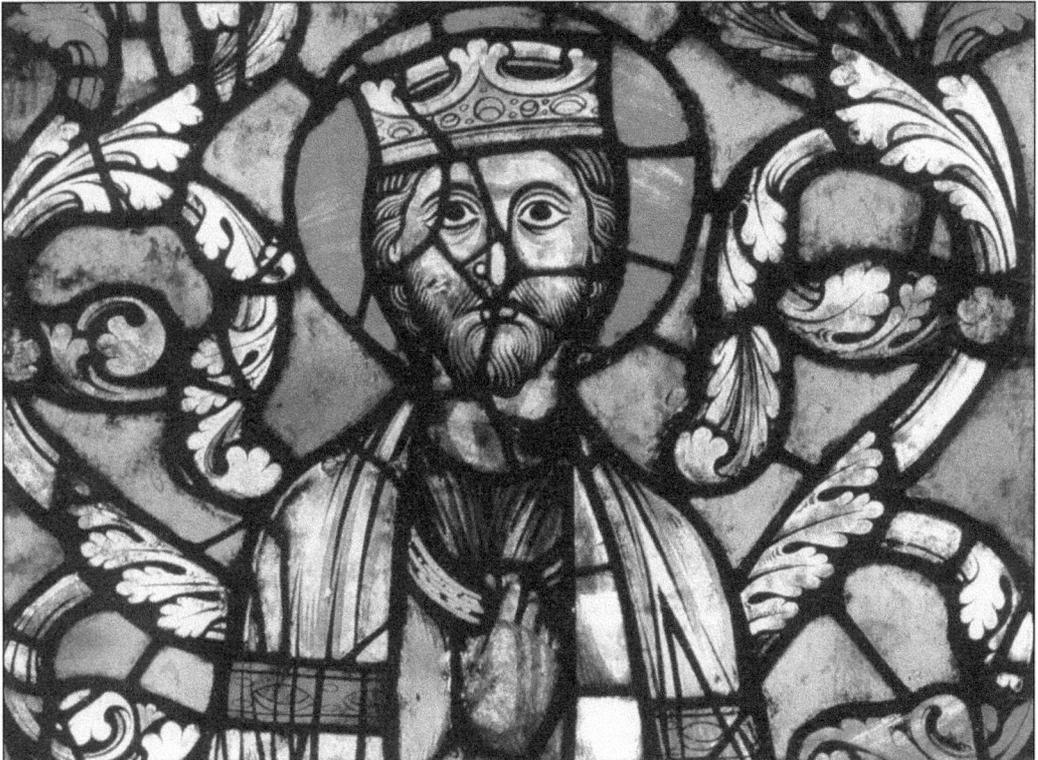

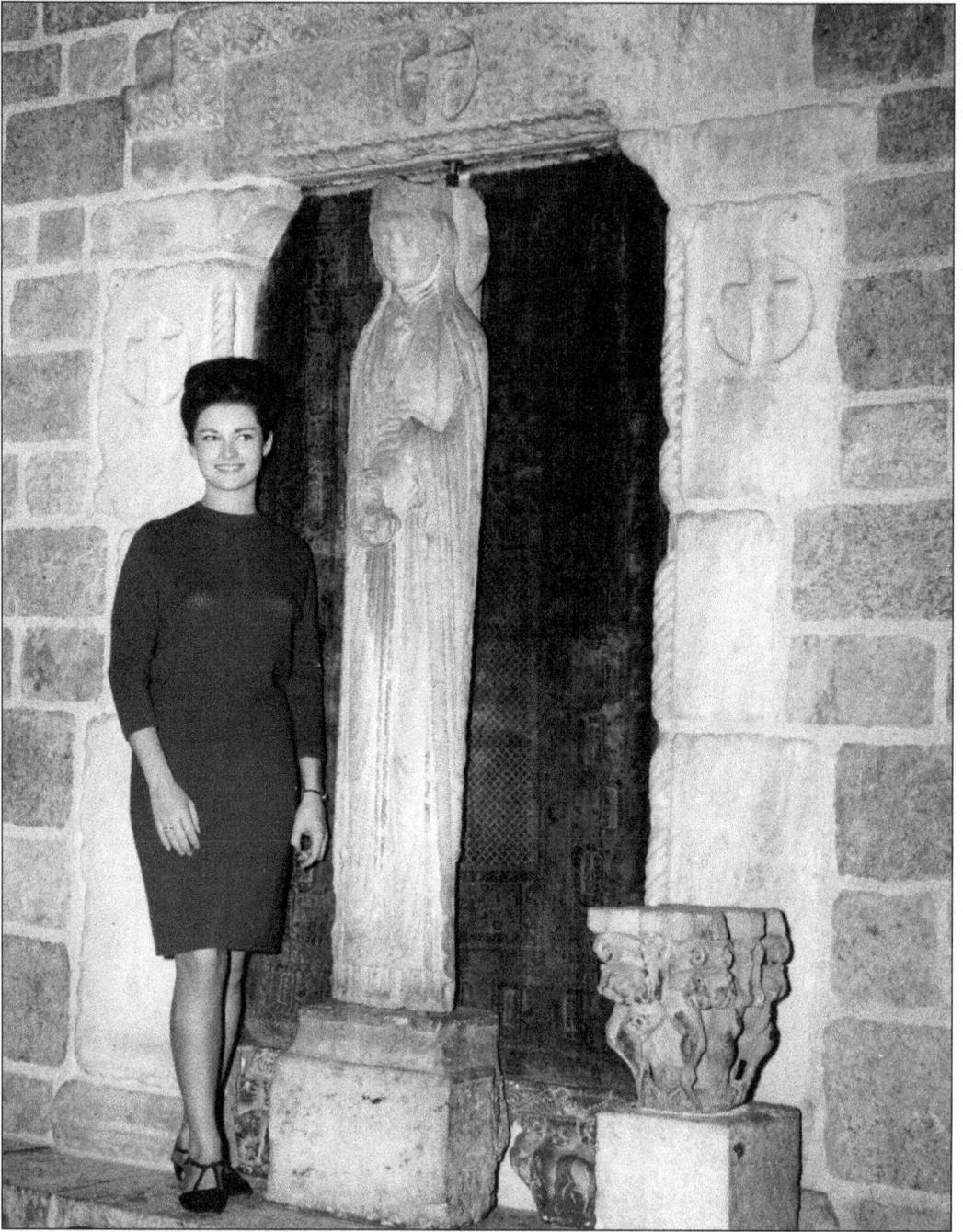

Jane Jayroe, Miss America 1967, poses beside a French medieval sculpture in Glencairn's great hall. During the 1960s, Oldsmobile was the official sponsor of the pageant, presenting each year's winner with a new car. Raymond and Mildred Pitcairn's son Garth owned and operated an Oldsmobile dealership in Langhorne, Pennsylvania. One of the benefits afforded to dealers was the opportunity to book an appearance by Miss America, and over the years several winners of the pageant visited Glencairn.

Six

THE BRYN ATHYN
HISTORIC DISTRICT

The Bryn Athyn Historic District comprises Bryn Athyn Cathedral and three former Pitcairn family residences: Cairnwood, Cairncrest, and Glencairn. The cathedral, dedicated in 1919, continues to serve as an active place of worship. When the Pitcairn residences were no longer used as homes, they were gifted by the families to support the work of the New Church. These buildings now serve as outstanding examples of the "adaptive reuse" of historic structures.

Harold F. Pitcairn died in 1960 and his wife, Clara, passed away in 1964. In 1968, their family gave Cairncrest to the General Church of the New Jerusalem, which now uses the building as its international headquarters. Raymond Pitcairn died in 1966 and his wife, Mildred, remained at Glencairn until she passed away in 1979. The following year, the Glencairn Foundation, the charitable arm of the Raymond and Mildred Pitcairn family, gave Cairnwood and Glencairn, along with their contents, to the Academy of the New Church. The collections of the Academy of the New Church's museum (founded in 1878) were then moved from their home in the campus library building to Glencairn, where they merged with the Pitcairn collections to form Glencairn Museum. Cairnwood underwent extensive restoration in the 1990s and is now open to the public as Cairnwood Estate, an educational, cultural, and hospitality center.

In 2008, the US Secretary of the Interior designated the Bryn Athyn Historic District as a National Historic Landmark, one of only 17 sites in the nation to receive the designation that year. The distinction of National Historic Landmark is awarded to historic structures that have been determined to be nationally significant in American history and culture. On April 18, 2009, the Bryn Athyn Historic District hosted a daylong event to celebrate its new landmark status. More than 2,000 visitors were present for the occasion, which included a ribbon-cutting ceremony with officials from the federal, state, and local governments, and a representative from the National Park Service.

With the help of community volunteers and the support of the Pitcairn family, an extensive restoration of Cairnwood began in 1994. Cairnwood Estate can now be rented for a wide variety of meetings and special events and has become one of the leading venues for weddings in the Philadelphia area. Research is ongoing to support the interpretation and preservation of Cairnwood's buildings and grounds, and students from Bryn Athyn College and neighboring institutions compete for internships in history and education, marketing, and event management. Educational programs and hands-on activities have included a Gilded Age book club, architectural lectures, exhibitions, and workshops. In the photograph above, women in Victorian costume pose at the entrance to the stable and carriage house during a Cairnwood event. (Courtesy of Allure West Studios.)

Guided tours of Cairnwood Estate interpret three floors of the mansion, including the family and servants' quarters, as well as the garden house and carriage house. The carriage house features Cairnwood's original horse-drawn carriages and sleighs and Raymond Pitcairn's 1927 Packard (above). In the photograph below, a local company provides carriage rides of the grounds during the Grand Tour, an event in April 2010. (Above, photograph by Chara Odhner; below, courtesy of Allure West Studios.)

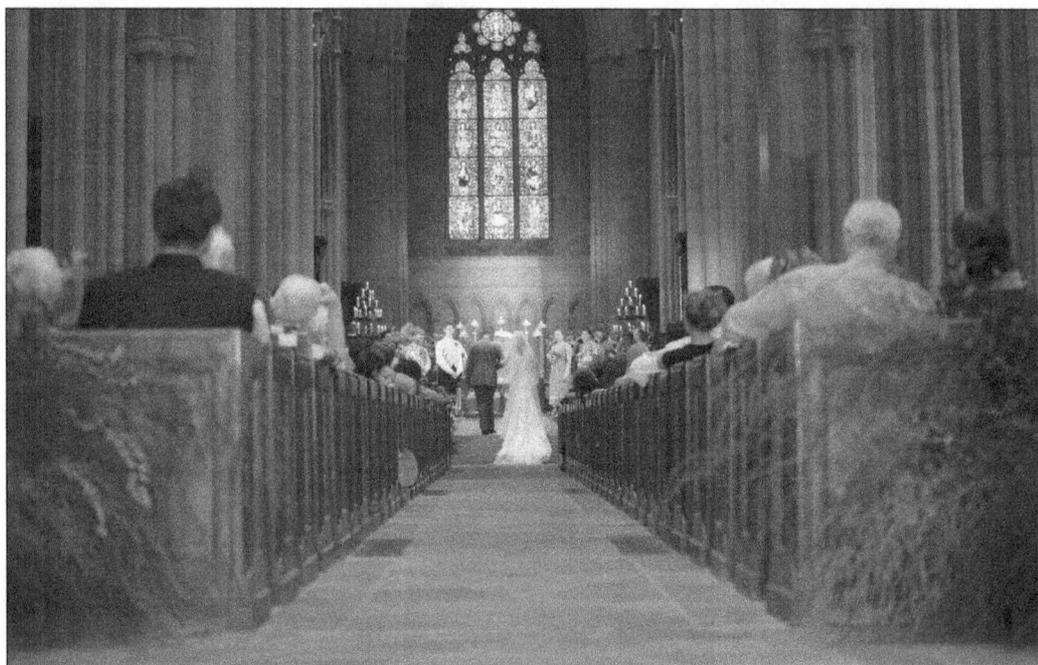

Bryn Athyn Cathedral is the episcopal seat of the General Church of the New Jerusalem and the central place of worship for the Bryn Athyn congregation. The cathedral serves as the site for many Sunday services, weddings, funerals, and baptisms and also hosts guided tours and a variety of special events. In the photograph below, the cathedral is lit for a night view as part of an event in 2010, Landmarks in Lights: A Celebration of Faith. (Photographs by Chara Odhner.)

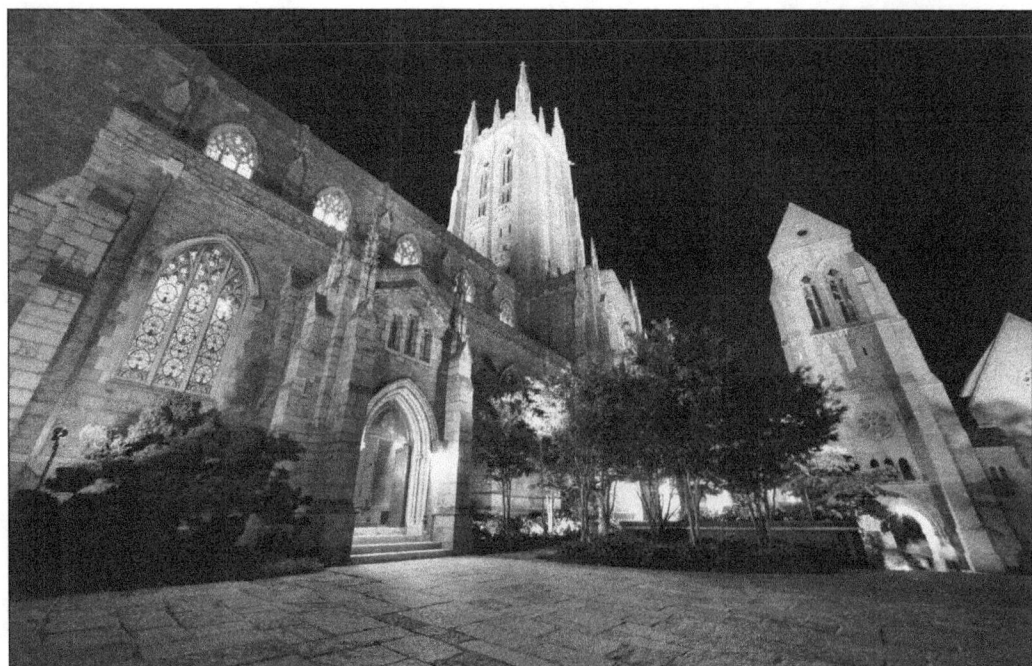

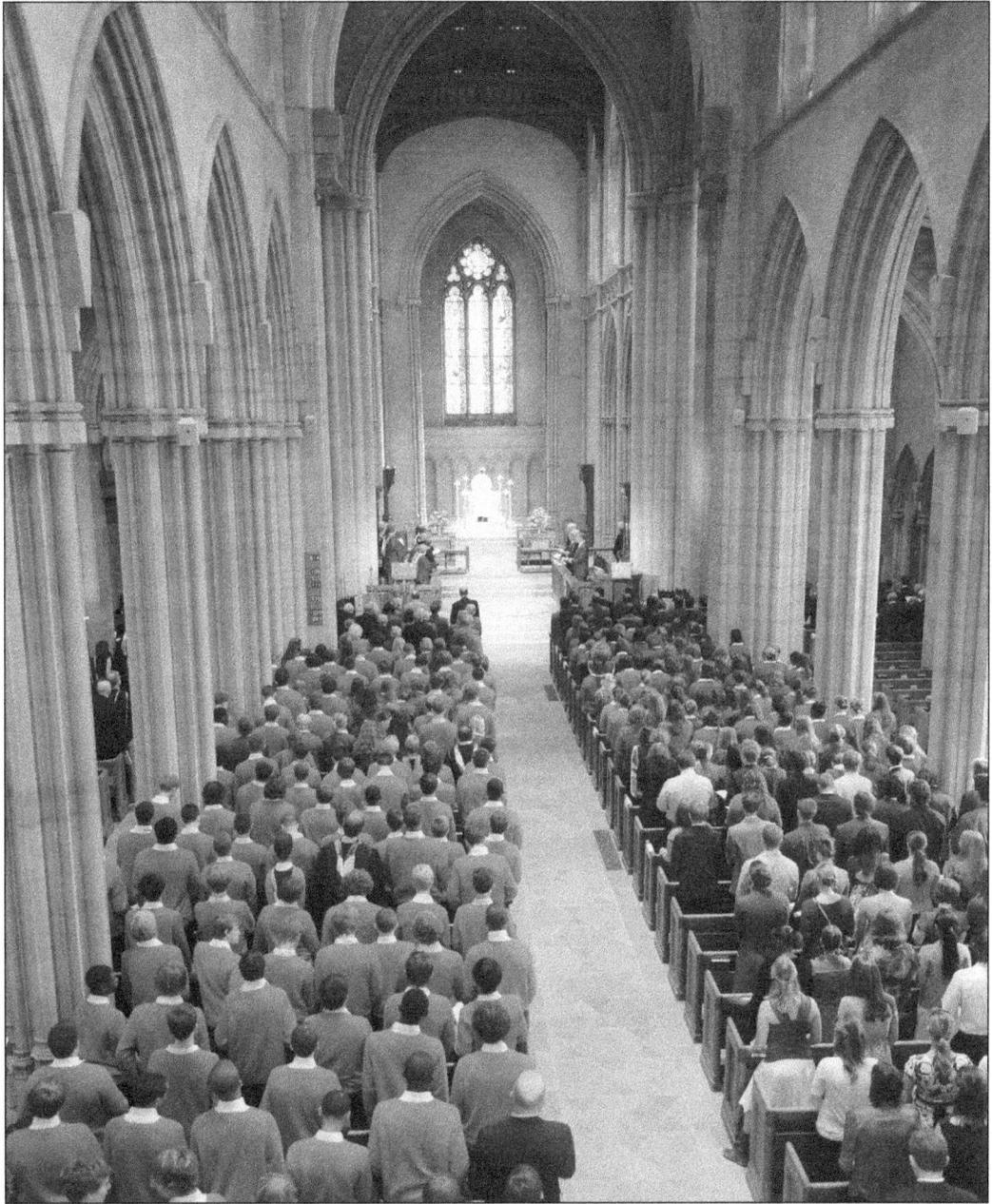

Students, faculty, and alumni of the Academy of the New Church attend a worship service in Bryn Athyn Cathedral on Charter Day in 2008. The schools, established in 1876, received a charter from the State of Pennsylvania that same year. In 1917, Charter Day was celebrated for the first time, and the opening ceremony has been held in the cathedral since the 1920s. The Charter Day celebration occurs in October and serves as a homecoming opportunity for alumni. The Academy of the New Church includes the Secondary Schools, with a Boys School and a Girls School, Bryn Athyn College, and the Academy of the New Church Theological School. (Photograph by Randy van Zyverden.)

Cairncrest currently serves as the international headquarters for the General Church of the New Jerusalem, with offices for the bishop, the assistant bishop, the treasurer, and the departments of education and outreach. (Photograph by Chara Odhner.)

The Reverend Dr. Jonathan Rose, series editor of the *New Century Edition of the Works of Emanuel Swedenborg*, leads a Bible study class in the Cairncrest living room in October 2010. (Photograph by Chara Odhner.)

Visitors explore the Greek Gallery on January 16, 1982, the occasion of the official opening of Glencairn Museum. The museum's galleries, many of which are housed in former family bedrooms, include spaces devoted to ancient Egypt and the Near East, ancient Greece and Rome, Asia, American Indians, and several galleries for medieval stained glass, sculpture, and treasury items.

Glencairn Museum is known internationally for its outstanding collection of art from a variety of cultures and time periods, used to educate visitors about the history of religion. The Egyptian Gallery features special exhibits on mythology, the Pantheon, and funerary magic, as well as miniaturized dioramas illustrating mummification and the judgment of the dead. (Photograph by Chara Odhner.)

Glencairn Museum offers guided tours, concerts, lectures, and special events and is a popular destination for groups from public and private schools. In 2007, in connection with an exhibition, Buddhism in Pennsylvania, a group of monks from a monastery in southern India worked for five days at Glencairn to create a traditional sand mandala, an ancient art form of Tibetan Buddhism (above). Annual events at the museum include a sacred arts festival, a medieval festival, and the Christmas sing, which has been held at Glencairn since 1937. As a tribute to Raymond Pitcairn's artistic vision, the first floor of Glencairn has been preserved in its integrity. In addition, the master bedroom and bath have been maintained with the original furnishings, and the chapel remains a place for quiet reflection. (Photograph by Chara Odhner.)

The internship program at Glencairn Museum attracts students who are interested in religion, art, history, and education. Interns lead tours for the general public, help with visiting school groups, and assist museum staff in the research and development of exhibitions, events, and festivals. (Photograph by Chara Odhner.)

A representative from the National Park Service presents Mayor Hyland Johns with a plaque designating the Bryn Athyn Historic District as a National Historic Landmark on Saturday, April 18, 2009. (Photograph by Chara Odhner.)

Visit us at
arcadiapublishing.com